HANDCRAFTED
MODERN

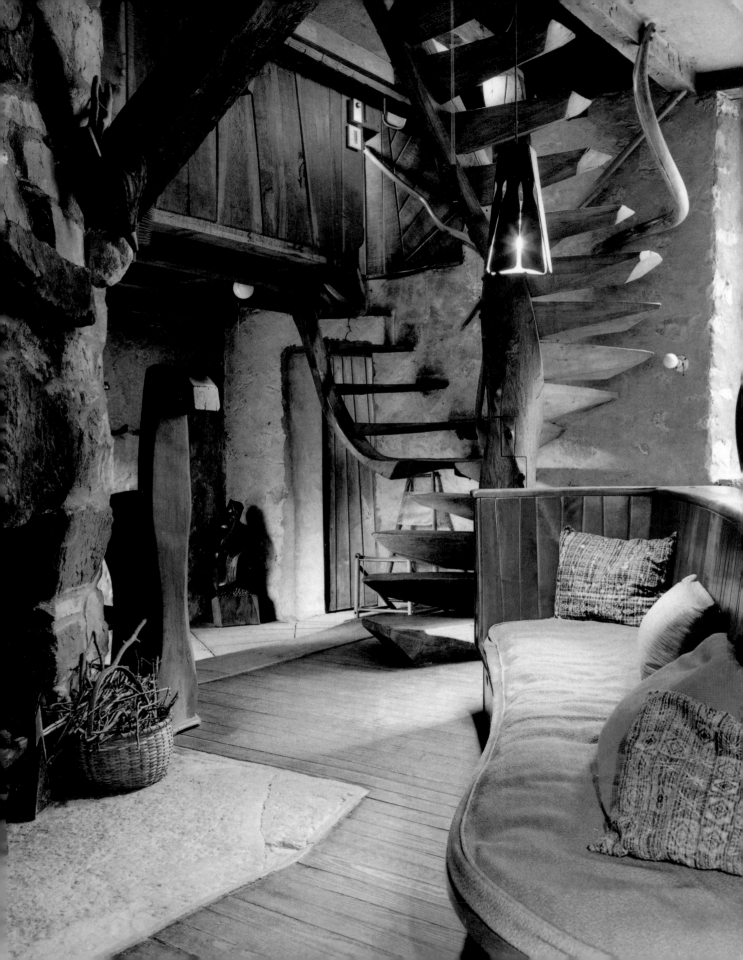

HANDCRAFTED
MODERN

AT HOME WITH
MID-CENTURY DESIGNERS
by LESLIE WILLIAMSON

RIZZOLI
NEW YORK

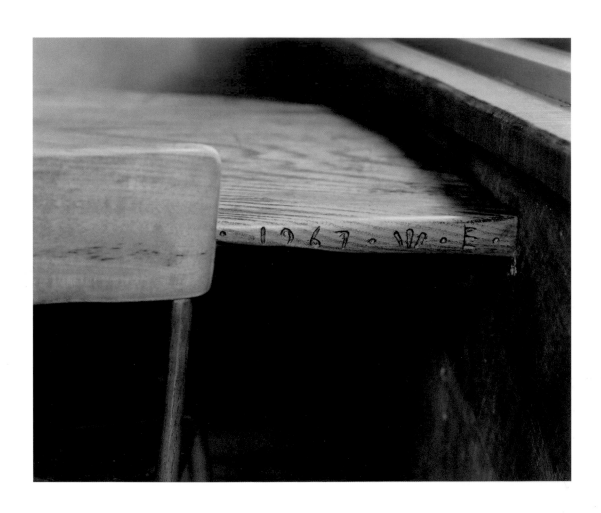

CONTENTS

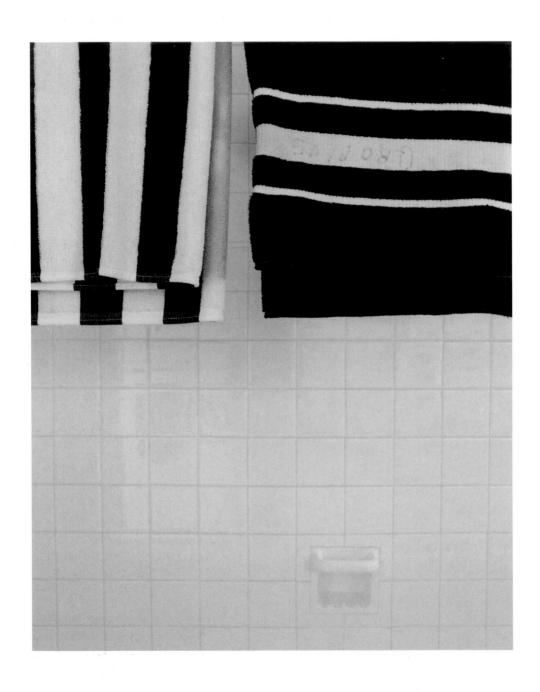

INTRODUCTION

Perfection is supremely uninteresting to me. When I first started learning about Modernism in college, it was hard to get beyond its stylistic veneer. I saw it as pristine, perfect objects and buildings with clean, stark forms, but rather removed from the reality of my daily life. Please understand, I loved it all, but it seemed inaccessible on an everyday living level. Then, on a vacation in New England more than ten years ago, a friend took me to see Walter Gropius's house in Lincoln, Massachusetts. At this time it was in disrepair. There was a tarp over part of the roof to prevent water damage and it was empty, but I walked up and peeked in the windows of the living room. The house was a revelation. It was modern, but it was, first and foremost, a home for a family. Although it was made with modern materials—glass block, chrome, acoustical plaster, metal-framed windows—it appeared to be crafted out of these materials rather than merely built. I finally saw that there were dimensions and layers to Modernism and what resonated with me were designs that were not simply about the building as object but about people inhabiting a space.

Many people have asked me how I began this project and the simplest explanation is good old-fashioned curiosity. I am neither an architectural historian nor a design scholar. I am basically a fan, like many of you I would guess. But I am also a photographer, and I interpret and understand the world through taking pictures of it. When I first got the idea for this book in April 2005, I assumed it already existed. I was visiting that mecca of mid-century design, Palm Springs, and found myself staring at a glass house perched on the side of the mountains. I had been intrigued by this house for years, and on this trip learned that it was the architect Albert Frey's home. He had bequeathed it to the Palm Springs Art Museum for the purpose of keeping one of his buildings completely intact and pristine. The museum made the house available only for architectural study and research. I was not an architect, nor did I have any reason for research, but I became obsessed with seeing inside that house. What would an architect build for himself, without the demands of a client upon him? Would he experiment? Would what an architect builds for himself be the purest manifestation of his creative vision? When I returned home to San Francisco, I went to William Stout Architectural Books to find this book on architects' homes that they built for themselves. All I found that day was that this book did not exist. There were a couple of books on Frey, but how the house was photographed was frustrating to me. They were classic architectural photographs—wide heroic interior and exterior shots—and they were undeniably beautiful but lacking. I wanted to see the little details of the house—how Frey lived. I searched the internet, I searched interiors books, I looked everywhere I could think of, but my curiosity was not satisfied. I wanted to see more. Being a photographer, I thought, I'll do this book. I do not photograph like an architectural photographer at all, but no matter, at least I would see inside Frey's home.

One year later I photographed the first house for this book, that glass box on the side of the mountains in Palm Springs. Finally I was standing in Albert Frey's home, and it did not disappoint. However, it was the Gropius House, the second house I photographed, that defined this project. I had compiled a list of dream houses. The homes were all over the world—Le Corbusier's cabin in the South of France, Oscar Niemeyer's home in Brazil—and Walter Gropius's home, which I had visited so many years before. Gropius's house had been restored as a house museum. The interiors were now richly detailed with the Gropius family's personal artifacts. All of Gropius's personal possessions in the house changed how

I viewed him as a person, much the way his home transformed my perception of Modernism. Before visiting his house, Gropius had always intimidated me. I once saw a portrait of him where he was rather stern and foreboding, but his home, full of his possessions, made me see him as a regular guy.

At this point I decided that all the houses in my project would have to be intact, with all possessions still in the house (or as close as possible). This decision changed everything. First of all, houses in this state of preservation are not that easy to come by unless the people are still alive, and I was drawn to the work of mid-twentieth-century architects, the majority of whom were no longer around. On top of this I was committed to only shooting houses that inspired me—it was still a personal project after all. I also narrowed the scope of homes to those inside the United States in order to keep expenses down. So quickly my dream list was shortened and I decided to broaden my view from only architects to include product and furniture designers. It was logical because many of the homes that interested me belonged to designers who were not confined by discipline. The Eameses, Wharton Esherick, even George Nakashima, all designed their own homes, but they were better known for furniture design. When I got an opportunity to photograph Eva Zeisel's country home, I decided that all the homes did not have to be designed by the designer—I certainly was not going to turn down the opportunity to shoot her house just because she did not design it herself!

So for the record, here is a list of criteria that evolved for this project and how I shot it. But keep in mind, I am an artist, not a scientist or documentarian, so I made exceptions when I was inspired:

1. The home has to be intact with the person still living there.

2. If the person is no longer living, and the house is a museum, it must be preserved as it was when the designer was living there, with their personal effects still in the home.

3. I tried to shoot the home as it was when I arrived. I would only move objects if they were distracting—mainly things with large name brands emblazoned on them.

4. I shot for two full days.

5. I used only natural light or lighting from the house, so the photographs reflect how the house would be for a person living there.

6. I shot everything on film.

With these criteria in mind, I let inspiration lead me where it may and photographed all the personal objects and quirky details as well as the overall picture of a room. There were many unexpected discoveries along the way. First of all, I became obsessed with these designers' book collections. I turn to books regularly as sources of inspiration, and I became intensely curious about what all these designers had on their shelves. For the most part, they were voracious readers with wide-ranging interests. There was one common denominator book that virtually every person in this book had on his or her bookshelf: Frank Lloyd Wright's *An American Architecture* (1955)—it is visible on Russel Wright's shelf. Another interesting fact is how there were so many connections between these people. When talking with some of these designers, I would bring up another designer I hoped to visit and I would hear a story about these designers meeting or working or just hanging out. Case in point, when I was photographing John Kapel's

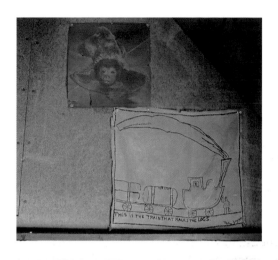

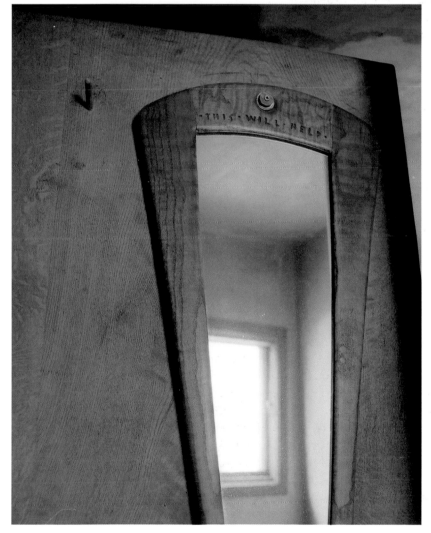

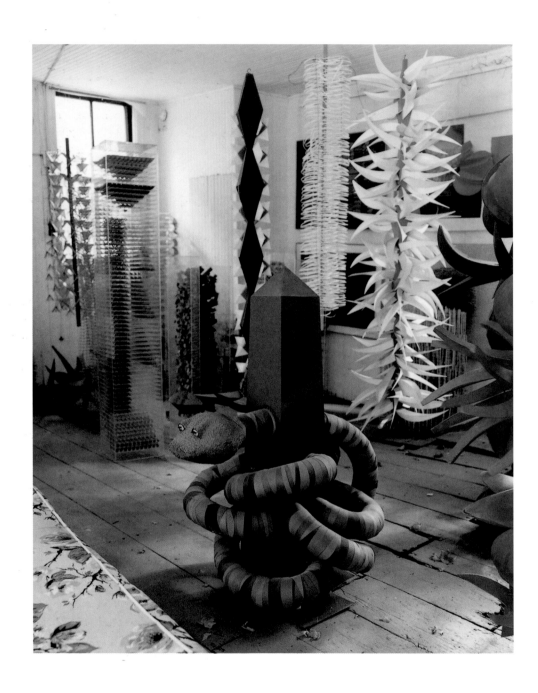

house, I asked him how he decided to start making furniture. He told me that when he was working at George Nelson's office, he had mentioned his interest in furniture design to a colleague who had encouraged him to make a go of it. That colleague was Irving Harper. Little coincidences like this happened throughout this project.

There were also a few shots that are burned in my memory because I did not take them. Ise Gropius's cookbook was sitting on the kitchen counter, complete with penciled-in notes on how "Gropi" preferred his duck a l'orange. I did not photograph it, and I will forever regret this omission! One shot I did take was of Gropius's towel hanging in his bathroom. I loved the way his name had been written on it in pen. Was Gropius worried someone would steal his towel at the Harvard pool? As I pondered why he would write his name on his towel, I realized that my view of Walter Gropius had completely changed. He was no longer an icon of Modernism. He was a guy worried about losing a towel. The same thing occurred in the Eames House when I saw Ray Eames's bedside table. On it was a carefully composed still life of objects—as there is on almost every surface in the house—but amid the objects were two bobby pins near the phone. I imagined her taking these two pins out of her hair before she went to sleep, such a universal exercise but also very human. Are the mundane objects in our life the things that humanize us? Throughout this project, I found this to be true, and it gave me a different view of these designers who are now so revered.

Other objects caught my eye because they were so unusual and seemed to reveal an intimate dimension to the artist's character. In the Esherick House I came across a little embroidered train next to a picture of a monkey. What is the story behind this, I wondered? When I asked the director of the studio, he asked me where I found it. Even after years of working at the studio, staff members continue to discover new details. In the attic, I found a mirror that has the message "This will help" carved into it. No one knows the exact story of this piece either but both made me smile. It is clear Esherick's sense of humor was a good one.

Irving Harper, now retired, spent many years making intricate sculptures. Their materials are ordinary—paper, pins, toothpicks, pasta, whatever is lying around—but Harper's designs resulted in beautiful and delicate constructions. His larger creations inhabit the entire first floor of his barn, and they towered over me as I walked through. He mentioned this barn to me very close to the end of my visit and I only had time to shoot one roll of film there because it was late in the day. Yet, finding this building overflowing with sculptures reinforced my awe in his unbridled creative energy.

So you see, every house had its own secrets to discover, and I even had the opportunity to have lunch with some of my heroes. (John Kapel even baked a homemade pie for me!) But when all is said and done, the pictures tell the story best. Our home is the heart of our private selves. What we have in it can be more telling than a portrait of our face. I consider these chapters to be portraits of these designers, and I hope they convey my deep admiration for them. Through the process of shooting this book, all of these designers transcended their status as icons of Modernism. I now see them more as extraordinary people than as demigods of design. I hope that you come away with the same revelation.

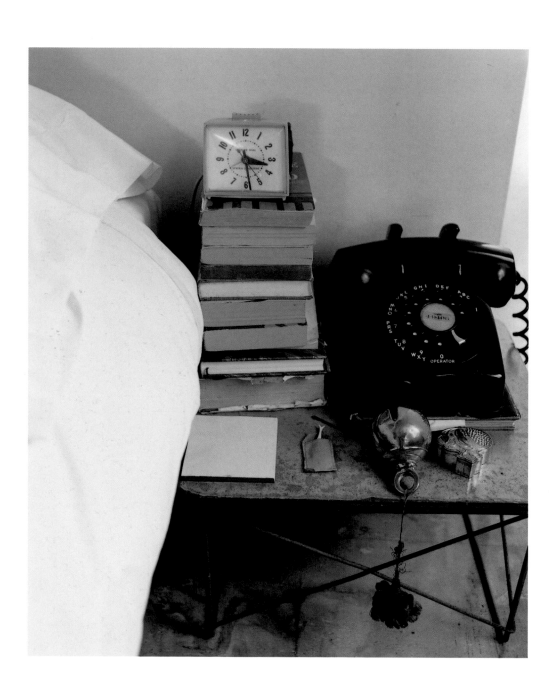

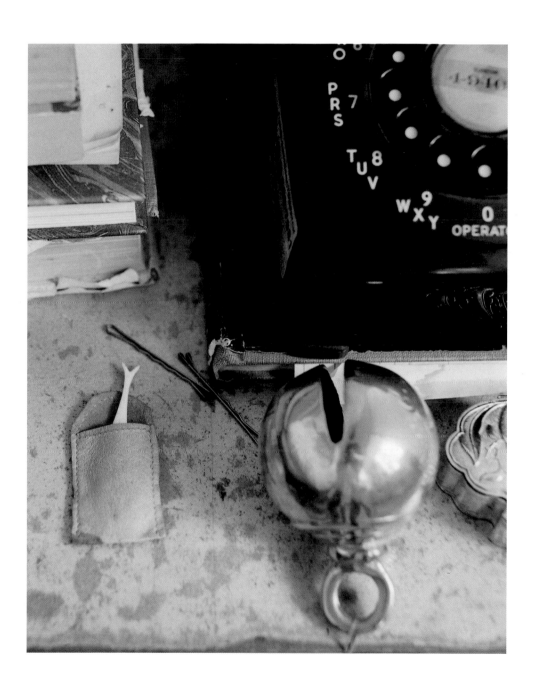

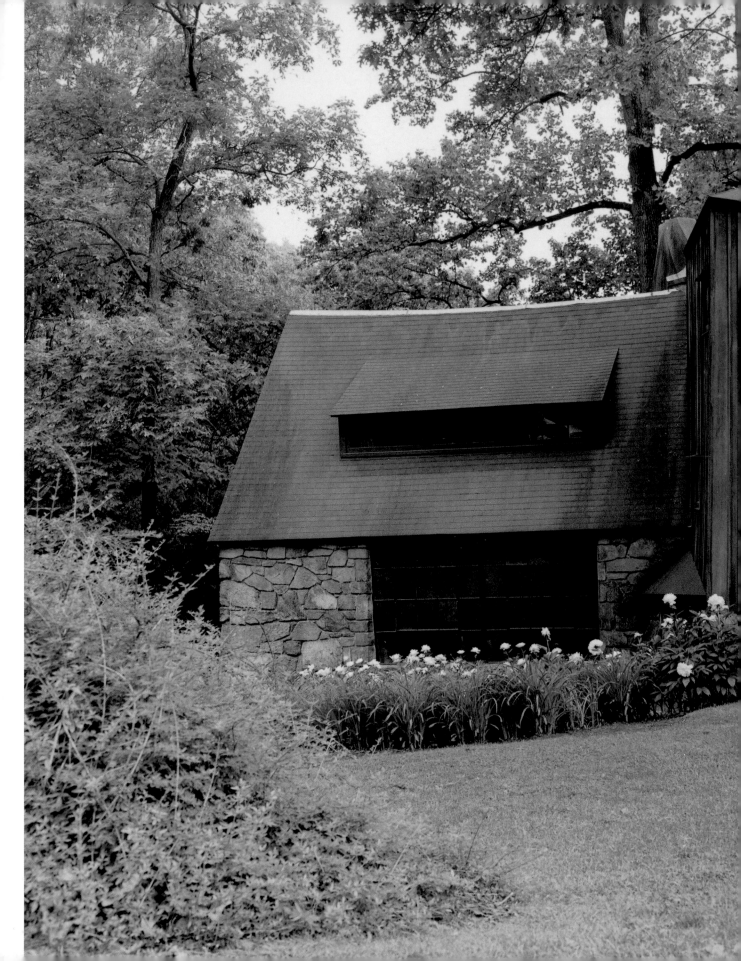

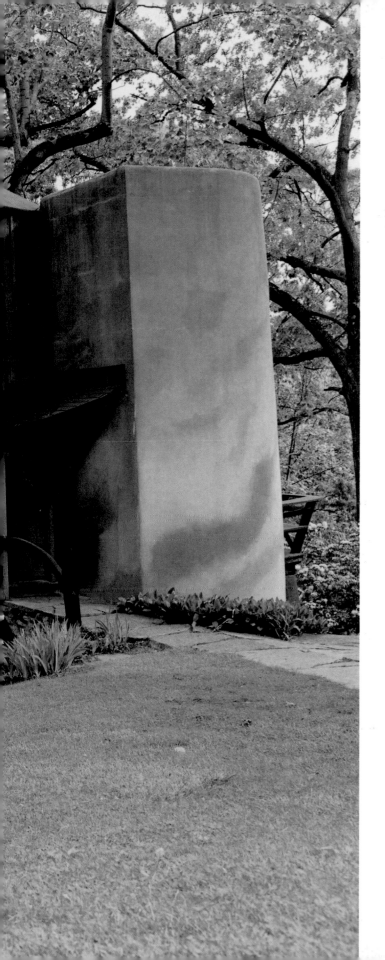

WHARTON ESHERICK

VALLEY FORGE, PENNSYLVANIA

No right angles, no perfect symmetry, let it all be organic and oddly, yet sublimely, put together: Wharton Esherick's home and studio in the mountains near Valley Forge, Pennsylvania, suggest that this could very well have been his motto. His devotion to a life of creative exploration exudes from every nook and cranny of this house—and nooks and crannies abound here! Everywhere I looked I found something created or designed by Esherick (1887–1970): woodcuts, paintings, sculptures, maquettes of his furniture commissions, the furniture itself. Yet it quickly becomes obvious that the house itself, with all its contents, is not only his masterwork, it illustrates Esherick's evolution as an artist.

I first saw Esherick's home in a magazine spread years ago, and I proceeded to clip out the article to save. Whenever I needed a jolt of creative inspiration, I would dig out the article because what I saw in his home was a pure unadulterated artistic vision. It was evident that he was inspired by the Arts and Crafts movement, Cubism, and even Expressionism, but his interpretation of these movements—be it in sculpture, furniture, or the architecture of his home—was uniquely his own. Perfect symmetry is rare here, and curves are far more common than hard, straight lines. From the largest piece of furniture to the smallest handmade spoon, right angles do not exist in Esherick's world.

Upon entering the house, my first sight was of the dining room and its picture window framing the Pennsylvania countryside. The dining table has a single leg and is attached to the wall to prevent it from, as Esherick put it, "walking out the door with a customer"—a very practical solution considering that his home oftentimes served as his showroom, though I am sure Esherick was joking a bit when he said it. The house is centered on a spiral staircase that was exhibited at the 1939 World's Fair, and as I climbed down from the kitchen and dining level, the stairs split and I found myself climbing these famous stairs up to Esherick's bedroom. The bedroom, like the rest of the house, is maintained as it was when Esherick lived here—even his clothes remain in the drawers. Esherick's family has meticulously preserved the home since his death and now runs it as a museum, open to visitors by appointment. Around his bed sit his favorite books and along the back of the curved sofa and on the cabinet lie perfectly rendered maquettes of his numerous furniture commissions—many even have working drawers.

Winding back down the stairs and continuing all the way to the bottom, I arrived at the main living area of the house. In a corner I found the story of Esherick's artistic evolution, told in his different media. A large wood desk (1927) with intricate carvings of the bare winter tree branches—clearly from his early Arts and Crafts period—and his captain's chair (1951) sandwich a Cubist-influenced wood sculpture of daughter Ruth's pet dog, Pup (1928). Along the other side of the desk hang numerous examples of his woodcut illustrations, which he did only early in his career (1920s to early 1930s), and beneath these woodcuts sits a double music stand from 1962. Thus, on one wall there is a span of about fifty years of Esherick's life sketched in his own artwork, and when considered with the stone wall before which all this sits—from the original structure he built in 1926—a fairly complete portrait of Wharton Esherick the artist emerges. To walk through Esherick's home is to walk through his life.

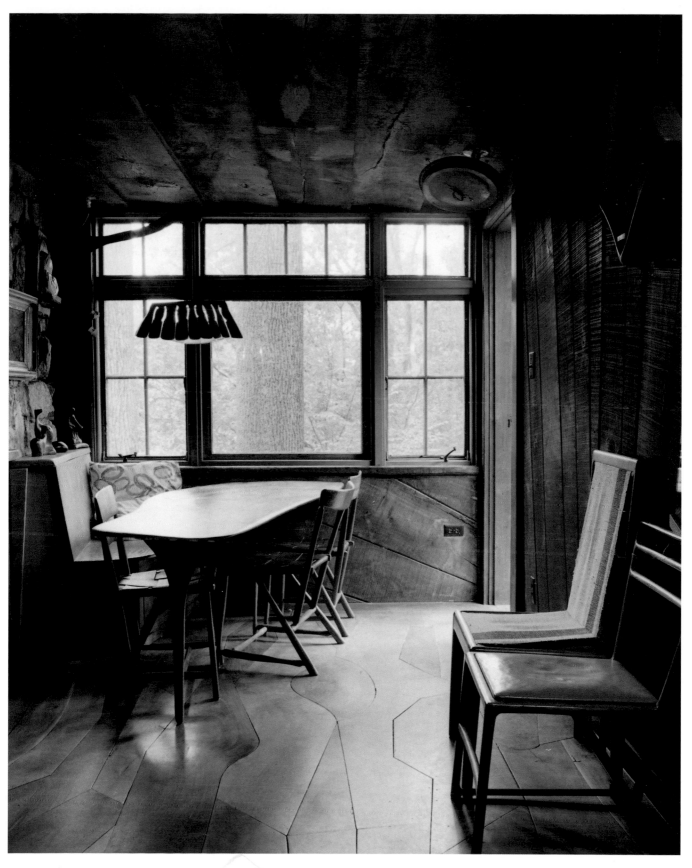

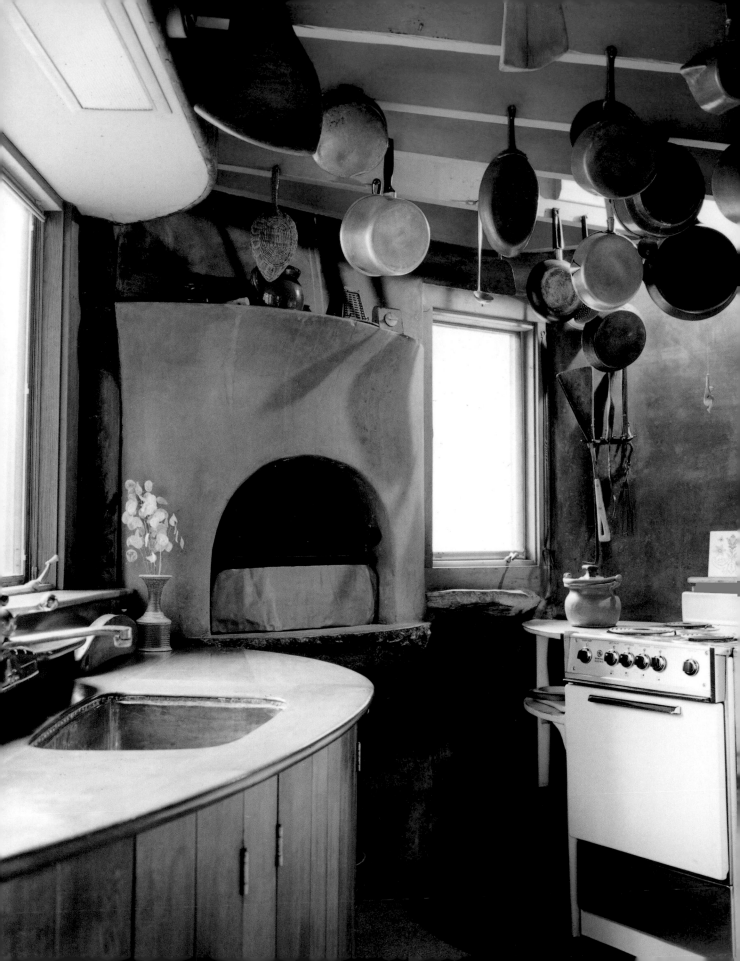

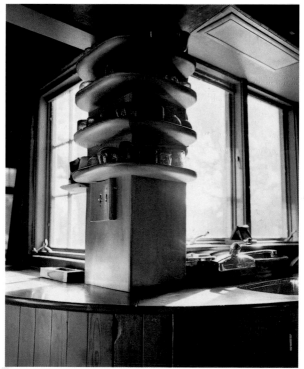

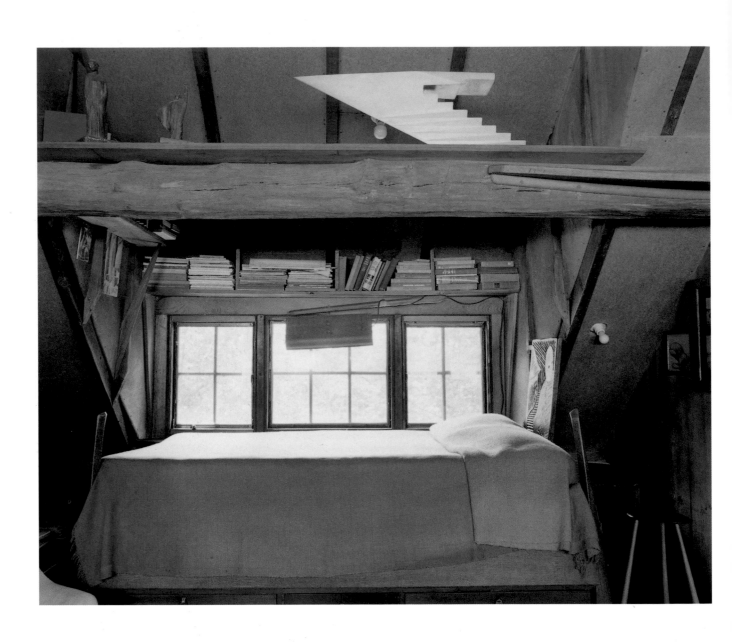

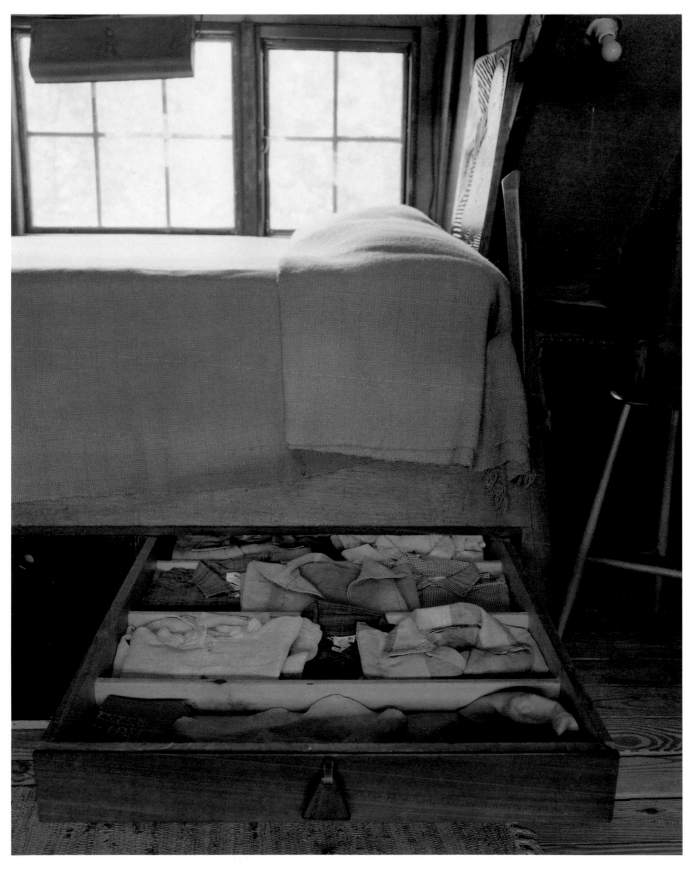

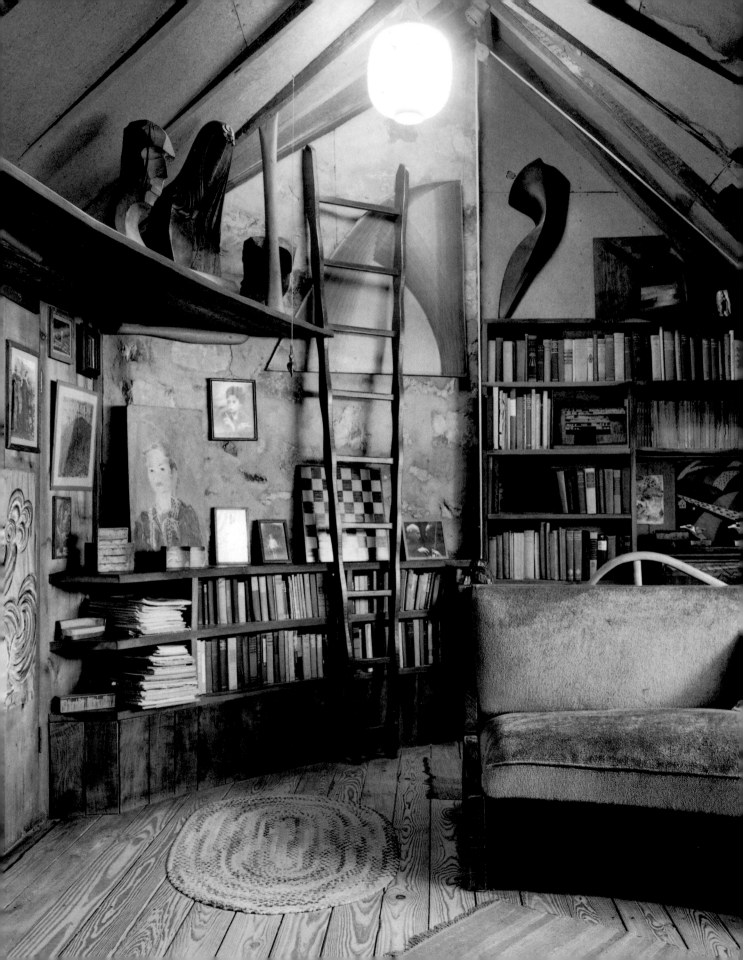

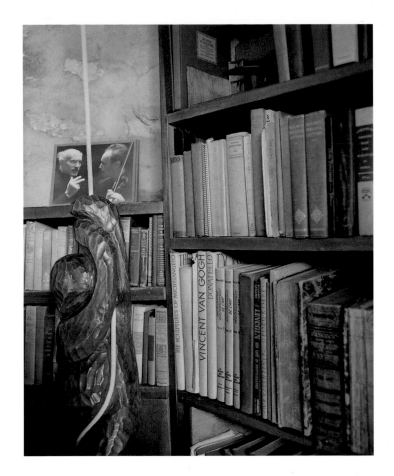

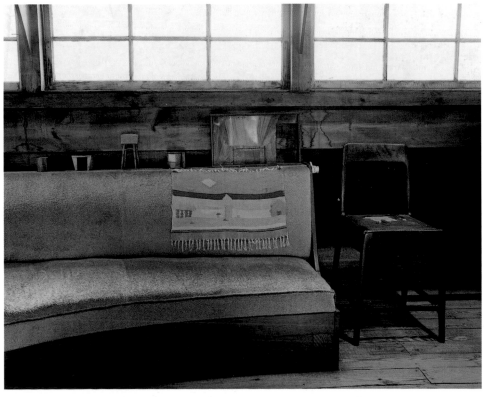

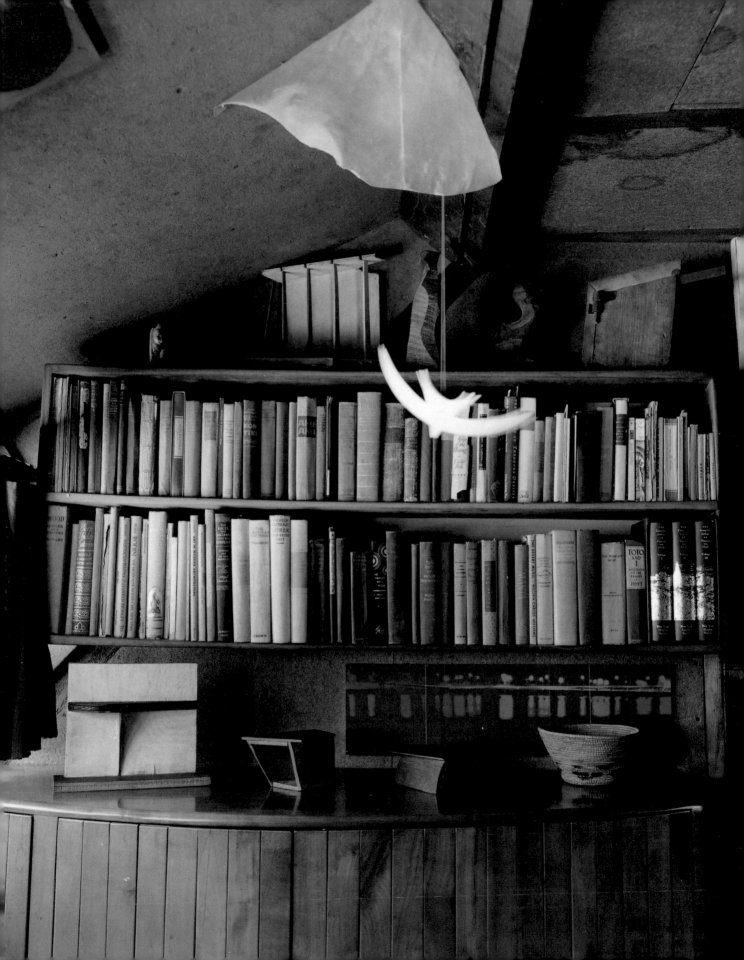

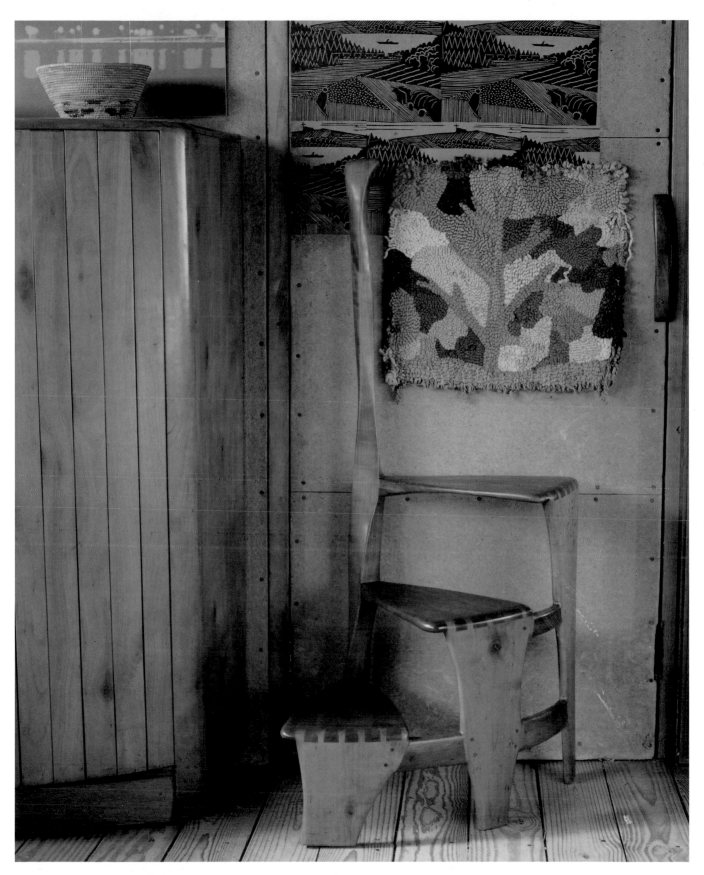

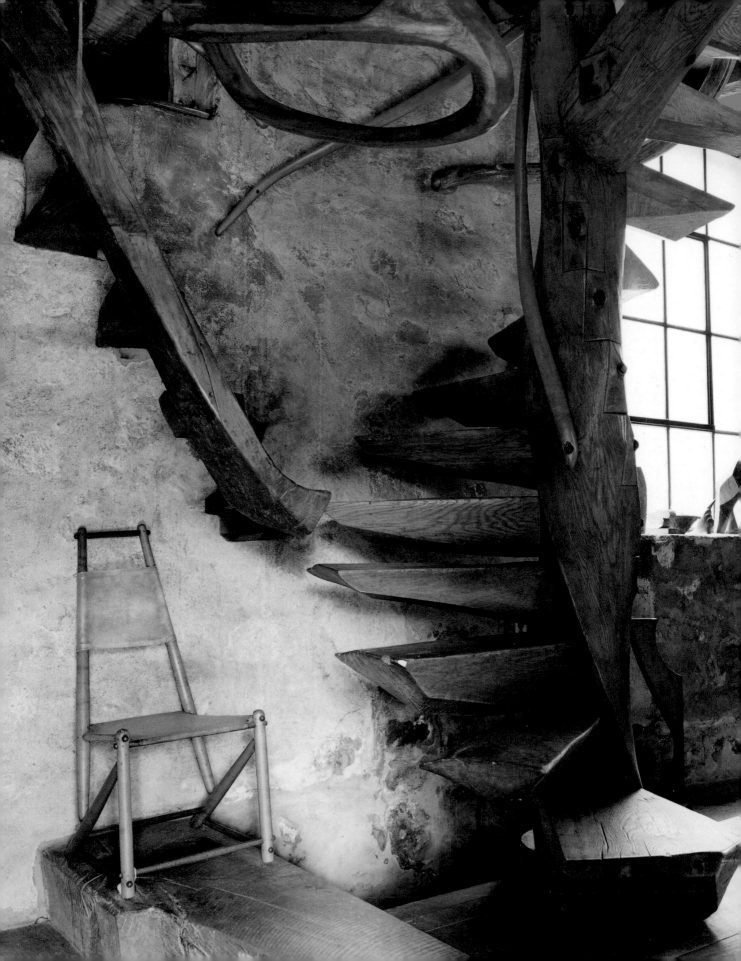

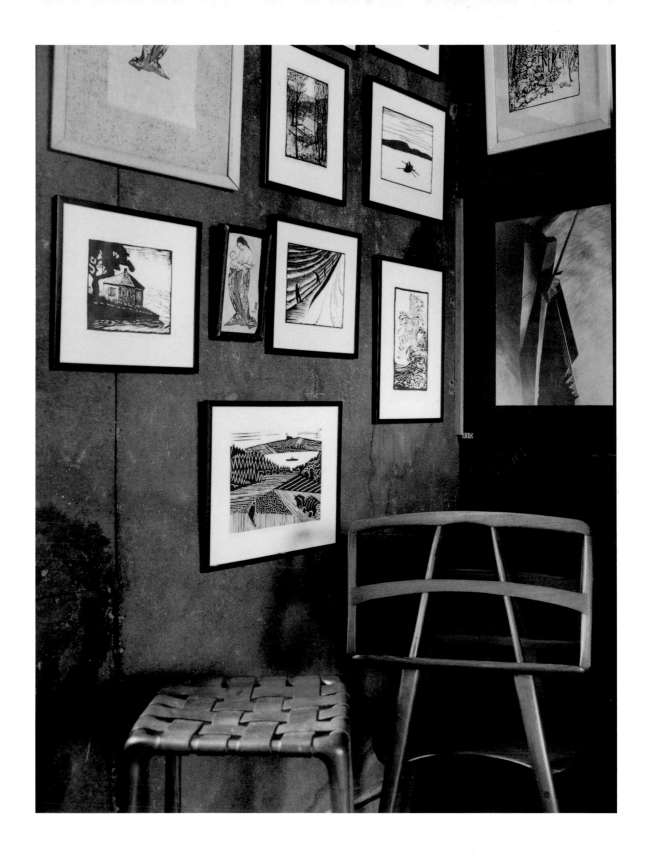

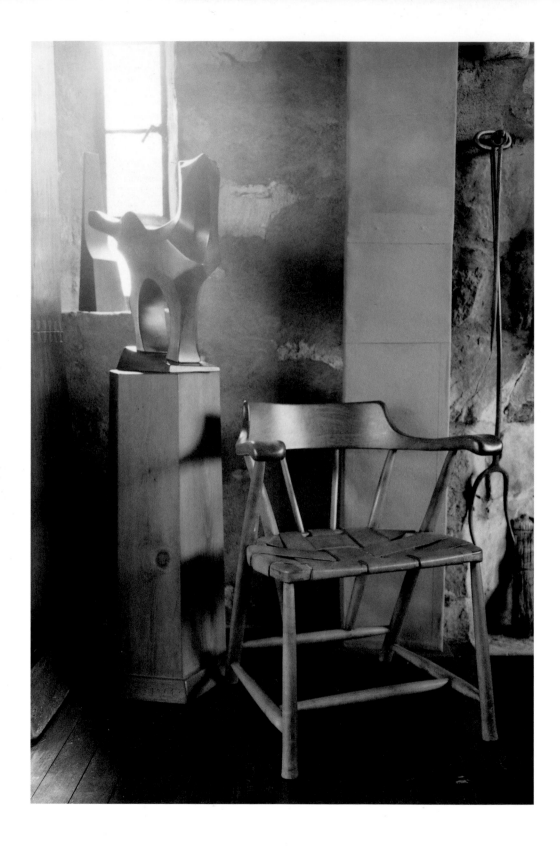

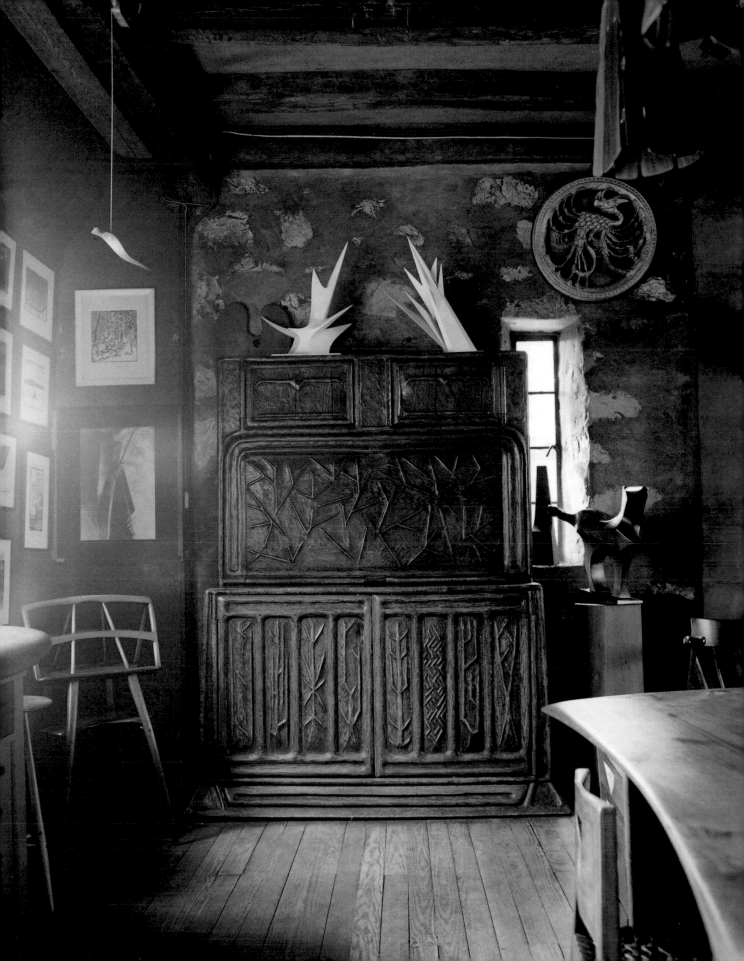

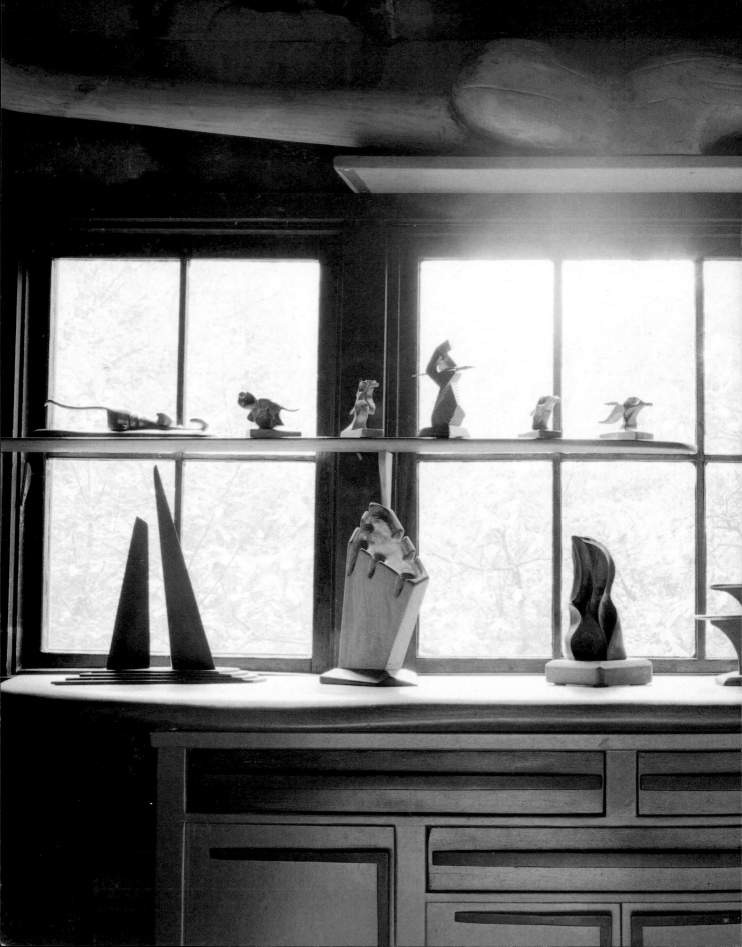

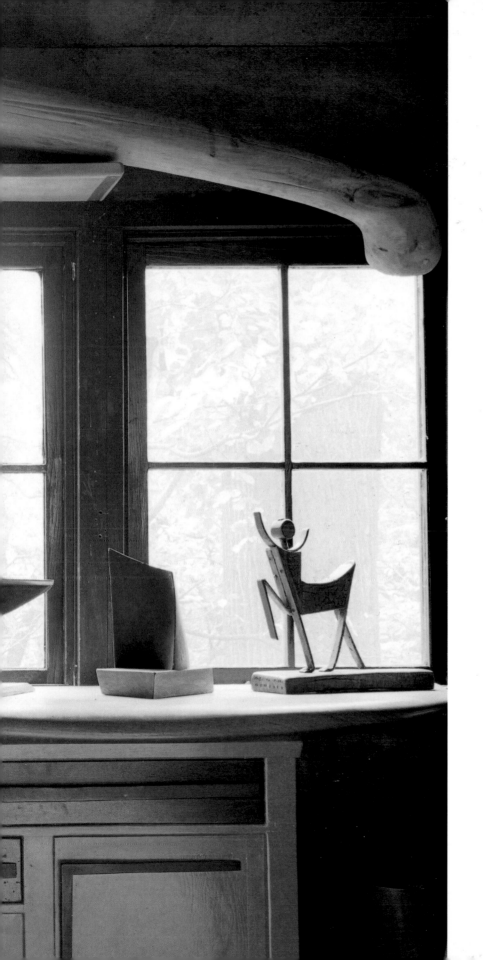

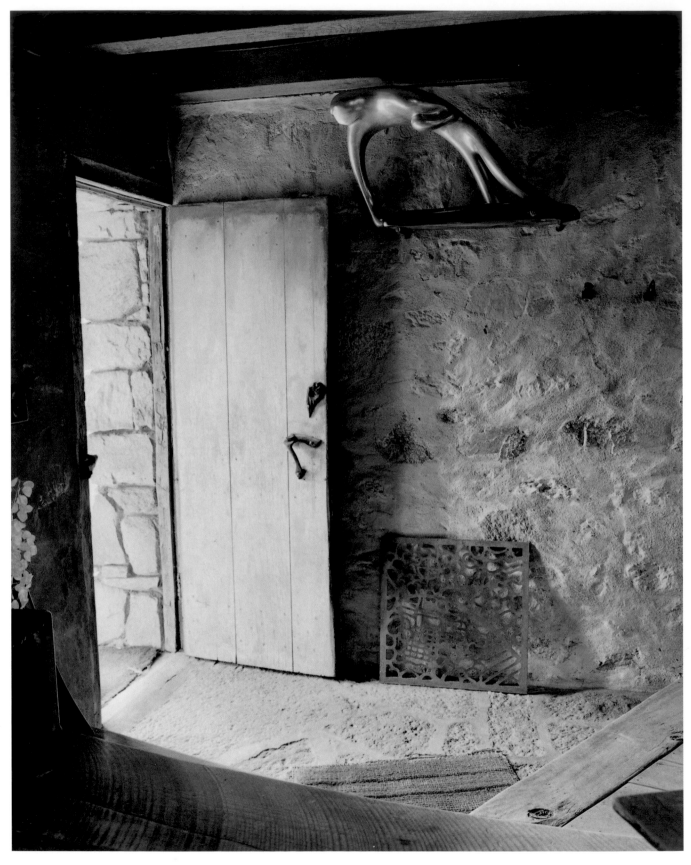

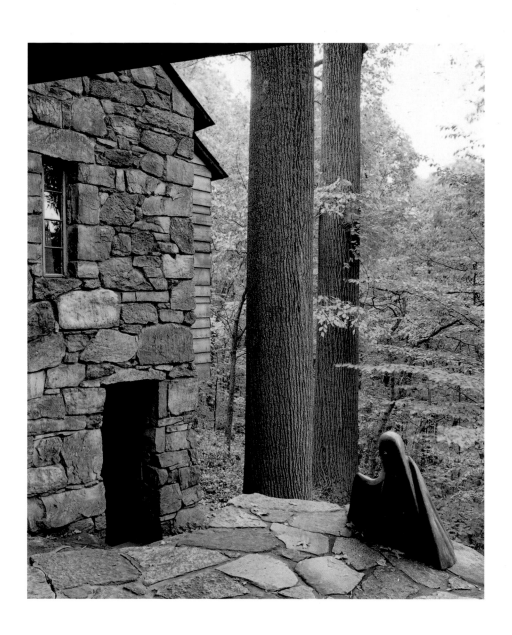

GEORGE NAKASHIMA

NEW HOPE, PENNSYLVANIA

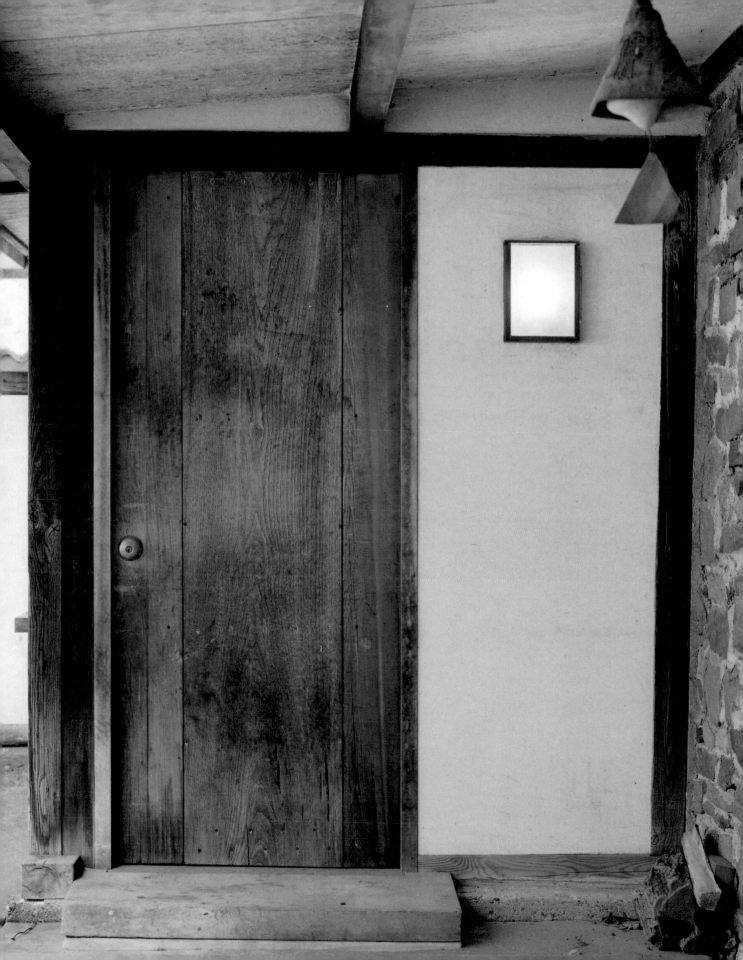

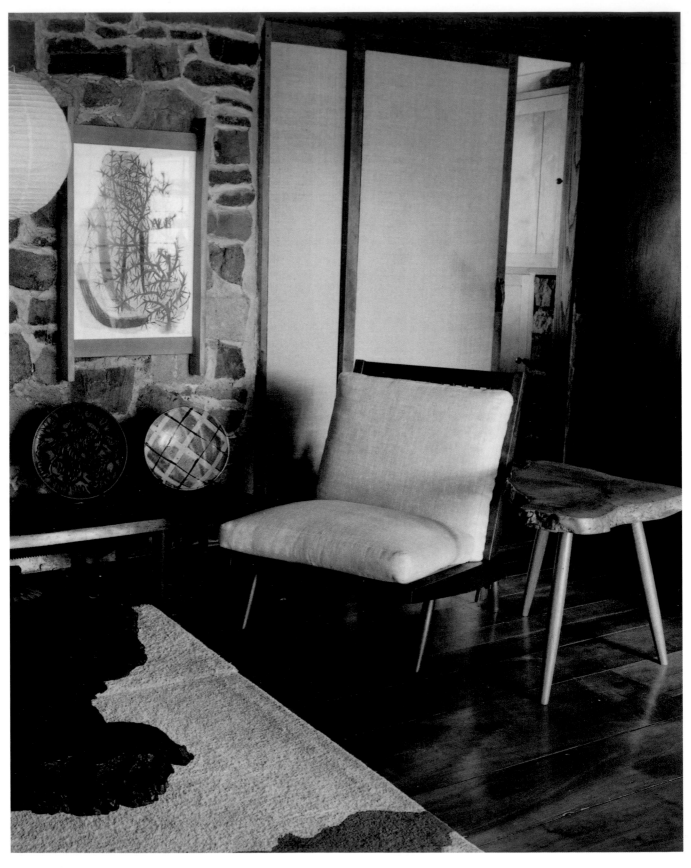

George Nakashima (1905–1990) referred to himself as a woodworker—a humble title for a man with one of the most distinctive voices in twentieth-century furniture design. His work, with its raw edges and obvious reverence for the wood from which it was made, has a virtuosic quality to it. I first became aware of his work sitting in the living room of a friend's home when I noticed how beautiful the chairs were. "Oh, they're Nakashima," my friend explained. Thus began my love affair with George Nakashima's work. Although he is probably one of the most acclaimed members of the American Studio Furniture movement, he trained as an architect, and it would be a disservice to Nakashima if I did not mention the richly detailed buildings that he designed—many constructed with experimental building techniques—on what is sometimes referred to as the Nakashima Compound in New Hope, Pennsylvania. Today there are fifteen buildings on this property, which he bought from a Quaker farmer. This stretch of land houses his furniture design business and workshops, now run by his daughter, Mira. At the center of this hive of creativity is the simple home he built with his own hands for his young family in 1947. His son, Kevin, lives here today and has kept it much as it was when his father was alive.

The first time I approached the front door, I was surprised by how rustic the entrance seemed—just a simple wood door with a bit of firewood piled next to it. But as I entered the main living room, I was awestruck. All of the furniture and of course the structure itself is by Nakashima, including a Long Chair (1947) next to the window and a pair of Conoid chairs (1960) that sit at the dining table. Ceramics, found objects, and a sounding sculpture by Nakashima's close friend Harry Bertoia round out the composition in the room. The serigraphs were a mini-collaboration with his good friend Ben Shahn—the prints by Shahn and the frames by Nakashima. The windows are covered with traditional shoji screens, which diffuse the light, creating a beautiful glow that extends to the bedroom. Here, a single pedestal desk has a piece of bitterbrush used for the drawer pull brought back from Idaho, when Nakashima was interred at Minidoka internment camp during World War II.

Next door to the family house is the Reception House. In his later years this is where Nakashima entertained. He referred to this structure as his swan song, and it was the last building he designed on the property. Completed in 1977, it contains a living-dining room as its heart, with a tearoom and Japanese bath off to either side. A collection of Japanese slippers greeted me at the door, and as I slipped off my shoes and put on the simple indigo slippers, I pretended I had been invited here for dinner—how wonderful it must have been to receive an invitation to dine with the Nakashimas!

The living room has a daybed with an exquisite burled English oak headboard. Around an unusual cross-cut burled wood coffee table sit stools with cushions covered in Japanese Mingei hand-dyed indigo cloth, originally made for the Rockefeller House in Pocantico Hills, New York. A massive dining table sits ready for guests and in the far corner next to the stone fireplace is a built-in desk illuminated by an Akari lamp by Isamu Noguchi. Slipping back on my shoes after a long day of shooting, I was sad to go. Although I spent two days in Nakashima's private world, the compound holds many more discoveries waiting to be revealed. I felt like I had just scratched the surface.

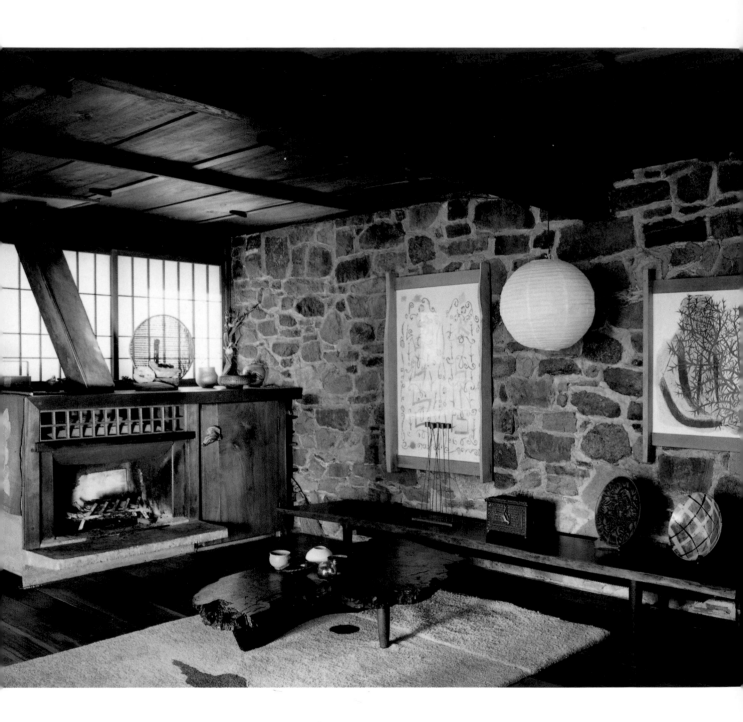

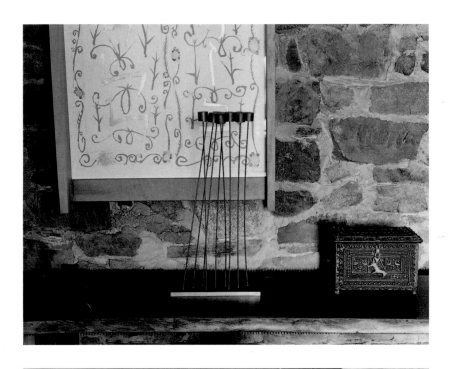

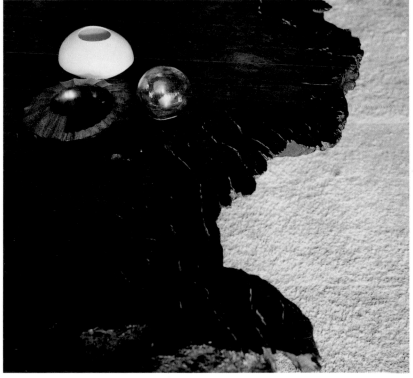

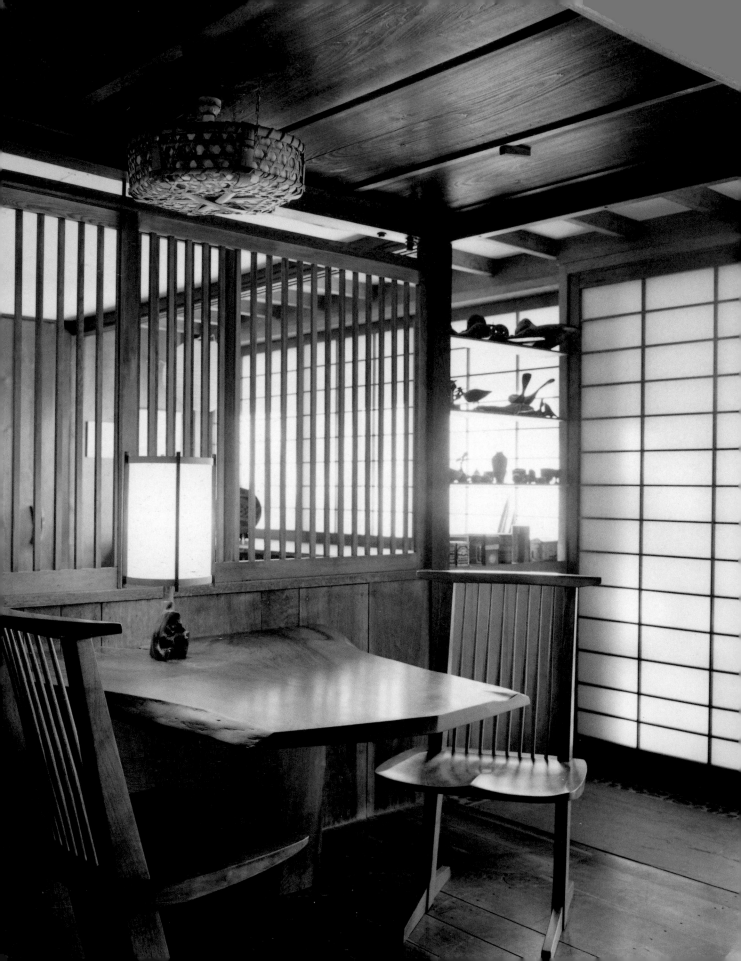

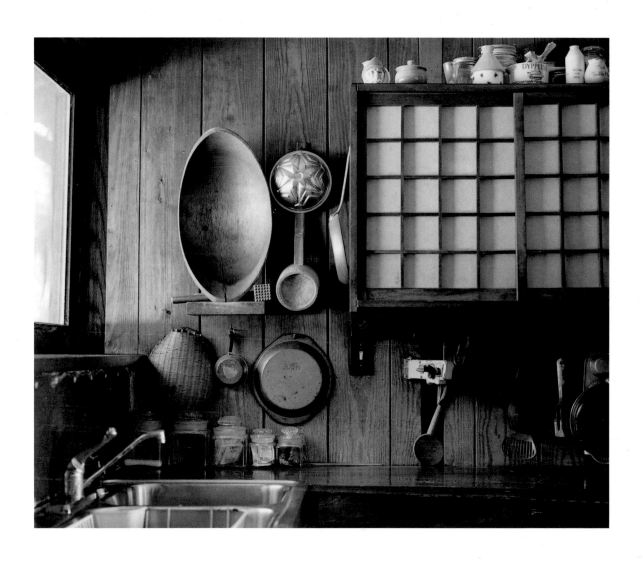

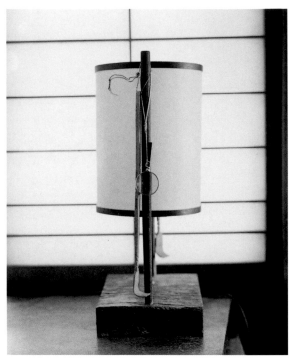

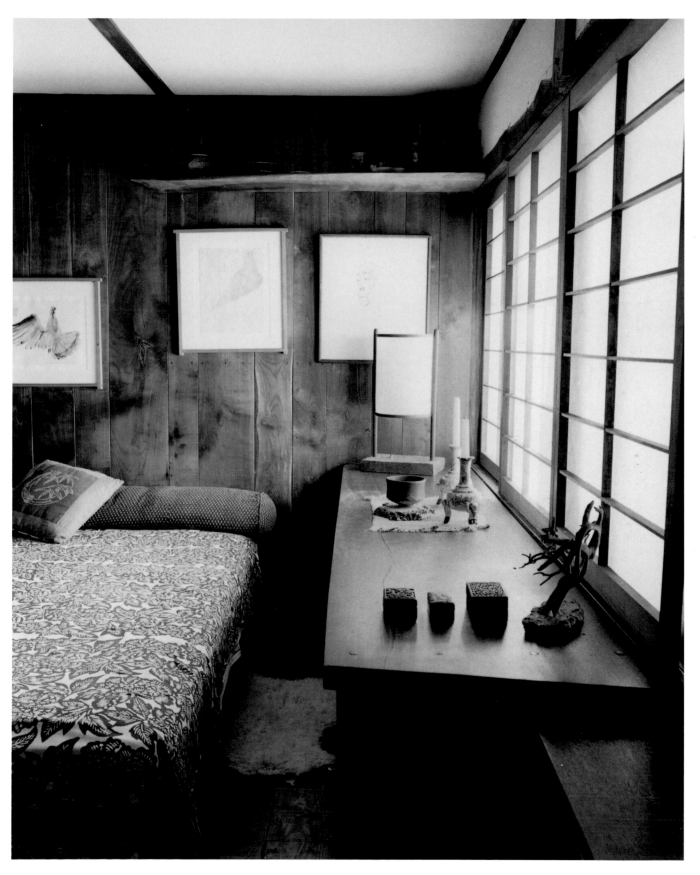

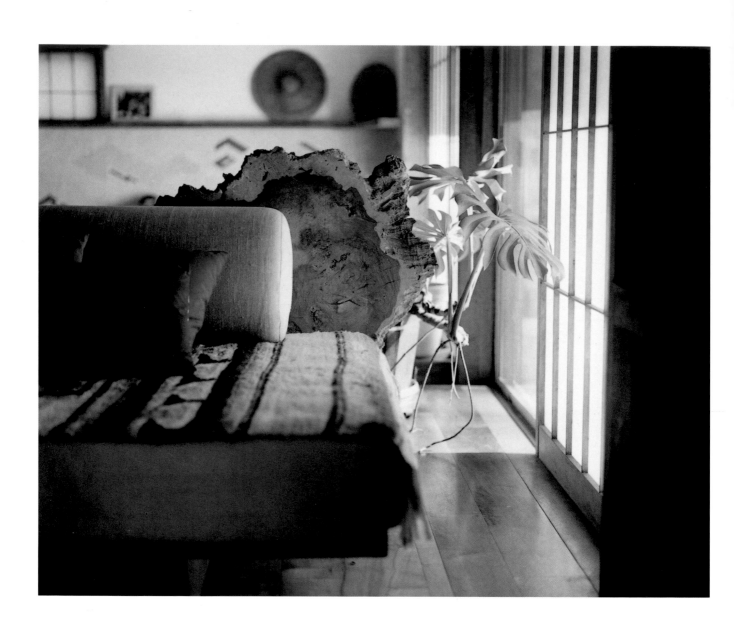

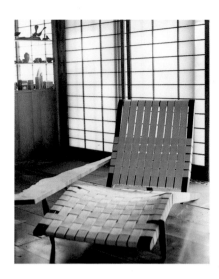

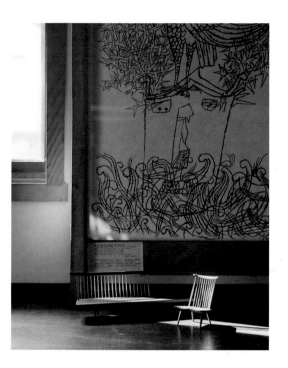

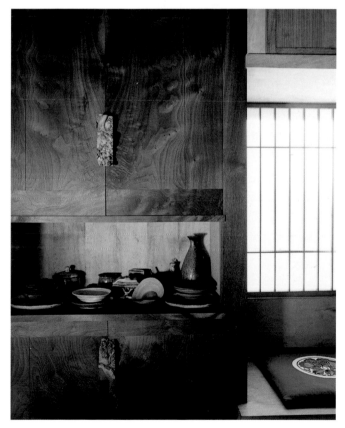

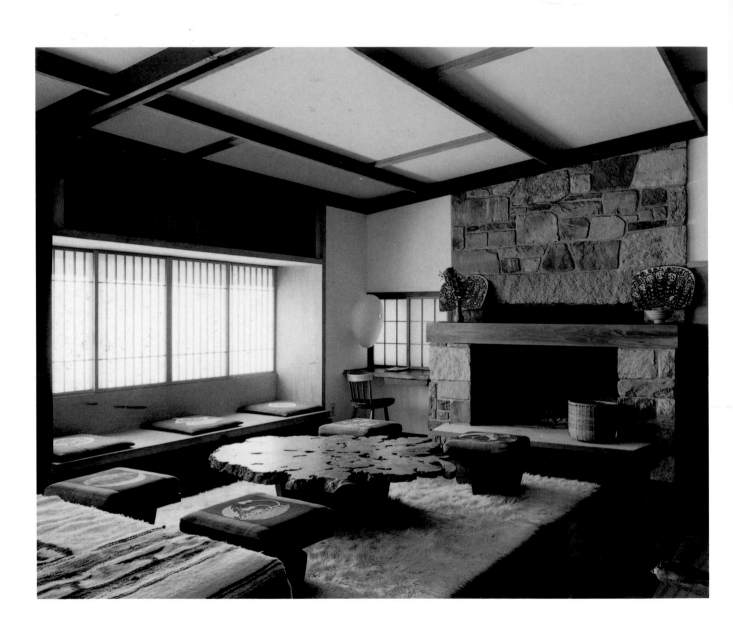

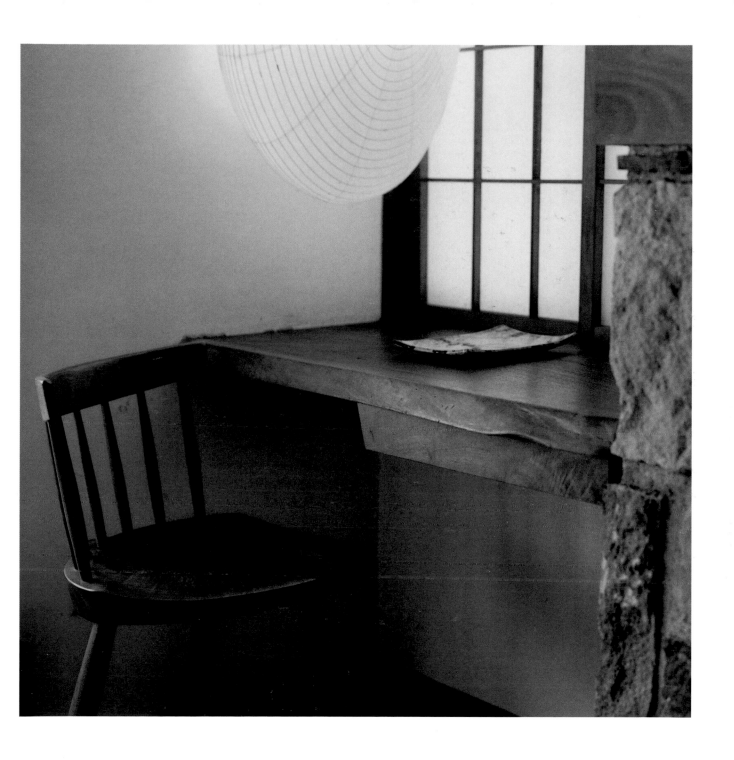

HARRY BERTOIA

BARTO, PENNSYLVANIA

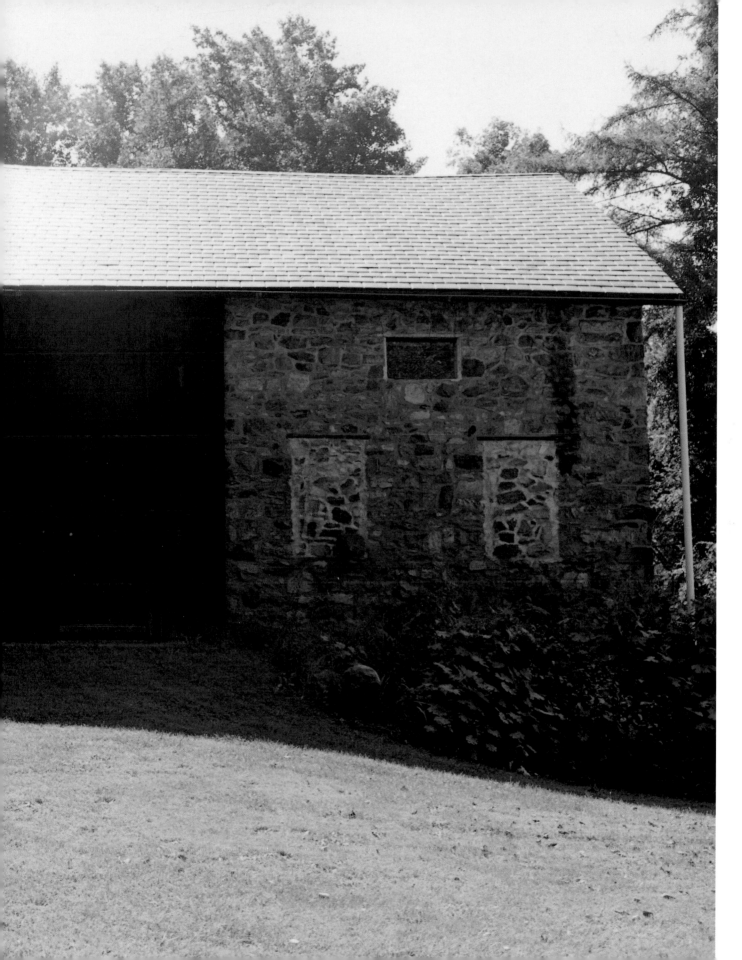

In my mind, Harry Bertoia (1915–1978) has always been synonymous with the wire mesh-like chairs he designed for Knoll Furniture, most notably the Diamond Chair (1952). I thought of him as a furniture designer. I knew a few tidbits of information about his career—such as he preferred to work with metals, went to the Cranbrook Academy of Art, worked with the Eameses (even created their wedding rings)—but I had little knowledge of him beyond these basic facts. It was only when I was photographing George Nakashima's house that I was introduced to Harry Bertoia the sculptor. I accidentally brushed up against one of his sound sculptures while I was shooting there and was immediately startled and then intrigued by this clanging bunch of metal rods. I asked Mira, George Nakashima's daughter, about the piece. She told me that Harry and her father were great friends, and then she said, "That is a place you should shoot—Harry Bertoia's barn."

About a year later, I found myself standing at the door of the infamous barn, behind the Bertoia home in the rural Pennsylvania countryside. Harry Bertoia and his family moved here in the early 1950s and lived in this house until Bertoia's death. His son, Val, continues to live here today. As Val led me into the barn, he revealed that it has been kept much as it was when his father was alive. Inside, rows of Bertoia's sound sculptures greeted me—some double my height and others so small they could fit in my hands. Interspersed among these sculptures are a few huge metal disks suspended from the ceiling and various other objects, which dangle overhead from ropes. All of these turn out to be instruments with which to create sounds as well. The room is basic, simply one large space, but Bertoia renovated it in 1968 and added floor-to-ceiling windows, which give it more a feeling of a cathedral than a barn. It served as a recording studio and performance space, and many of the tapes from his recordings are stored here. There is a small seating area off to one corner for those lucky enough to have been invited to a performance, and a ladder leads up to the loft space that still has the flat file cabinets where Bertoia kept his monotype prints years ago. The barn is relatively minimal—monastic even—and yet within its walls I felt like I was in a sacred space. Each sculpture, each chair, the structure of the barn itself—they are all imbued with Harry Bertoia's passion for this art form he created. He called it Sonambient. I was lucky enough that Val gave me a mini-performance so I could understand how one would play these sculptures. As he walked among the rows, he strummed some of the sculptures, gently tapped others, and each rang out with its own distinctive sound. And as he left me to photograph the space, the sculptures hummed as I worked.

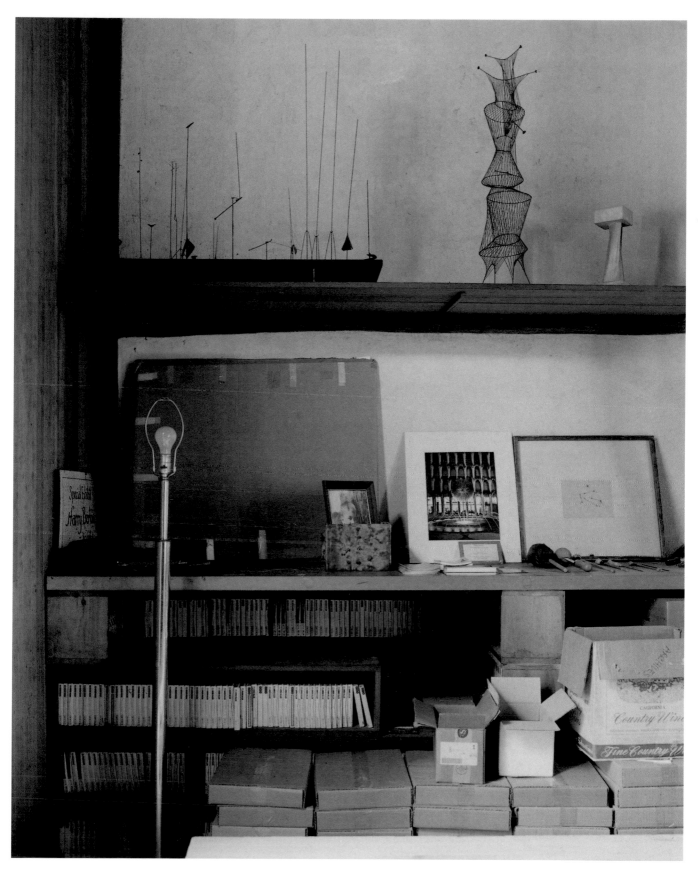

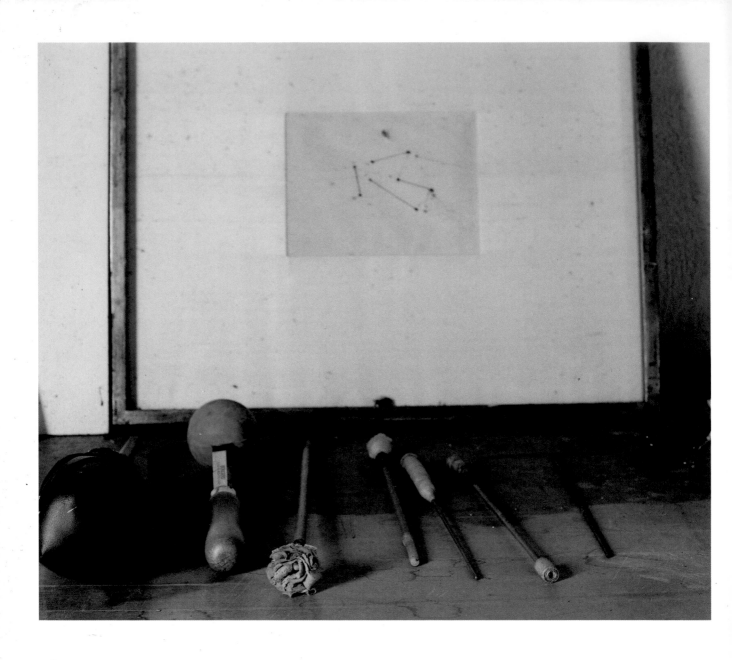

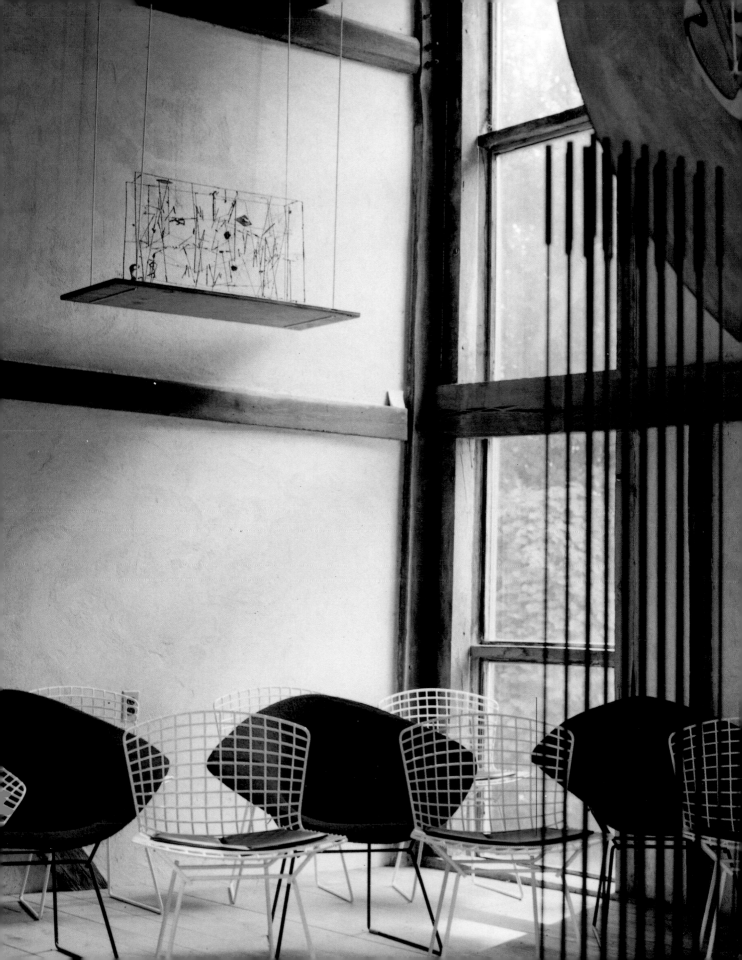

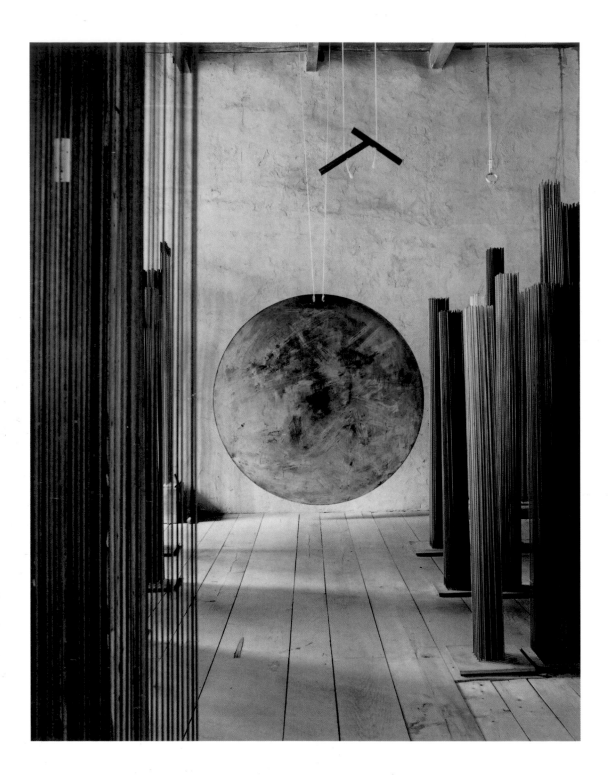

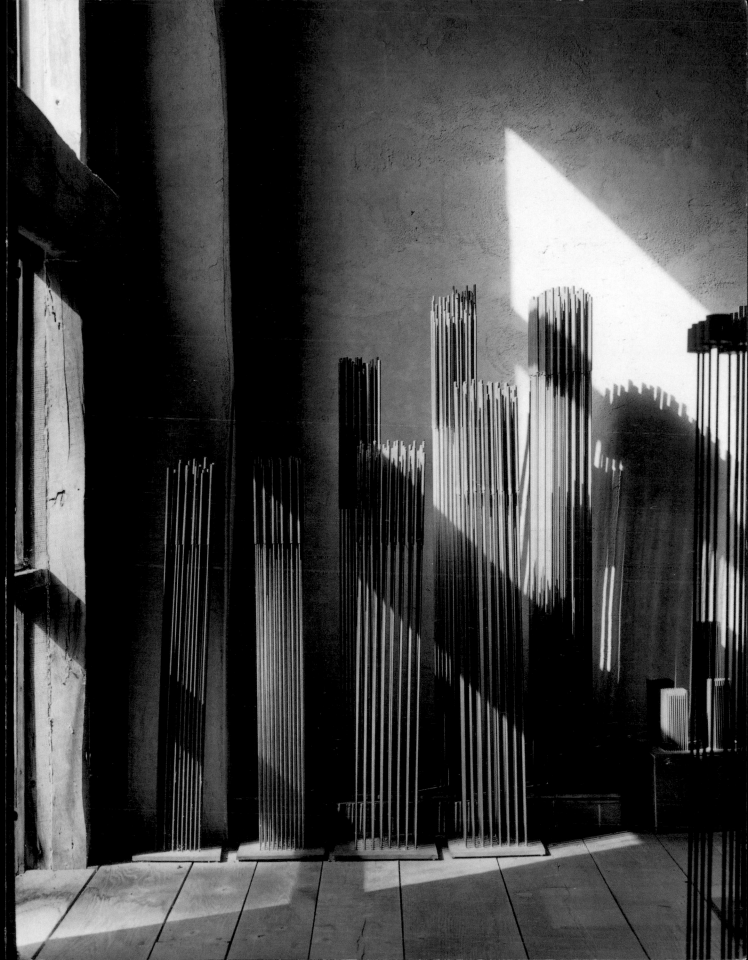

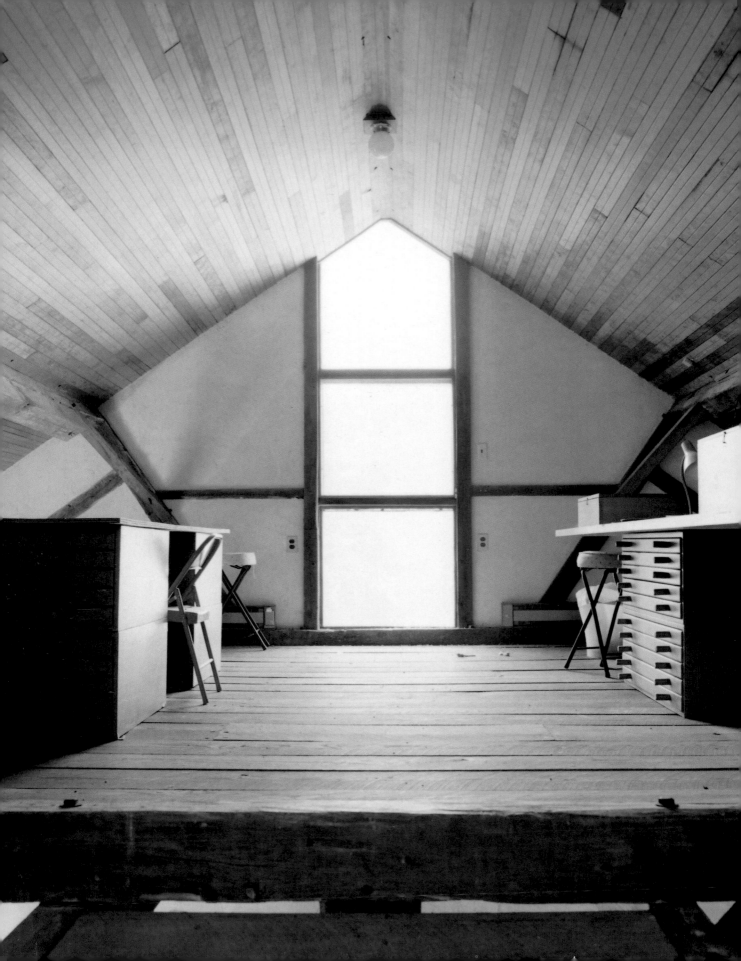

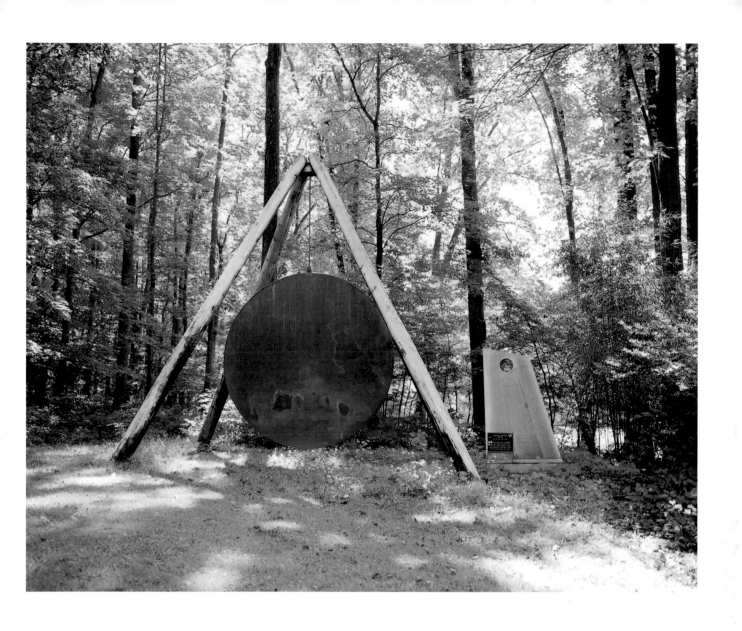

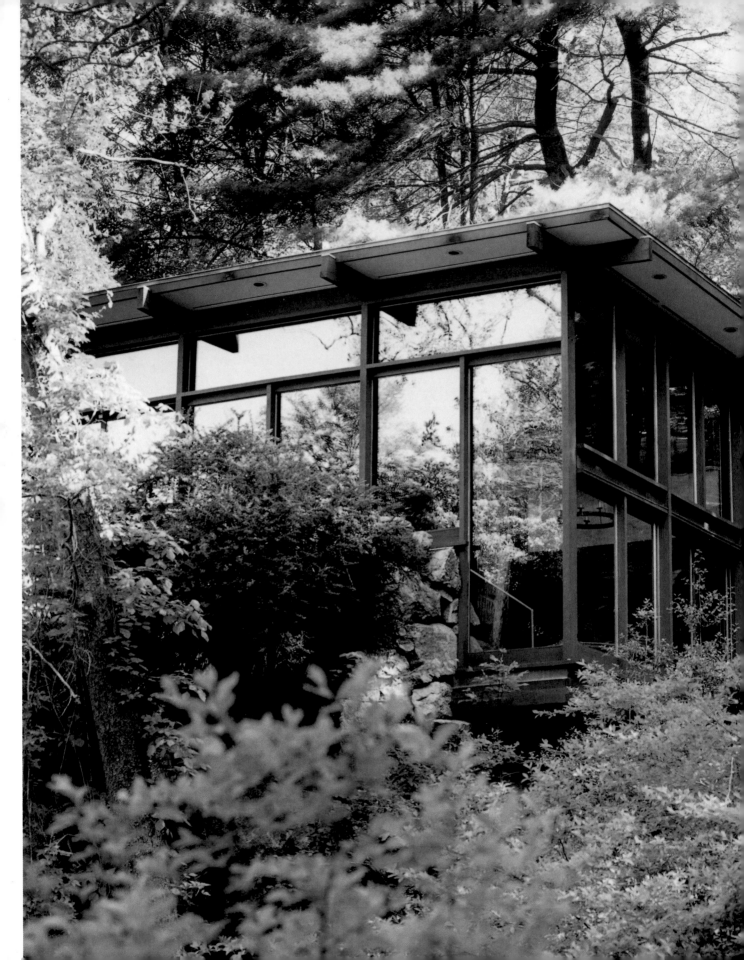

RUSSEL WRIGHT

GARRISON, NEW YORK

I first came across Russel Wright (1904–1976) when I saw his name on the bottom of a plate at a dinner party. This chartreuse plate turned out to be a piece of the best-selling dinnerware in American history, Wright's American Modern dinnerware. Not only the designer of dinnerware, Wright produced furniture, textiles, and home accessories, and, perhaps most significantly, he introduced the concept of a uniquely American way of living that was gracious and warm yet modern and practical. He and his wife, Mary, wrote the book *Guide to Easier Living* (1950), and through it they introduced a fresh view of how to create a more efficient and inviting home to the American masses. In Garrison, New York, Wright built a model of this concept of modern living. He said that his house "must not be thought of as a prototype—it is an exaggerated demonstration of how individual a house can be." On the edge of a former rock quarry sits Russel Wright's ultimate design laboratory, his home, which he called Dragon Rock.

Working with architect David Leavitt, Wright created a home and studio with the goal of marrying the structures to the landscape. They did this by using materials found on the property—mainly stones and timber—to give the house its dominant architectural and material qualities. Large stones are used for walls, stairs, and floors. In the dining area the stone floors extend outside to create a seamless transition from indoor room to outdoor patio. An uncut cedar trunk supports the main roof in the dining and living area. As I was photographing this area I heard a loud thud against the floor-to-ceiling glass windows. A fat robin had run into the glass. It staggered and eventually flew away, but I would wager that he was heading for that cedar trunk.

For all the grand and sweeping architectural gestures, the joy of Wright's Dragon Rock is in the details. First of all, no two doorknobs are alike. I got an inkling of this when I opened the front door for the first time. I was not sure whether to turn or pull the big metal quarry hook that stood in for a traditional door-knob (I turned). For the studio door Wright used a particularly well-shaped rock, and found objects are used for all the other doorknobs as well, including a vintage brass doorknob with a cherubic face on it. As for the walls and doors, Wright clearly viewed these as surfaces for experimentation. I gave up count-ing when I reached twenty different treatments—pine needles mixed in paint on the living room wall, a hundred butterflies laminated in clear plastic in his daughter's bathroom, a door covered in the bark of a birch tree, and so on. In a corner of the upper terrace of the living room, behind a Wright-designed chair, the wall is divided into panels, each with its own special surface treatment, among them sea grass cloth, an Audubon print of a turkey with artfully burnt edges sandwiched under Plexiglas, and copper sheet-ing. Wright placed two different panels of copper on the wall, and each has aged slightly differently—it is a beautiful testament to the temporality of materials. Wright has planted the idea in my brain and I am determined to try it out for myself some day. I suspect this is exactly what Wright intended with his home. His fearless enthusiasm for design and willingness to experiment is as inspiring today as it was in the mid-twentieth century. Russel Wright's Dragon Rock shows us all how endless the possibilities are, if we are only willing to think beyond the conventions.

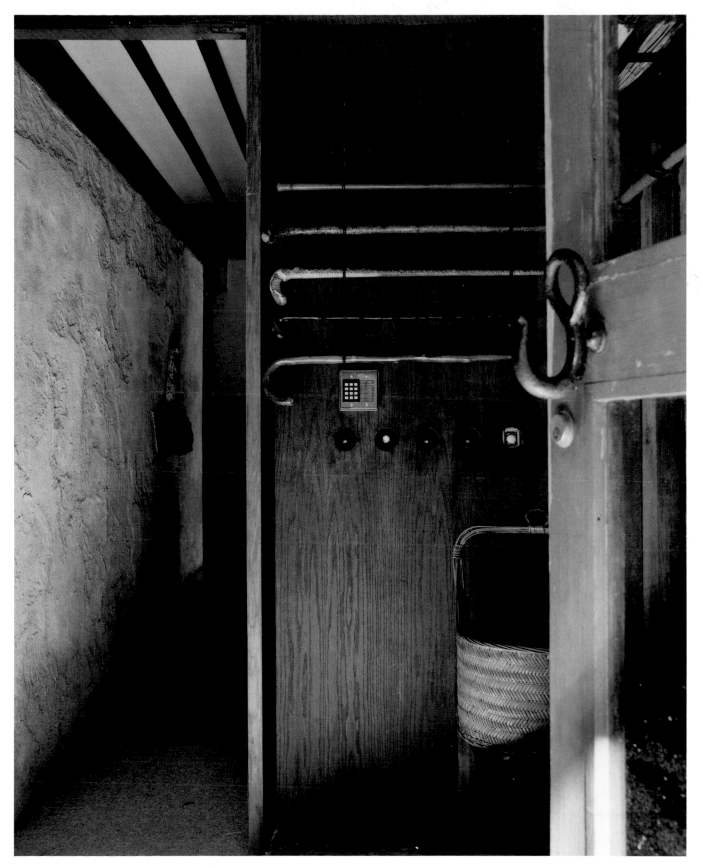

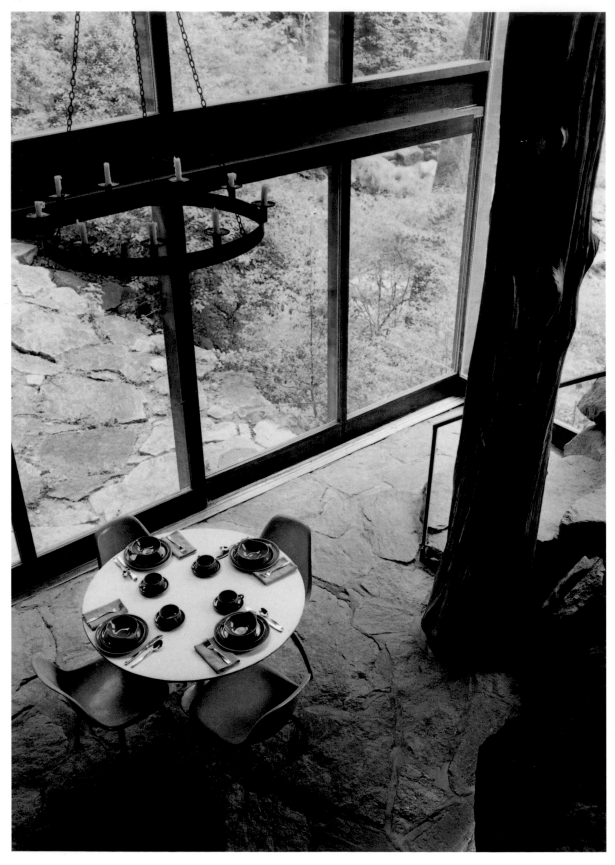

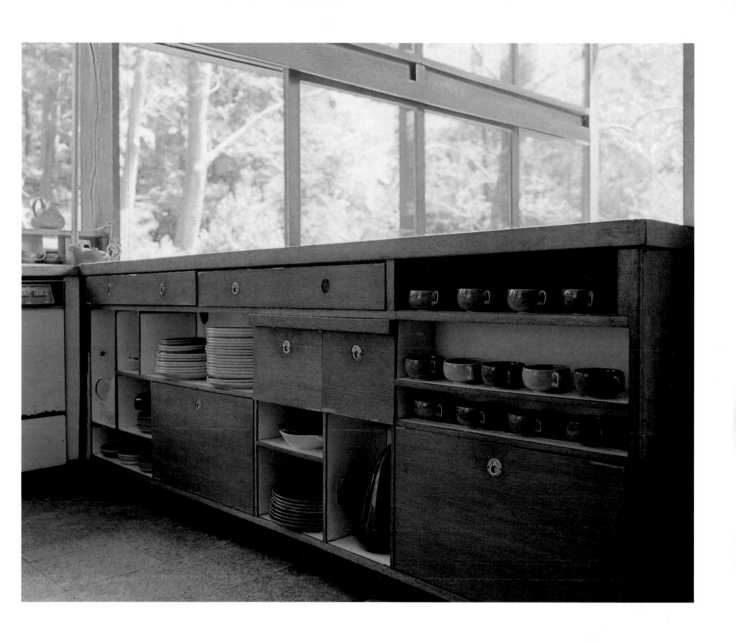

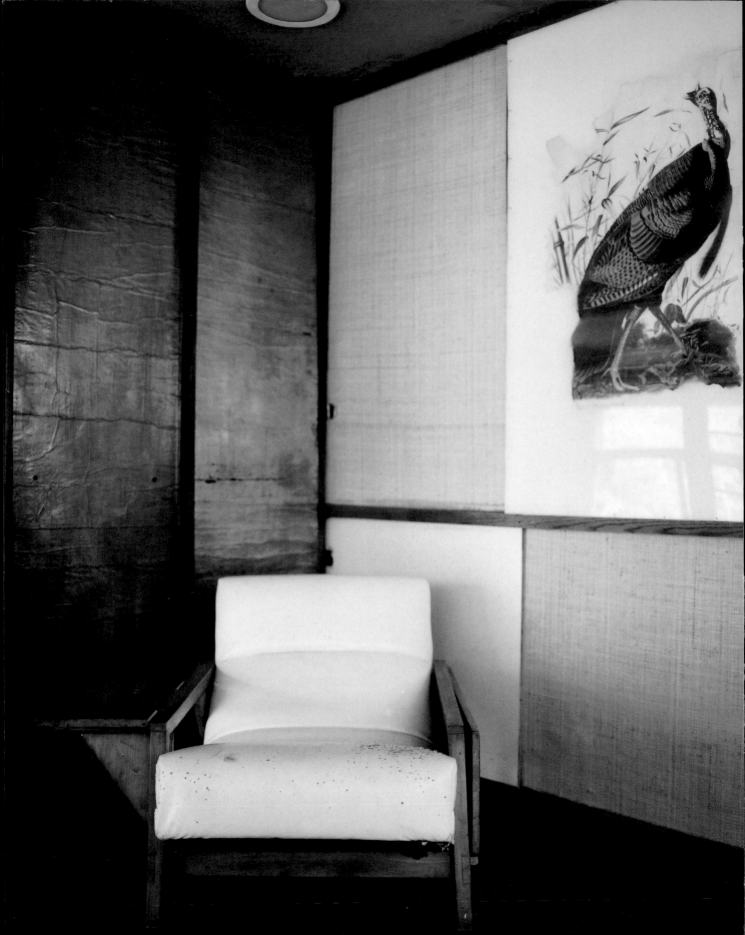

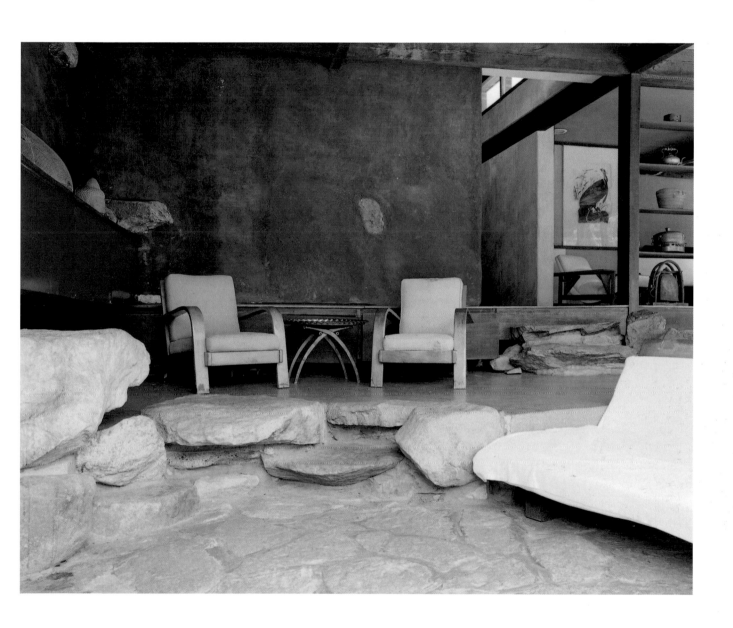

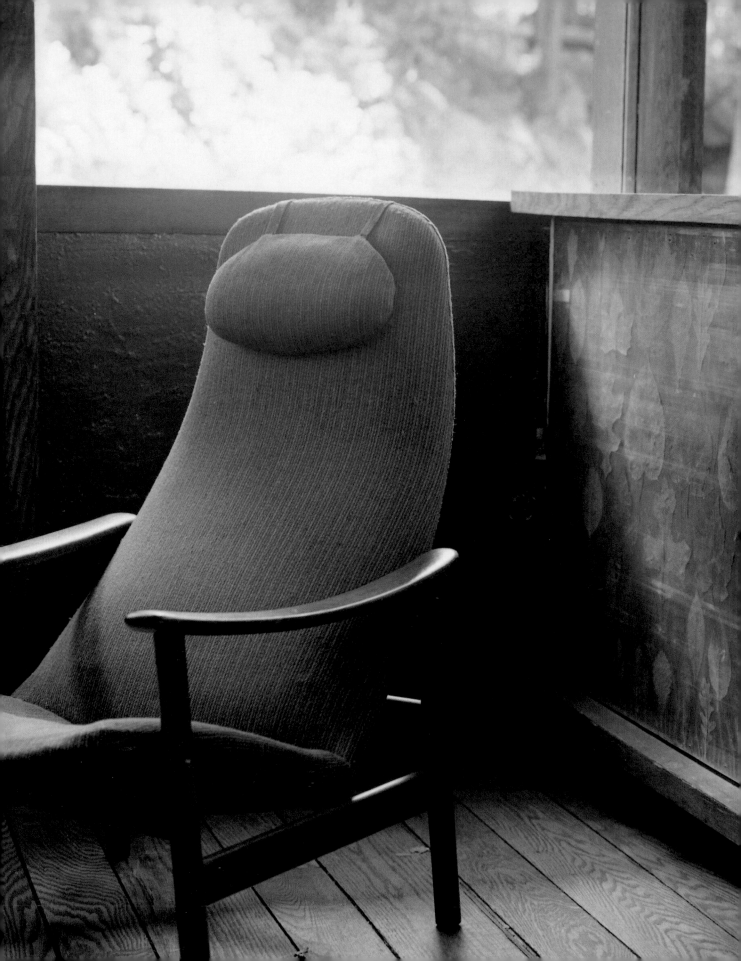

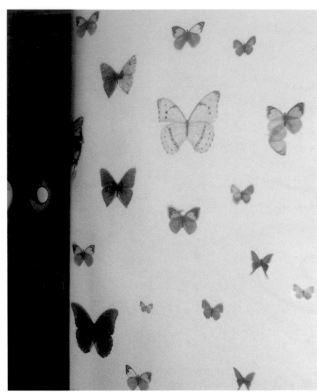

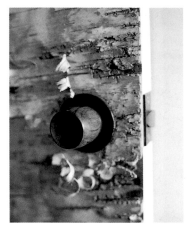

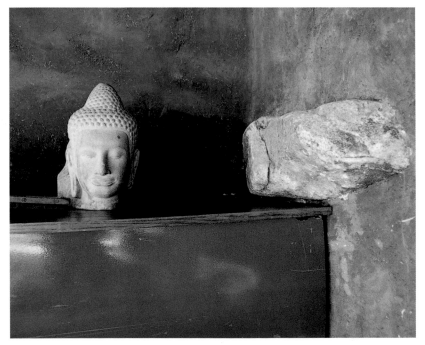

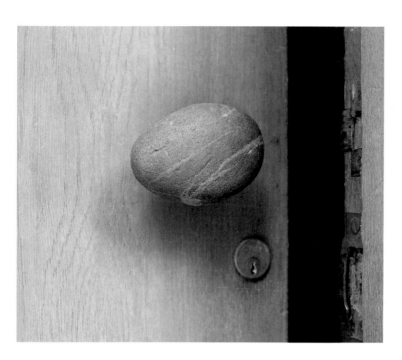

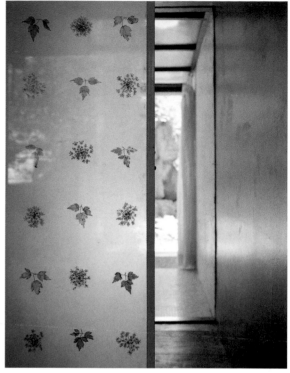

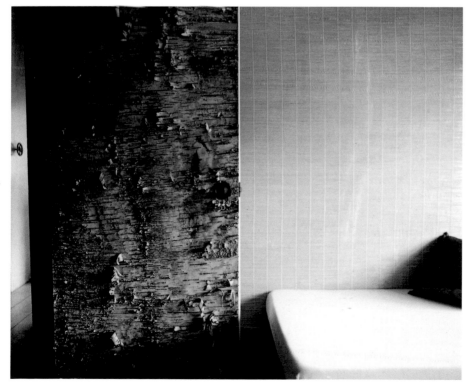

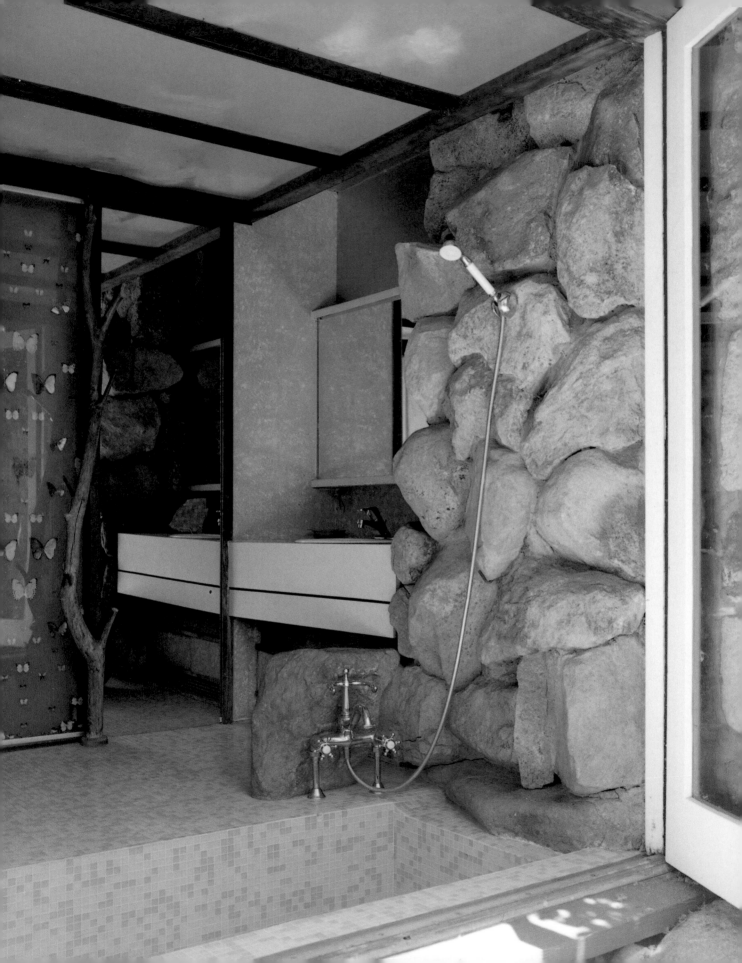

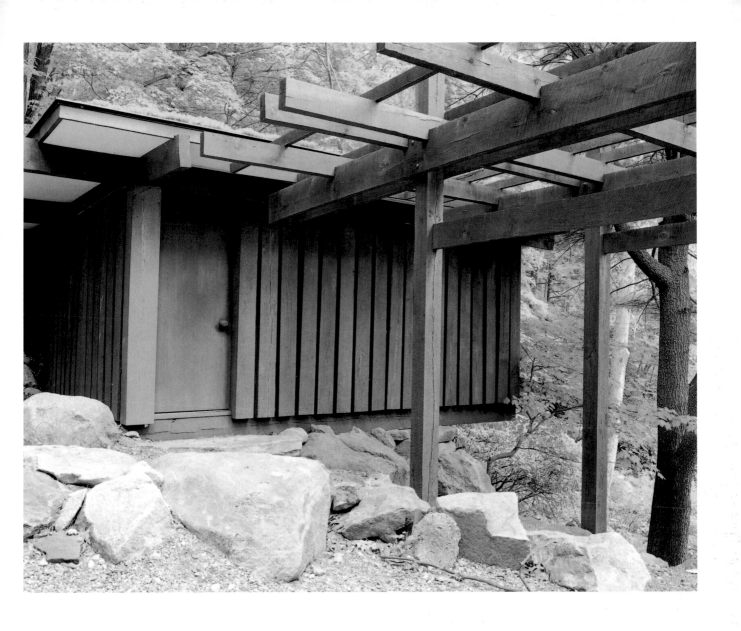

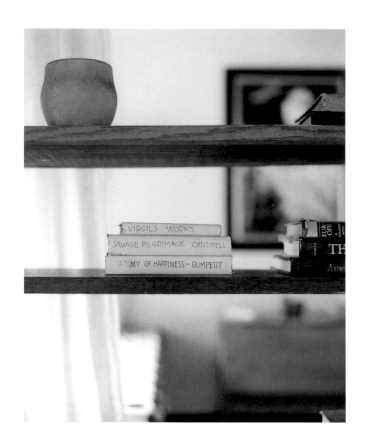

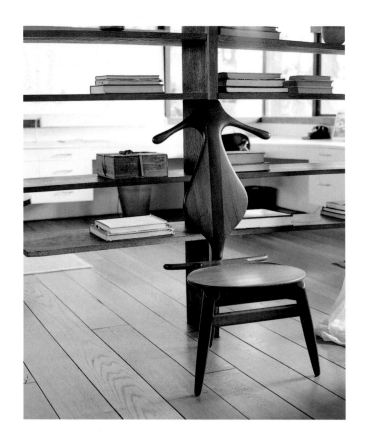

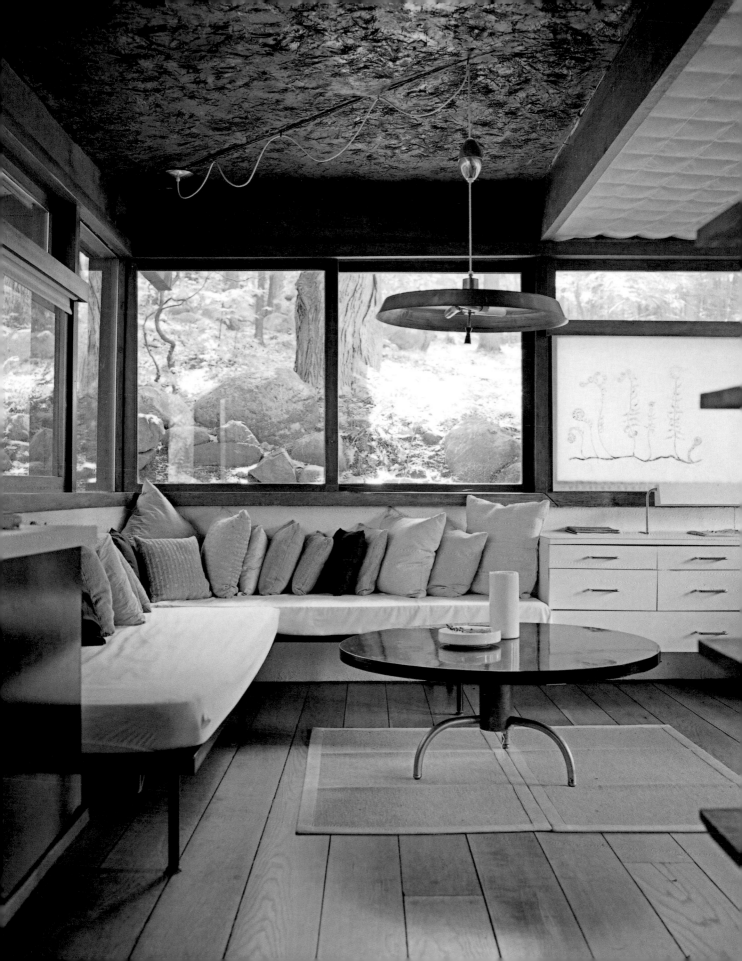

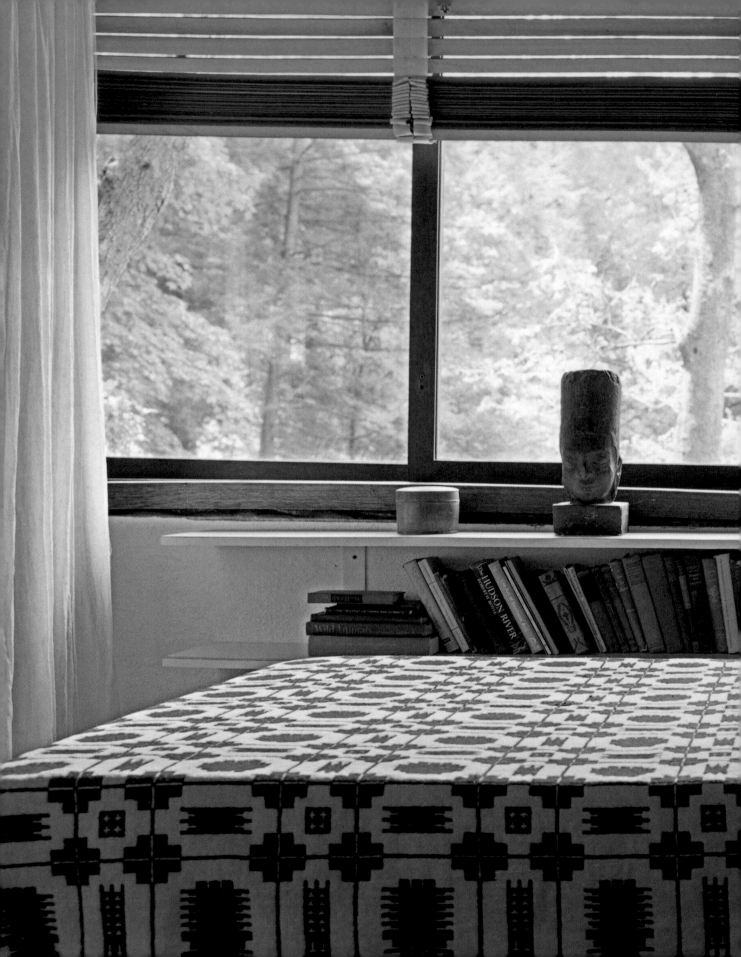

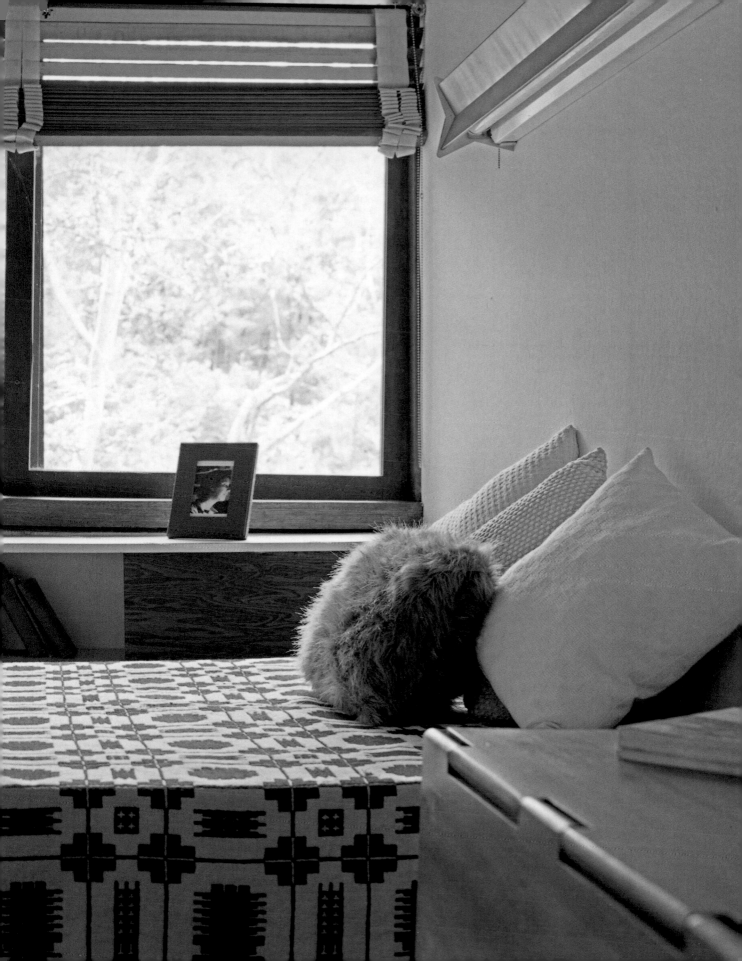

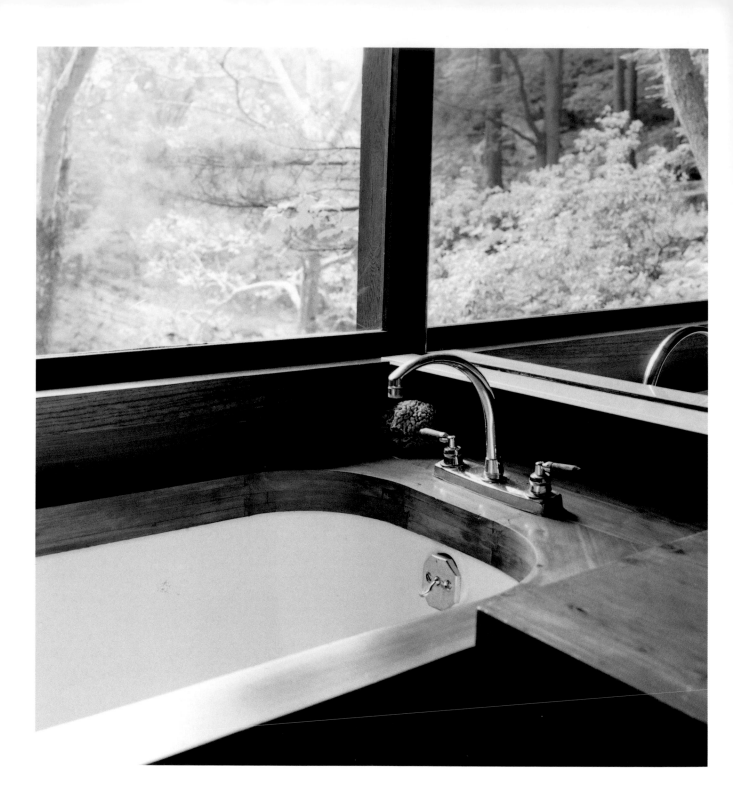

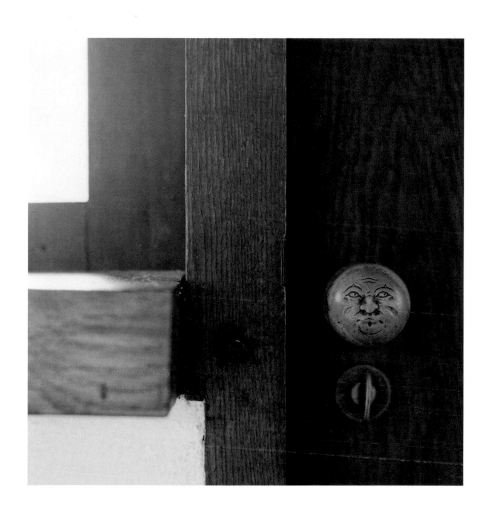

JENS RISOM

NEW CANAAN, CONNECTICUT

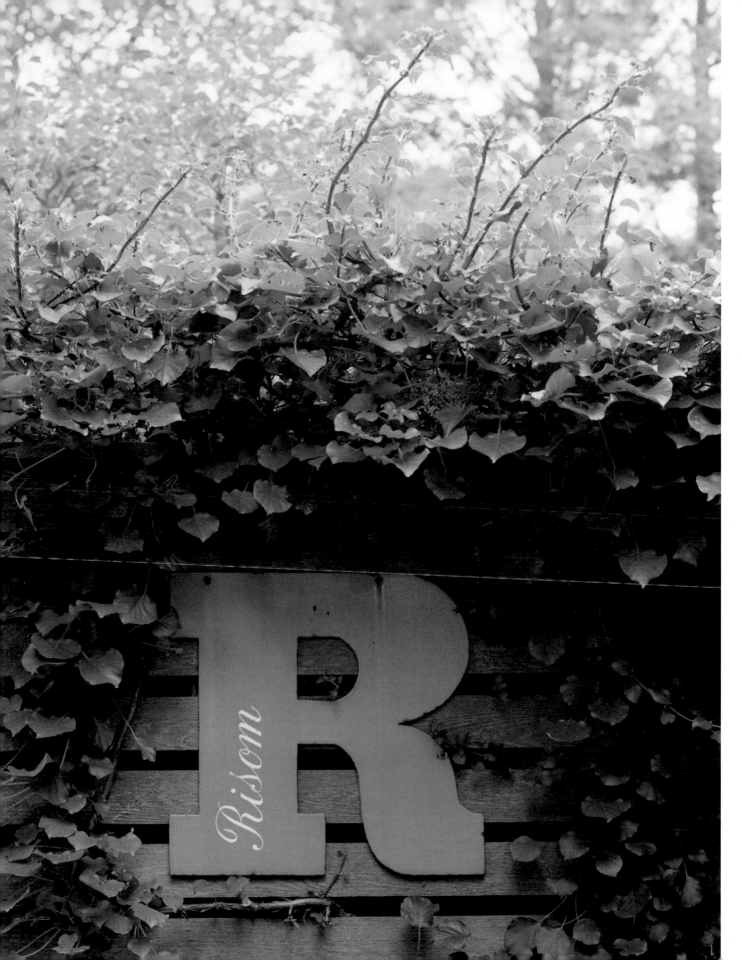

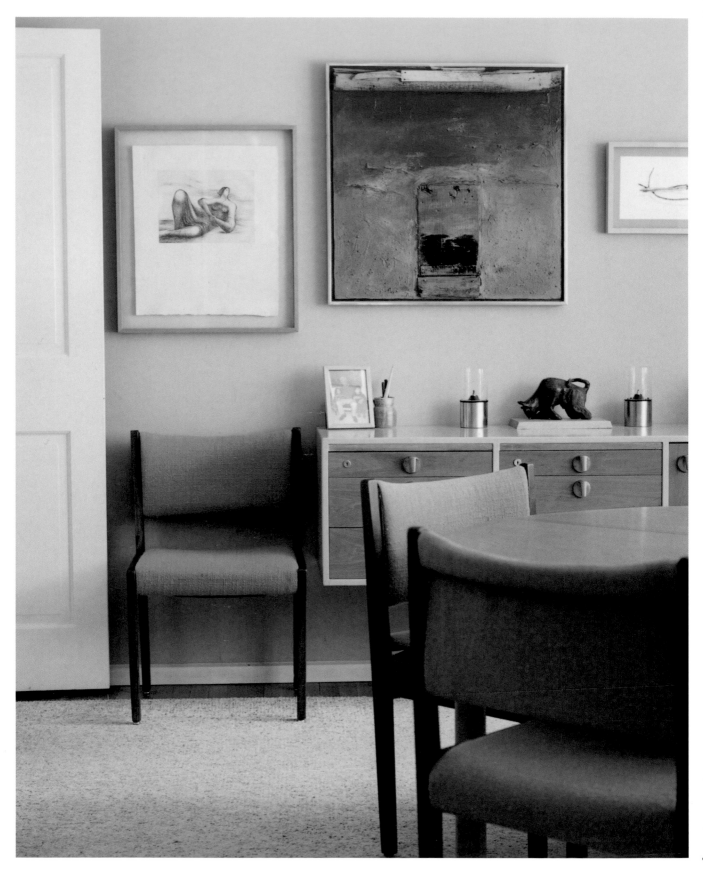

"I came to the U.S. to see what modern American furniture design looked like and you know what I found? There wasn't any!" This is what Jens Risom (b. 1916) told me in his lilting Danish accent at lunch on the first day I was photographing his home. Over smoked salmon, cheese, and a delicious dark rye bread, Risom told me about his first experiences in the U.S. in the early 1940s. This was one of those moments when I felt like I should pinch myself to make sure it was real. I could ask anything I wanted of a design legend! Jens Risom is truly one of the pioneers of American furniture design. Although he came to the U.S. to find modern American design, he ended up becoming one of its progenitors. His designs for Knoll Furniture and later his own firm, Jens Risom Design, Inc. (JRD), are among the classic designs of the mid-twentieth century. To be able to sit and chat with him about all his experiences was a pinch-worthy moment, and I took full advantage. I asked about his road trip with Hans Knoll in 1941 and that famous photograph for *Playboy* in which he posed with designers Charles Eames, Edward Wormley, George Nelson, Eero Saarinen, and Harry Bertoia (apparently they did not even have a drink or chat after the photo shoot—"a missed opportunity," as Risom put it).

His home in New Canaan, Connecticut, is a comfortable bungalow that backs up to acres of woodlands preserved by the New Canaan Nature Center. Risom substantially renovated the interior before he and his wife, Henny, moved in ten years ago. He demolished walls and reconfigured spaces to make it precisely suit their needs. A honey-colored oak is the predominant surface in both the dining and living room and is one of Risom's additions. He designed the cabinets for maximum storage and matched the fireplace mantel in the same warm wood tone. The cabinet in the dining room appears deceptively like all the rest in the house, but open it and there is a perfectly outfitted bar, complete with wine storage and every kind of bar and wine glass imaginable—highballs, double old-fashioneds, brandy snifters, red wine and white wine glasses—all in boxes on the inside of the doors. The furniture throughout the house is predominantly Risom's own designs from both Knoll and JRD, with the exception of a wood and cane chair by his former classmate in Denmark, Hans Wegner, and Arne Jacobsen's Swan (1958) and Egg (1958) chairs in the living room. Talking about furniture design at lunch, Risom said, "Good design goes with good design. It doesn't matter what style or period." I thought of this as I was studying his groupings of art and sculpture that are throughout the house. Above the fireplace is a Vilhelm Hammershoi painting from the turn of the nineteenth century, a modern twentieth-century painting, and a few small metal sculptures including a bronze Buddha head. Such disparate eras and styles, but Risom has arranged them in a way that makes them sit comfortably together, like members of the same family.

Moving into Risom's studio and office in the back of the house, I was excited to find drawings and drafting triangles on one of the desks. Two large golden Rs—remnants from his JRD showrooms—flank his other desk. Across the hall lies the bedroom with a picture window, which was so inviting I immediately made a beeline to the green Risom chair sitting next to it. With a view out to the acres of serene trees behind their house, it was hard to pull myself out of that chair and finish the photo shoot. As I left I thought about all the stories that Risom shared with me during my two days photographing his house, and this time I did pinch myself.

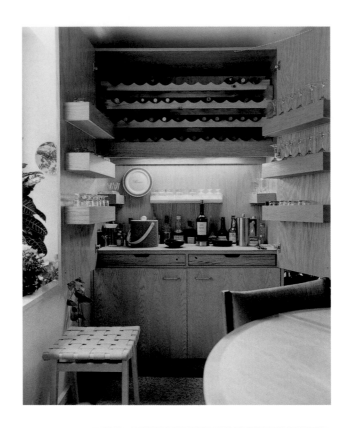

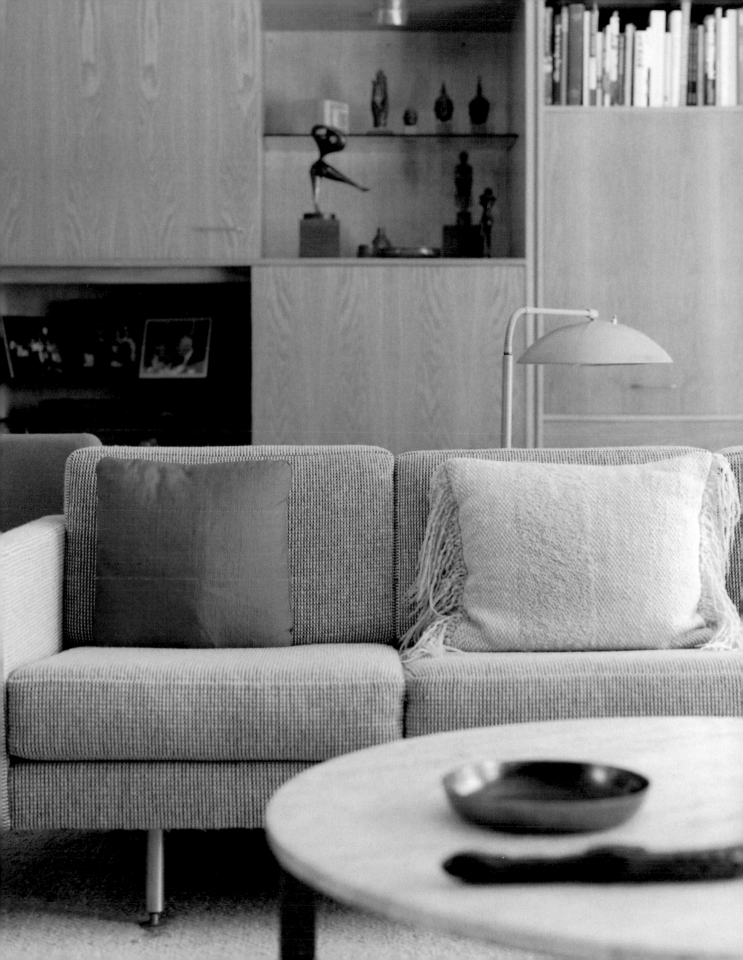

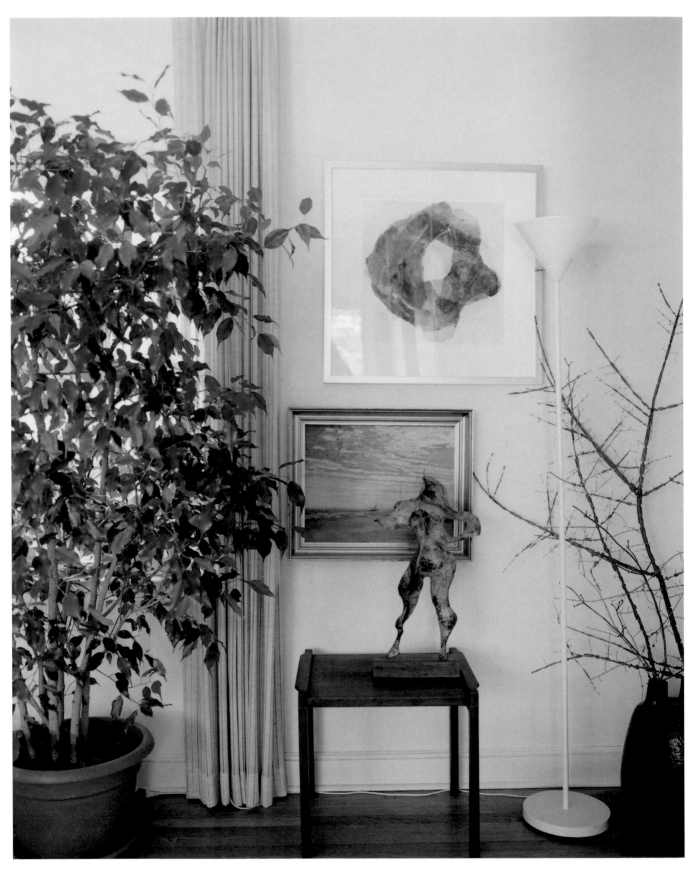

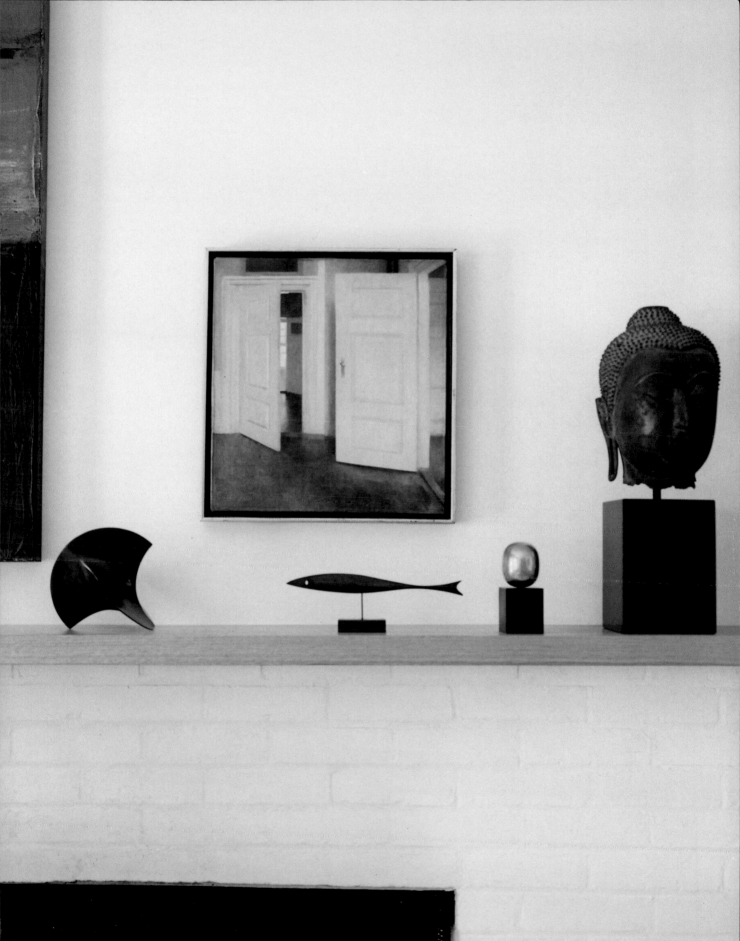

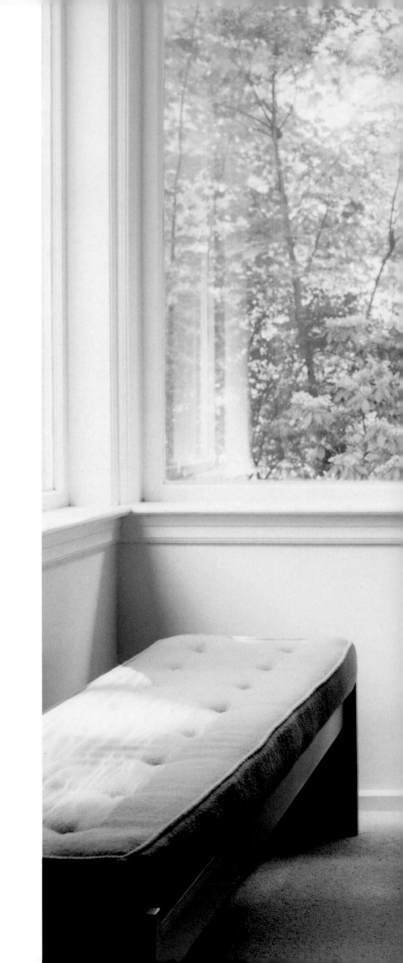

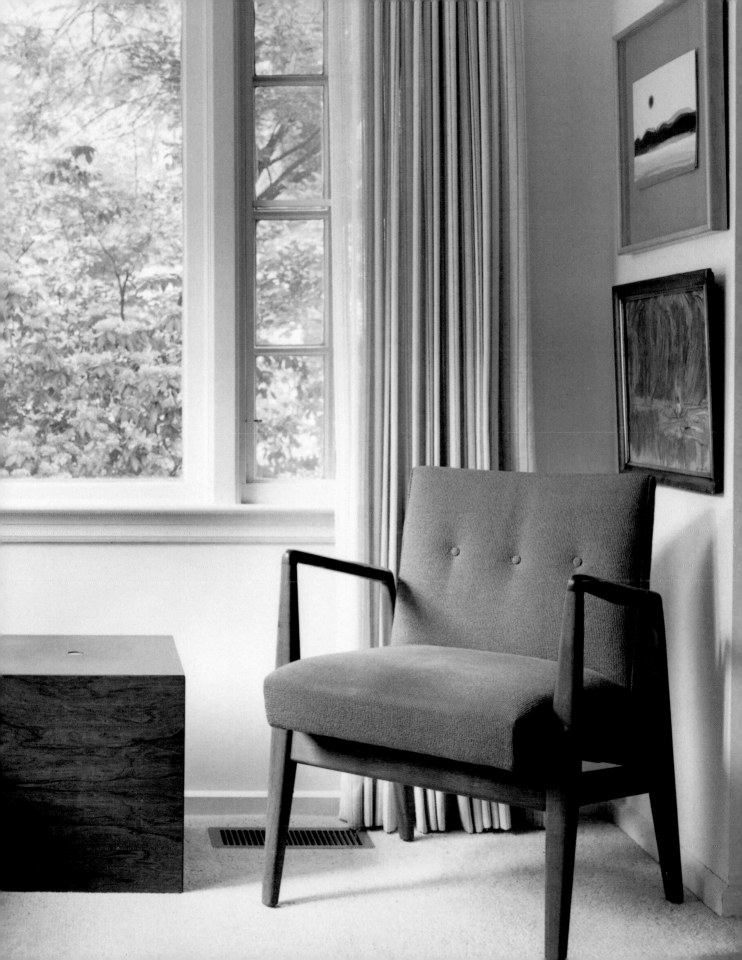

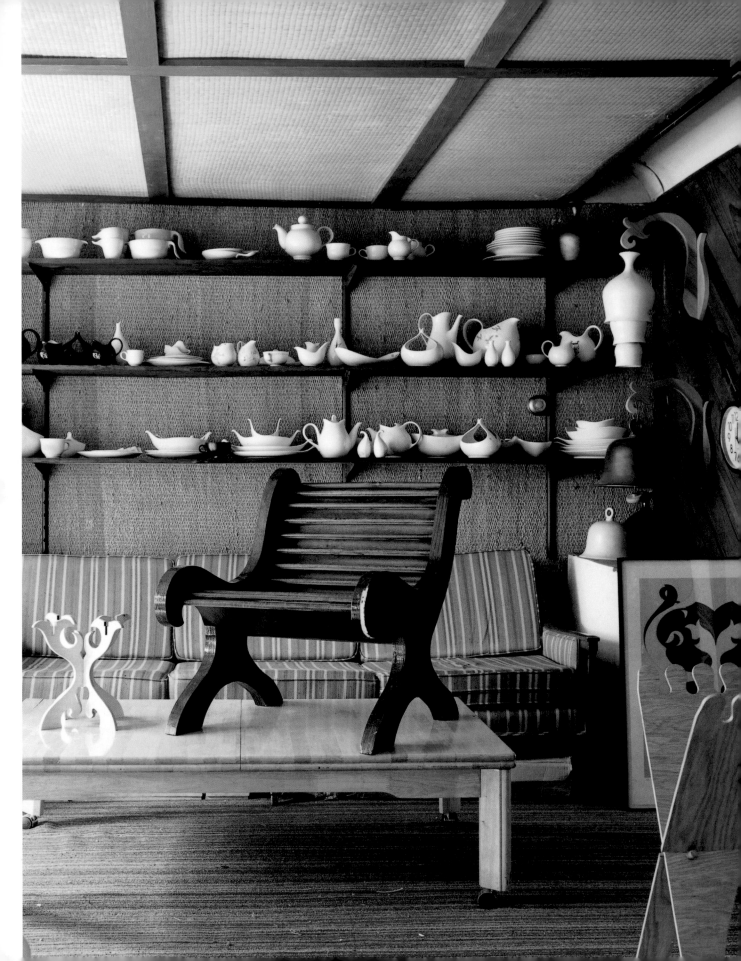

EVA
ZEISEL

ROCKLAND COUNTY, NEW YORK

To refer to Eva Zeisel (b. 1906) as the grande dame of industrial design is an understatement. Possibly the best-known ceramic artist of the twentieth century and arguably the most important, her career has spanned more than eighty years and counting. She began her creative life by entering the Academy of Fine Arts in Hungary at the age of seventeen and quickly decided that she would focus on a craft so that she could support herself. This was not the easiest goal since it was 1924 and opportunities were not plentiful for women, yet support herself she did. In the 1920s she worked in Germany at the height of the Bauhaus influence, in the 1930s she became head of the China and Glass Industry of the Russian Republic at the beginning of that country's industrialization, and from the 1940s onward she designed products for a multitude of companies in the United States. In 1946, less than ten years after her arrival in the United States, Zeisel had her first solo show at the Museum of Modern Art. Although she is most widely known for her designs of plates and other ceramic pieces, she has designed furniture, tiles, rugs, wood objects, and metal pieces. Throughout her long and prolific career, sensuous fluid forms are a recurring element. Her "playful search for beauty," as she describes it, drove her to create a world of mass-produced objects meant to be used and enjoyed in everyday life.

Zeisel's country house in Rockland County, northwest of New York City, chronicles this life in design, but it took me a while to realize it. Upon entering her living room, I was surprised by its Old World European feel with dark heavy furniture and ornate tapestries. These traditional pieces were joyfully juxtaposed with Japanese porcelain dolls, portrait paintings, and wood knickknacks collected during her long life. A bright red settee sat unassumingly to the side, yet on second glance it has the sensuous curves present in almost every iconic Zeisel design. Around a corner, I found a room full of Zeisel's own paintings—all portraits—on a wood-paneled wall much like a quaint chalet in Switzerland or the Bavarian forest. As I climbed the stairs to the second-floor studio and continued up to the attic, I found myself stepping out of Old World Europe and into the world of Eva Zeisel, industrial design legend. There are shelves upon shelves of her product designs in both the studio and the attic. Zeisel estimates she has designed several thousand products in her career—and she continues to design today. A fair number of the products are in these rooms, and through them the evolution of her designs is evident. There are a few boxier Bauhaus-influenced shapes, obviously from early in her career, but curved feminine shapes dominate these rooms. Glasses, plates, teapots, casserole dishes, dinnerware—some with patterns, others plain—all happily cohabit on these shelves. In the main studio, tangles of wood objects sit backlit by an expanse of windows. Pull open a few drawers and Zeisel's tile designs pour out. What is most predominantly on display in this house is the consistency of Zeisel's singular vision. Even though the downstairs and upstairs are in drastically different styles, the downstairs made sense to me after inspecting her life's work upstairs.

Perhaps this is an oversimplification, but Zeisel's country home is a lot like her life: grounded in the Old World, yet boldly forging a new world in her own distinct style.

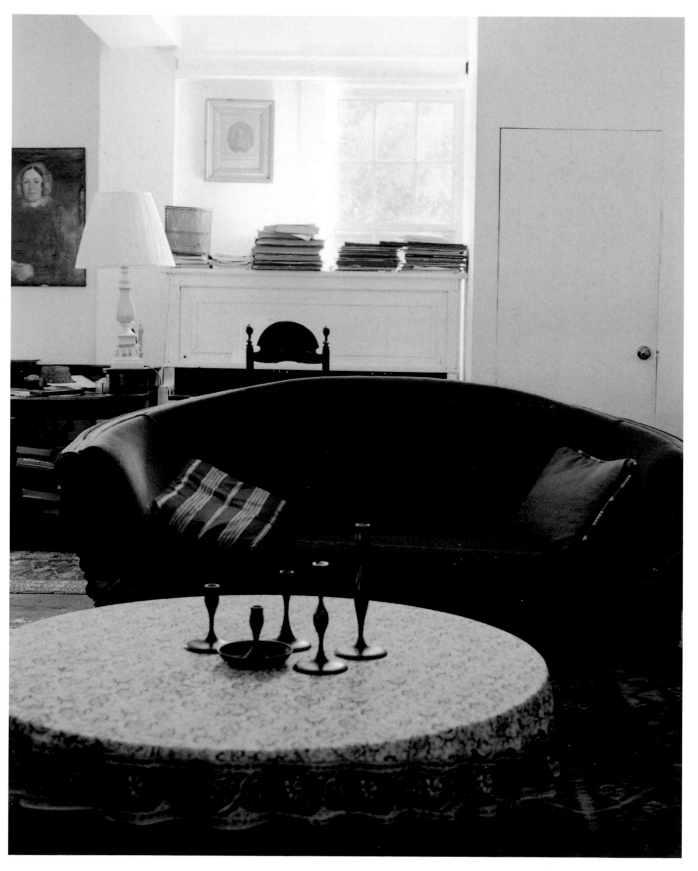

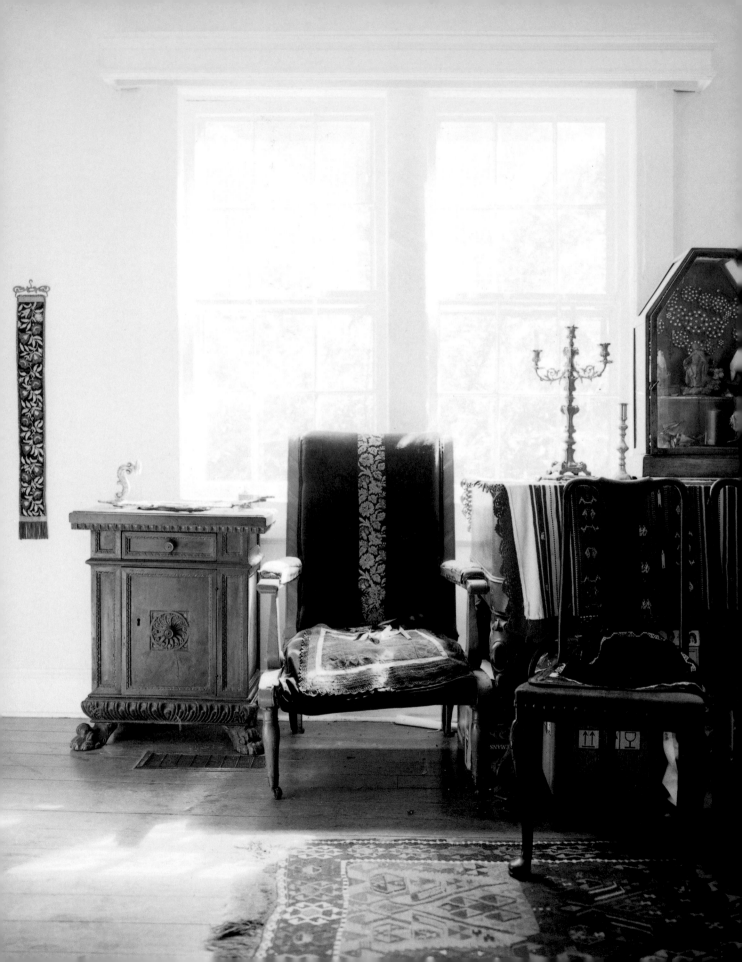

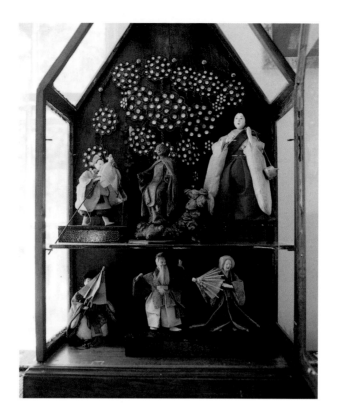

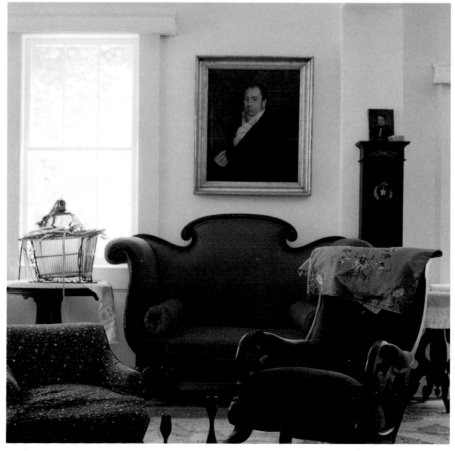

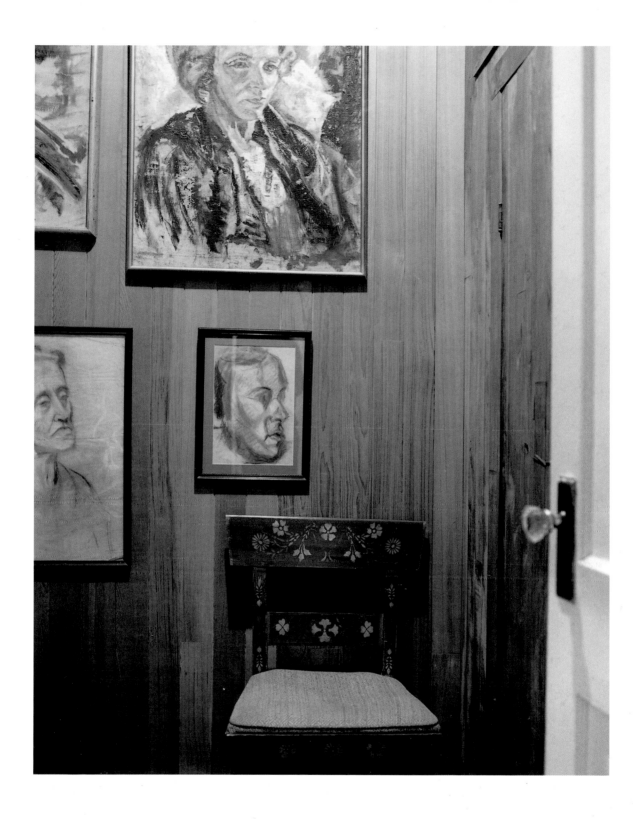

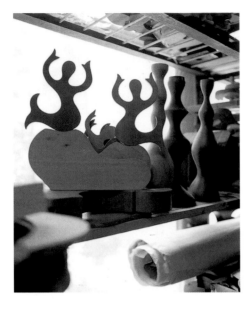

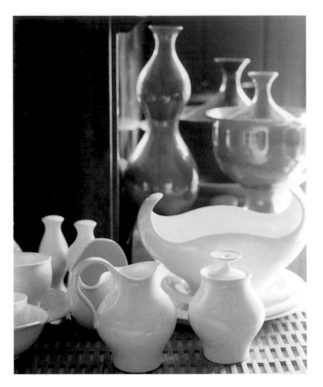

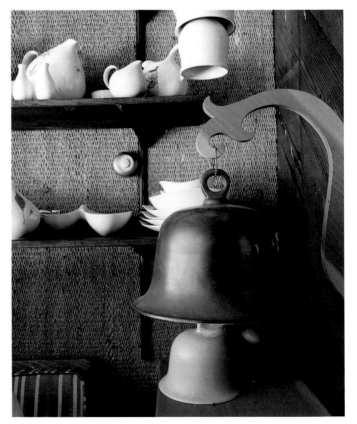

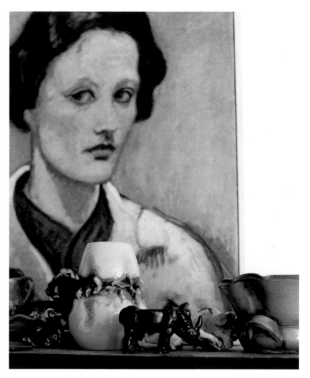

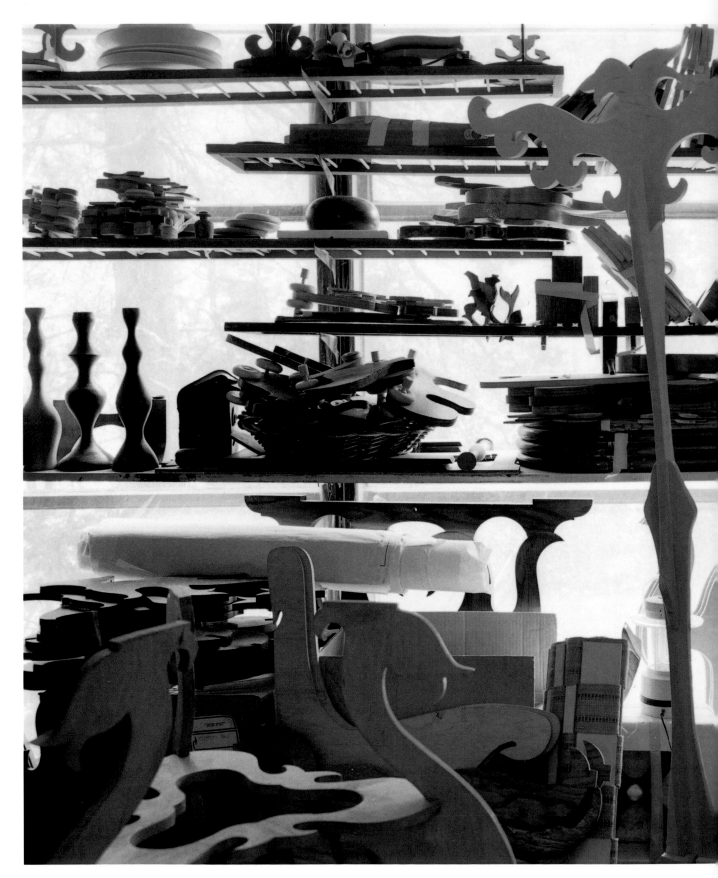

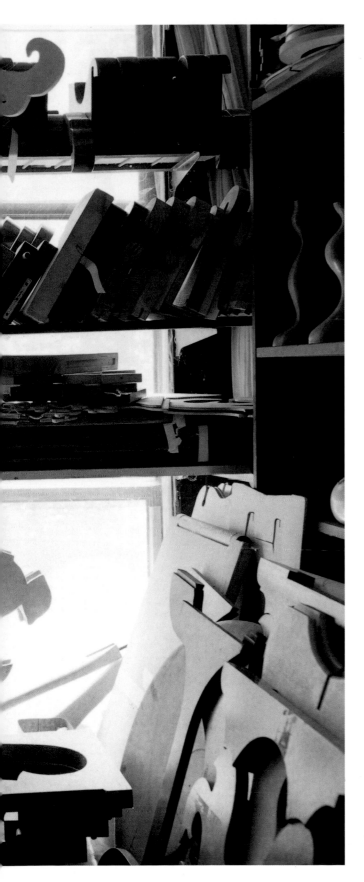

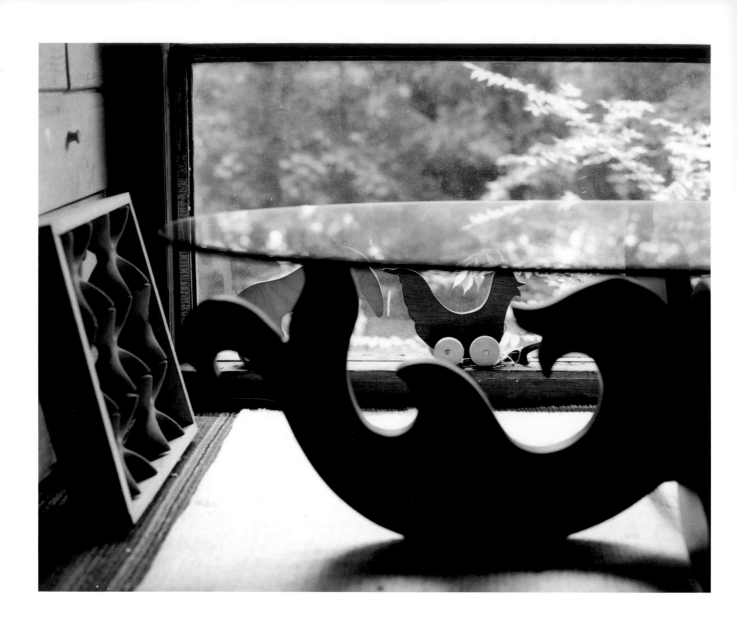

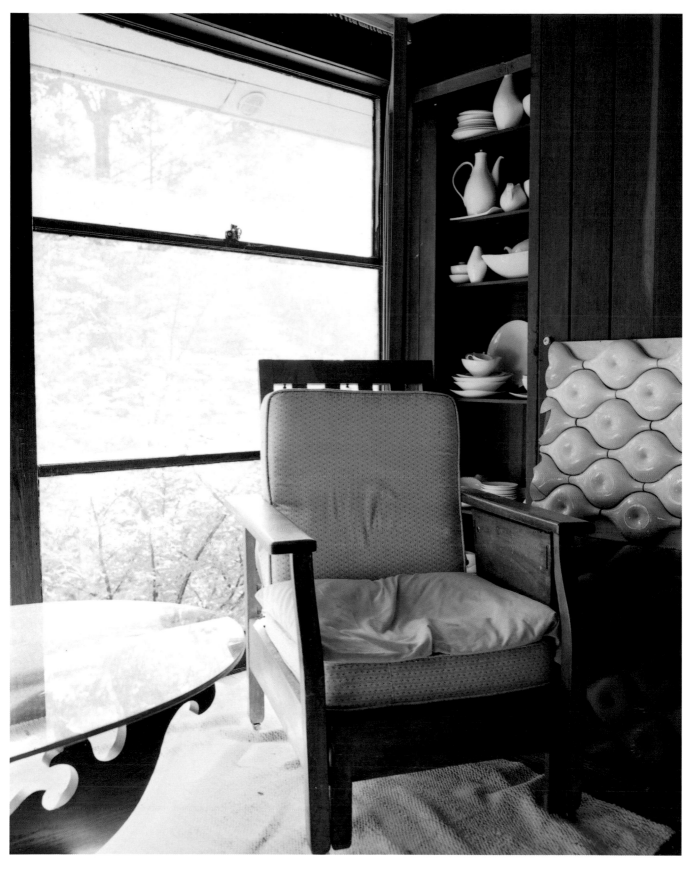

VLADIMIR KAGAN

NEW YORK, NEW YORK

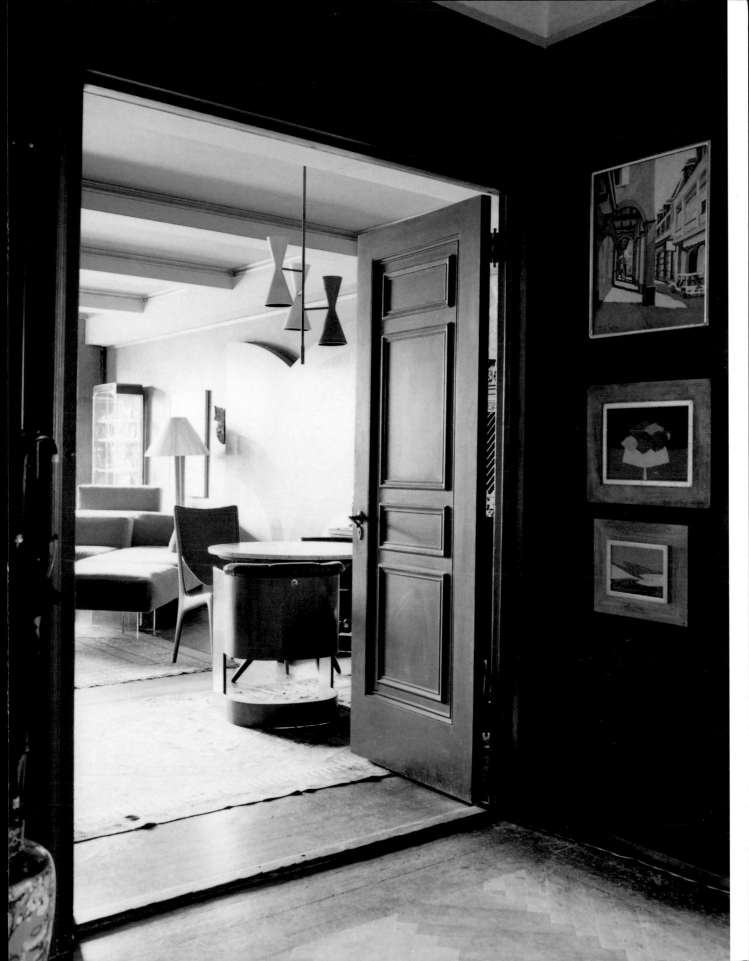

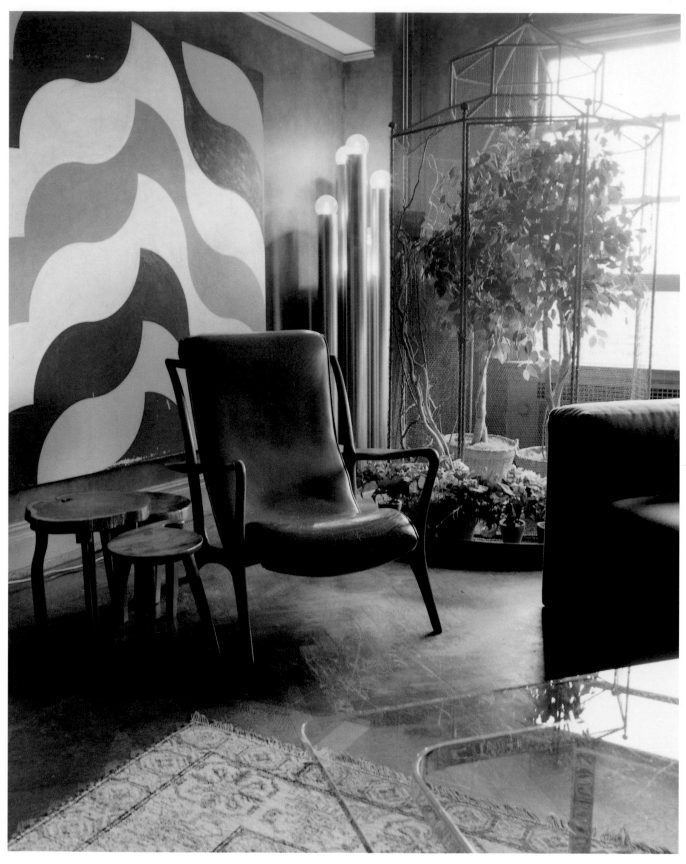

Riding up the fourteen floors to Vladimir Kagan's Park Avenue apartment for the first time, I was a bit nervous. His furniture designs, with their swoops and organic forms, have always struck me as not for the faint of heart. They are bold, in the best sense of the word, and epitomize 1950s and 1960s furniture design for me. So how would the designer of such originality and boldness live? As I entered the foyer of the ten-room apartment, deep burgundy walls and masses of artwork told me exactly what I should have already known: my imagination could never have conjured up the world I was about to enter. Kagan (b. 1927) has lived here for the past forty years with his wife, needlework expert Erica Wilson, and together they have created a home in which each room has its own distinct personality, much like its inhabitants.

Take the living room, for example. It overflows with Kagan's furniture designs from every era—in fact, the whole house does. Layered into a two-toned green landscape sit an Omnibus sofa (1969) and leather Contour chair (c. 1950s) surrounded by large abstract paintings by Frank Stella and Joe Crum and a life-size wood sculpture by Kagan's father, Illi. My favorite piece of furniture in the room is a collaboration between Wilson and Kagan, originally commissioned for *House & Garden* some fifty years ago. On a Contour rocking chair, Wilson has created custom-designed upholstery featuring an owl perched in a tree, all executed in hand-stitched crewelwork. The delicacy of the crewelwork might seem at odds with the clean modern form of the chair, but like everything else in the apartment, the unexpected combination has a visually striking effect.

Kagan's study, which is now his home office, is a traditional wood-paneled library. He was working in this room on the day I was photographing, and as I began to clear off some books to get a better look at the top of the coffee table he looked up, and revealed with a smile, "That table is from my bachelor days in the '50s! I had a mosaic artist who worked on churches do the top." The table sits at the base of a couch, and above it hangs a ship in a bottle dangling from the bottom of a painting. On top of a chest on the facing wall are more of Illi Kagan's wood sculptures, these considerably smaller than the one found in the living room. The bedroom has a much lighter tone than the study next door. Celadon green fabric covers the walls and more objets d'art occupy every surface and hang on every wall. On the dresser sits a small bust of young Vladimir, a self-portrait made about sixty years ago. Next to it lies a life-size cast of Illi Kagan's hand, and a collection of small wood boxes gather on another dresser on the far wall.

Each room unfolds into the next as an unexpected surprise. The colors and styles of each space have separate personalities yet cohabit harmoniously. The view from the bedroom into the mosaic-tiled bathroom exemplifies this. Stylistically it is a juxtaposition, but it works. Kagan told me that the "mosaic tile design flowed out of my decorative use of these tiles in my furniture." He even tiled one of the doors, and when I closed it, I could feel the weight of all that tile. If I had to choose a favorite room, it would be this bathroom. All mirrors, geometric patterned tile, and a touch of "wood" (in reality, a mottled-texture Formica) for the cabinet door, it is as unexpected and delightful as the Kagans themselves.

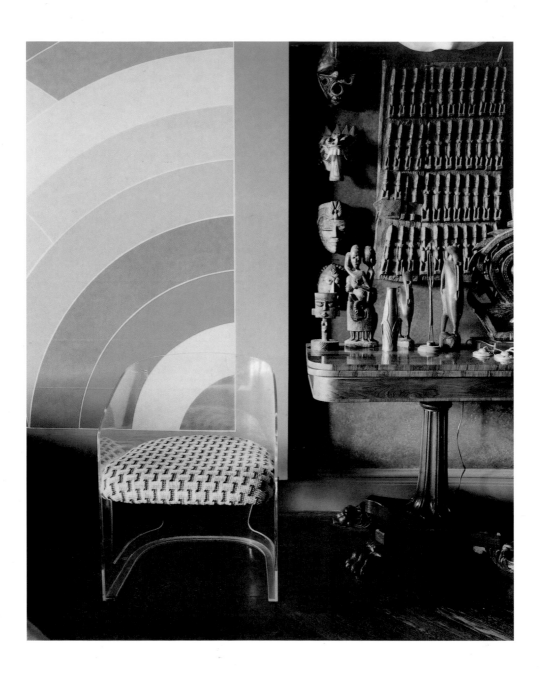

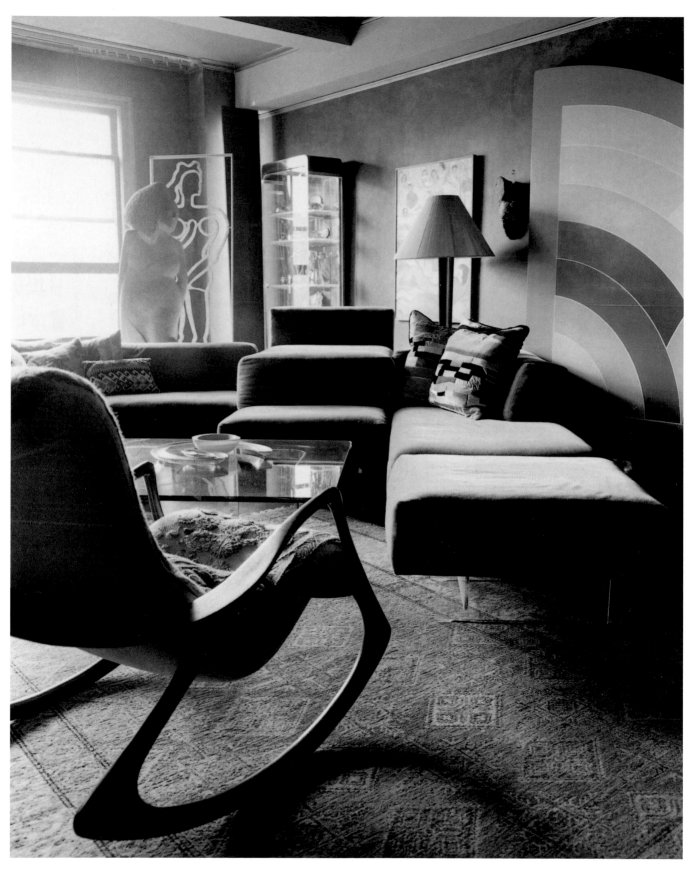

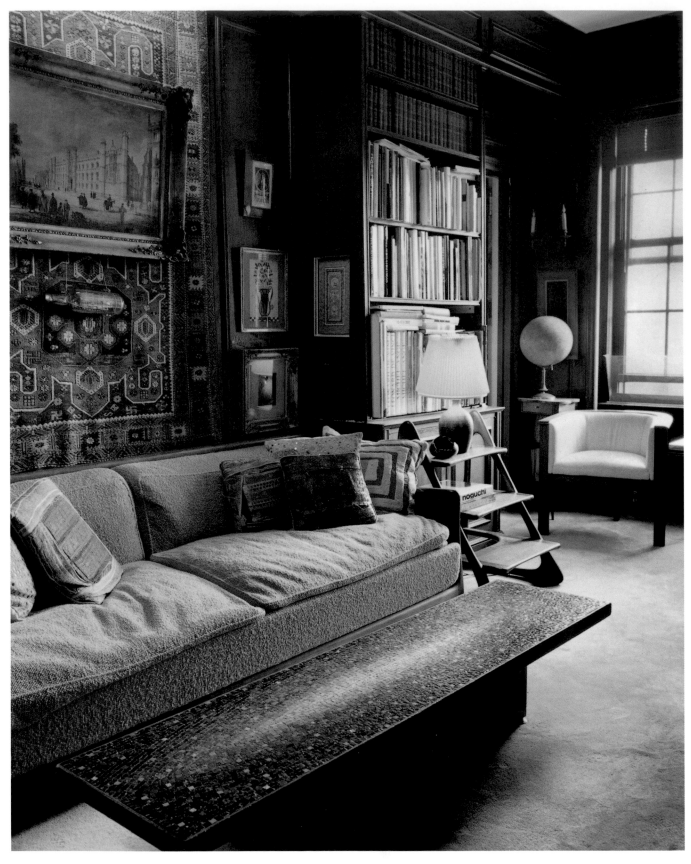

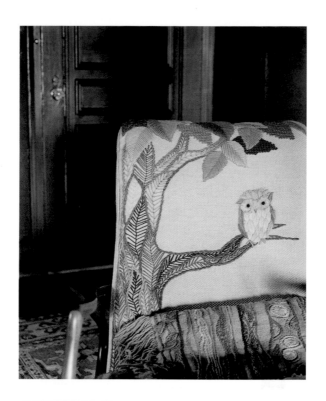

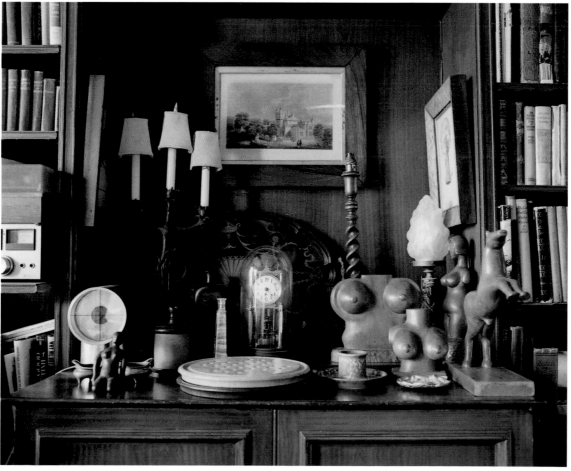

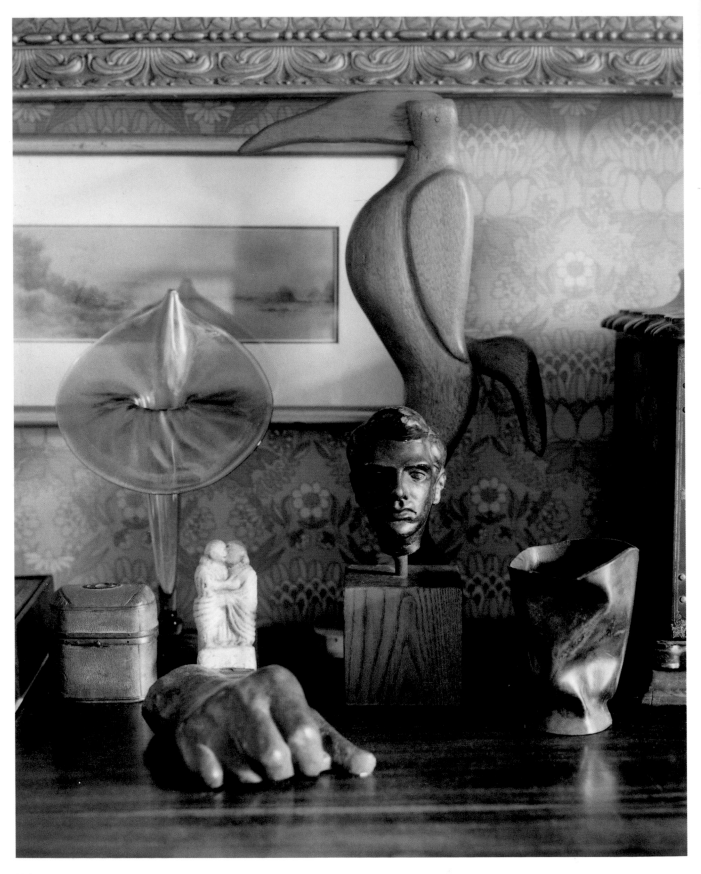

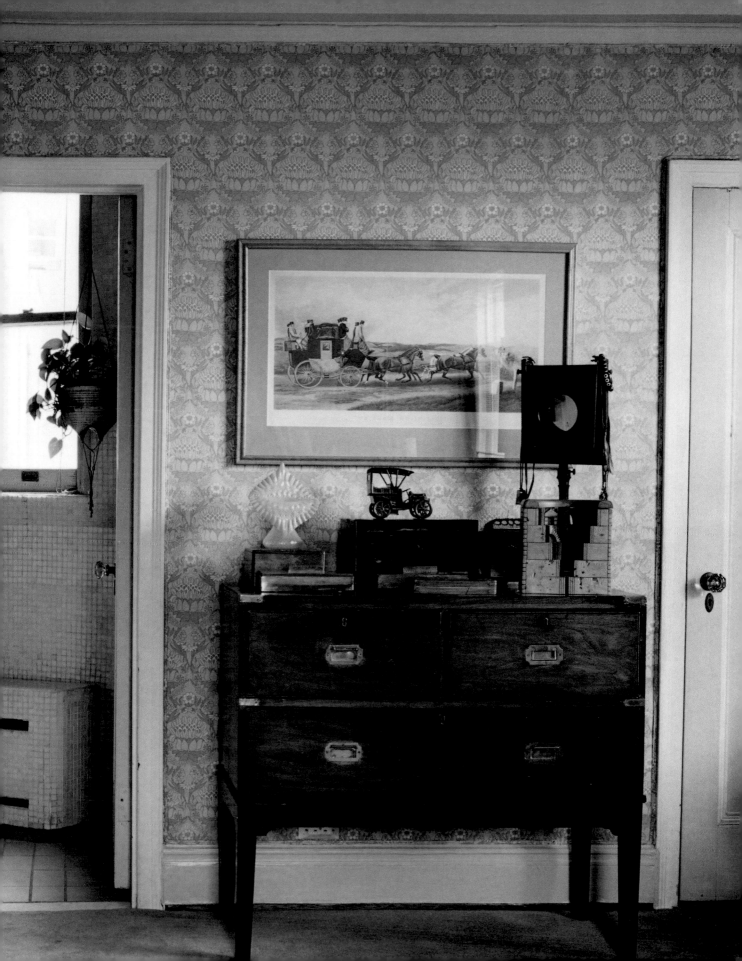

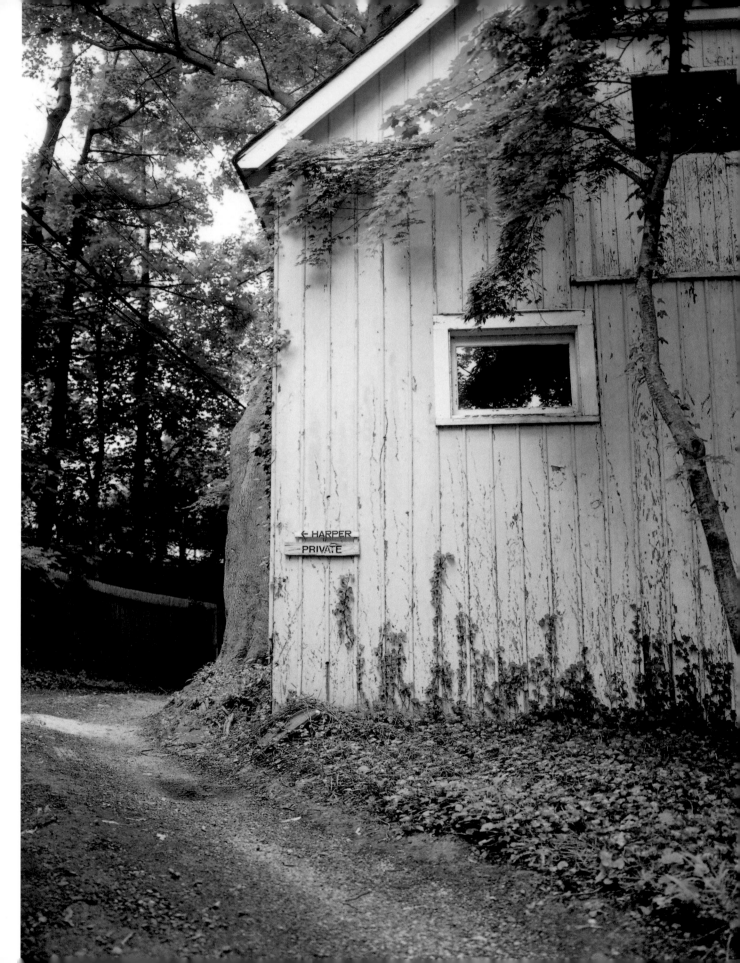

IRVING HARPER

RYE, NEW YORK

When I say the name Irving Harper (b. 1917), recognition does not immediately flash across people's faces the way it does when I bring up Charles and Ray Eames or Russel Wright. But when I begin to list some of his designs—the Marshmallow sofa (1956), the Herman Miller logo (c. 1940s), and the many Howard Miller clocks (c. 1950s)—it quickly becomes apparent that he is one of the most versatile industrial designers of the twentieth century. As a designer in George Nelson's office from 1946 to 1963, and at his own firm, Harper+George, from 1963 to 1983, Irving Harper spent his life designing and, more importantly, making things.

Since the 1950s Harper and his family have lived in a late-nineteenth-century farmhouse tucked behind a quiet neighborhood in Rye, New York. It is so well hidden that I circled around his neighborhood awhile before I finally saw the small wood sign reading "Harper" that marked his driveway. Once inside I realized that this was no ordinary farmhouse. When the Harpers moved in, Irving Harper customized it with built-in storage units for the kitchen, dining room, and living room. "I was very young and ambitious then. . . . I built it all myself," Harper told me. The house is populated by classic mid-century furniture, mostly from Herman Miller. A set of prototype Miller club chairs were brought home from the Nelson office one day. Many of Harper's own designs are throughout the house, including a mini–Herman Miller cabinet mounted on the bedroom wall and a free-form lighting fixture in the entryway. I learned this light was a one-off when I asked Harper where I could get one. He chuckled, "I made that from electrical supplies from the hardware store. I'll show you how to make one before you go." To my everlasting regret I forgot to remind him.

As notable as the furniture, built-ins, and lamp are Harper's paper sculptures. They occupy every wall and surface in the house. The subject matter ranges from abstract patterns to architectural models to tribal masks, but the constant in all of these pieces is the use of everyday materials. Although primarily working with paper, Harper would incorporate toothpicks, pins, plastic straws, and even spaghetti. Whatever there were multiples of, was on hand, and was not expensive found its way into his sculptures. Making these sculptures was originally a way to relieve the stress from a commission he had designing the Chrysler exhibit for the 1964 World's Fair, but since his retirement, they have become his main creative outlet. He has made more than two hundred fifty sculptures since he began in the mid-1960s. "It kept me sane," Harper explained, "The more intricate [the sculptures], the better!"

As I headed up the stairs to the third-floor studio where Harper made all these pieces, I swiftly saw that there are more sculptures than there is space to put them. They hang from floor to ceiling, propped three deep in the hall, and the bathtub is covered over to afford more space for display. "I finally had to stop making them because I ran out of places to put them," he exclaimed, "There are more out in the barn!"

As I was leaving I quickly peeked into the barn. Pushing the door open, I saw a room full of paper sculptures towering over me—most almost reached the ceiling. It was getting dark and so I shot off only one roll of film, but as I drove away, I made a promise to myself: someday I will go back and document these delicate creations of Harper's in the manner that they deserve.

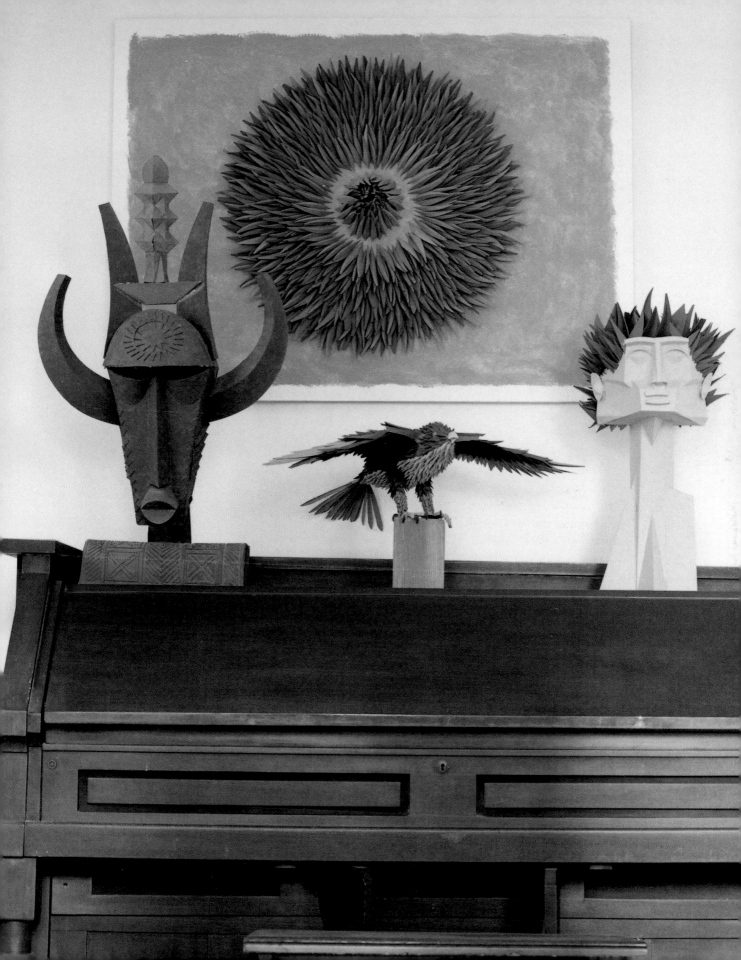

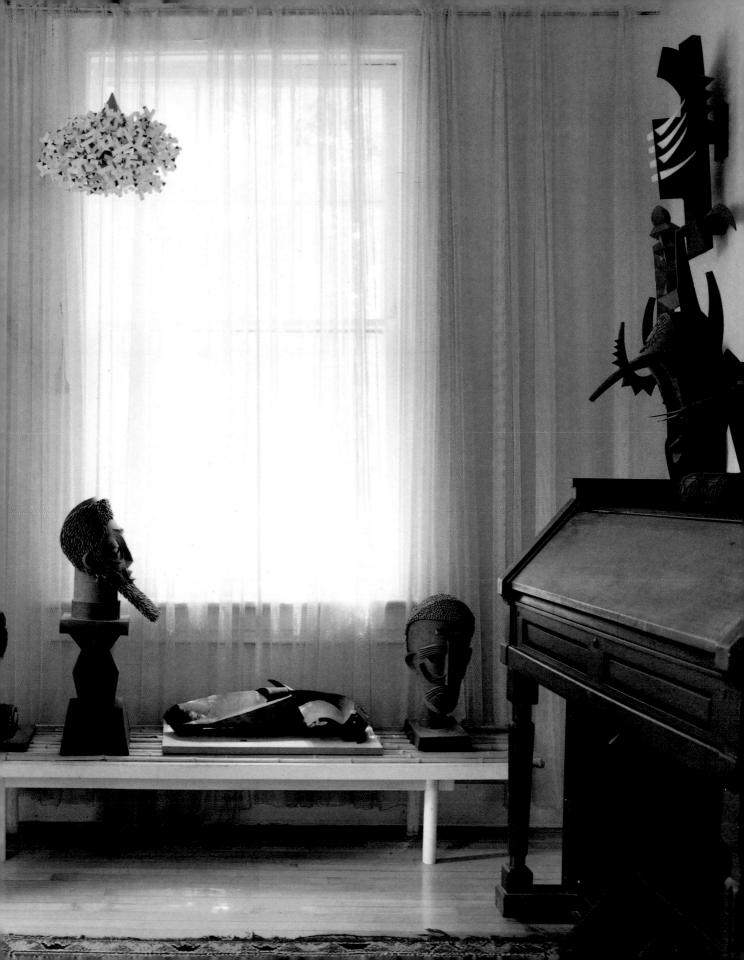

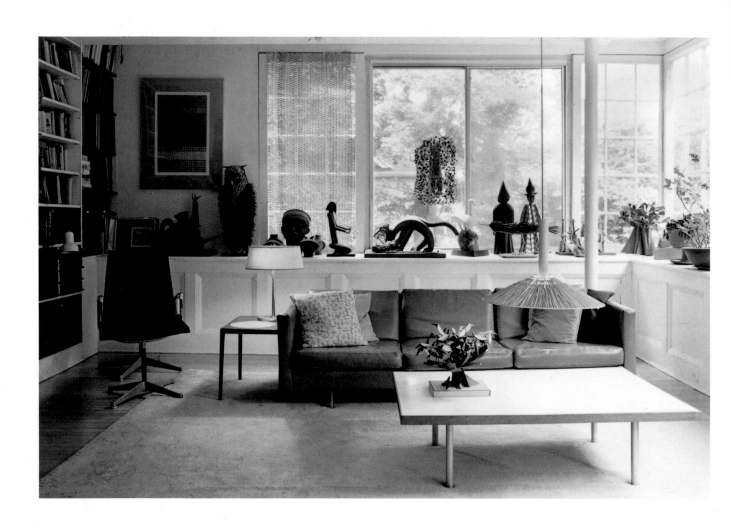

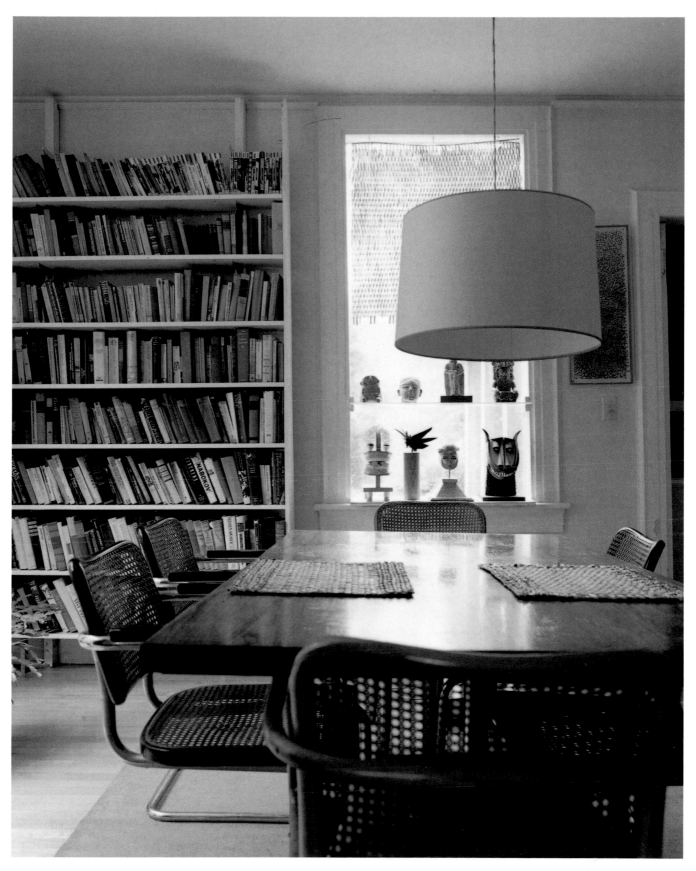

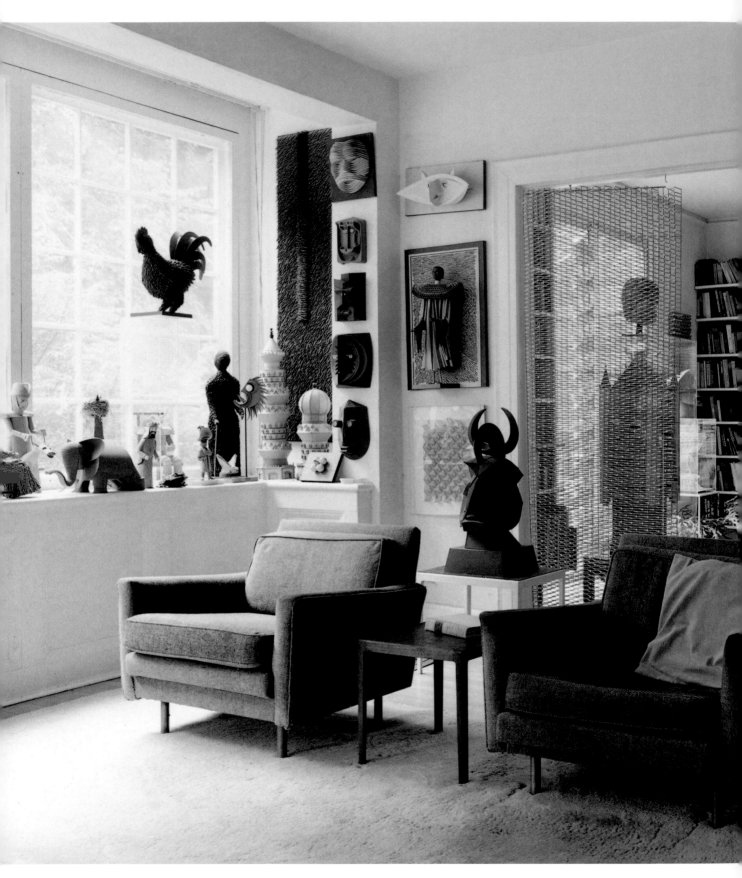

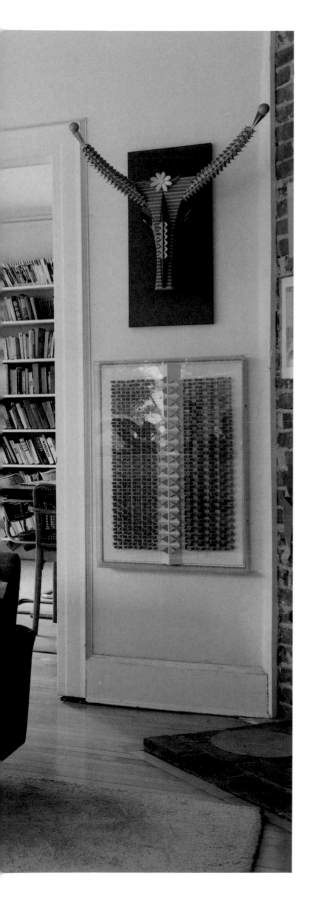

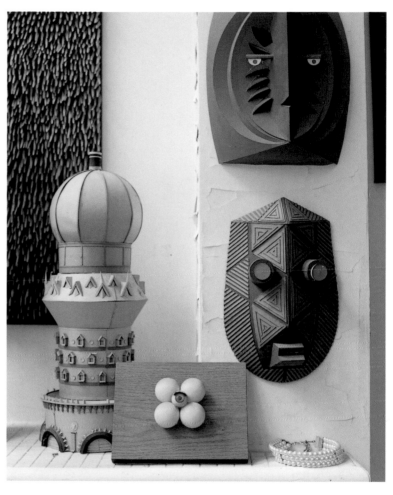

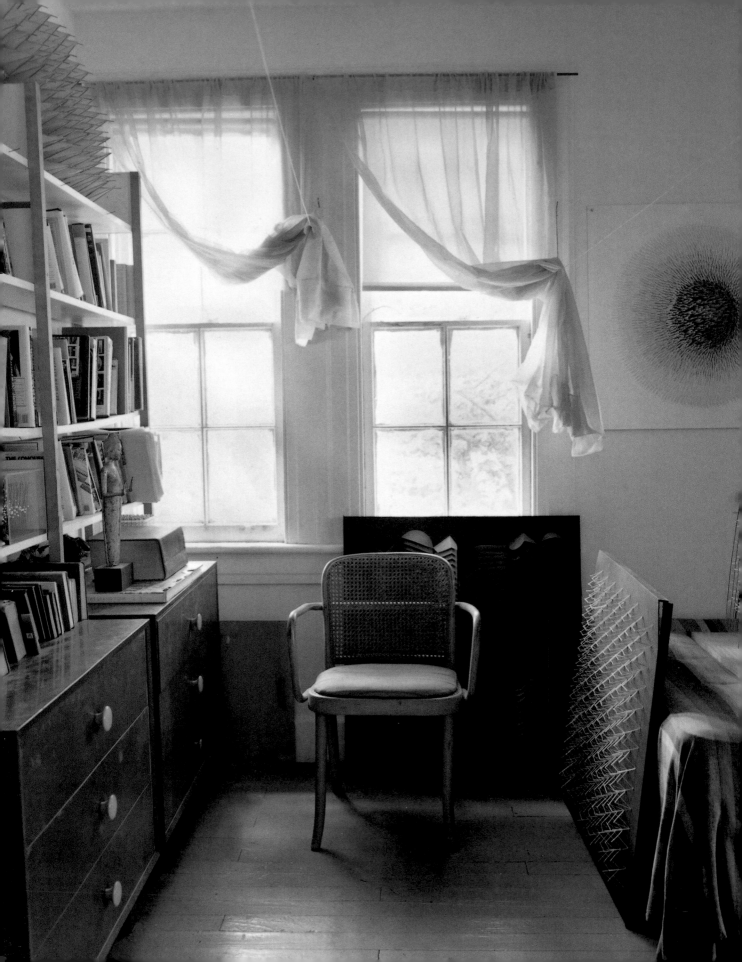

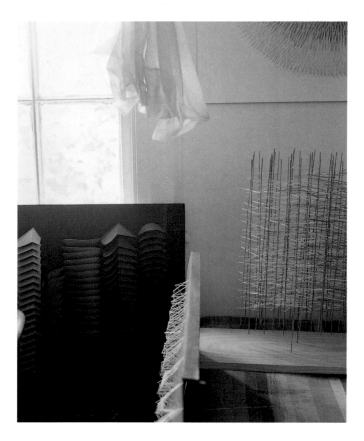

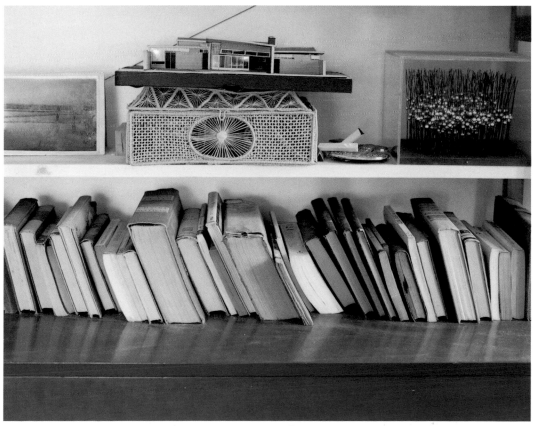

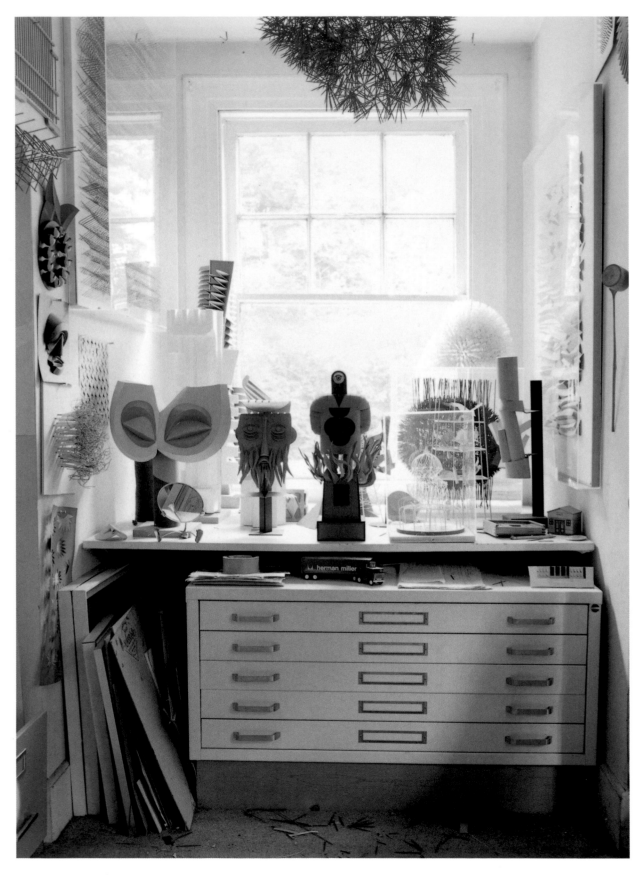

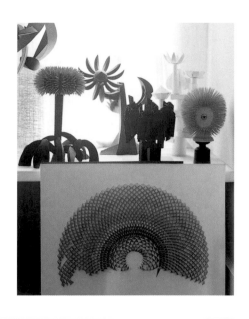

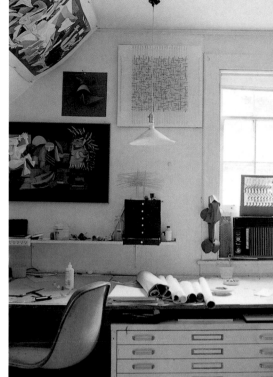

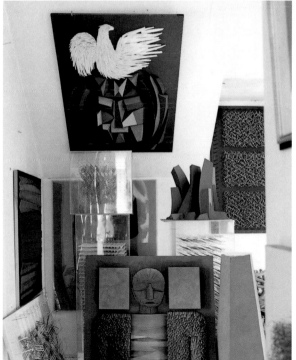

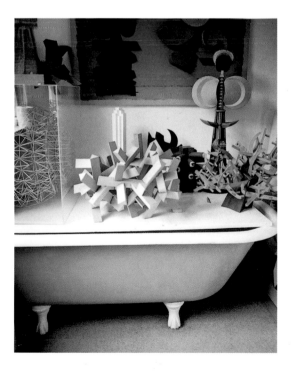

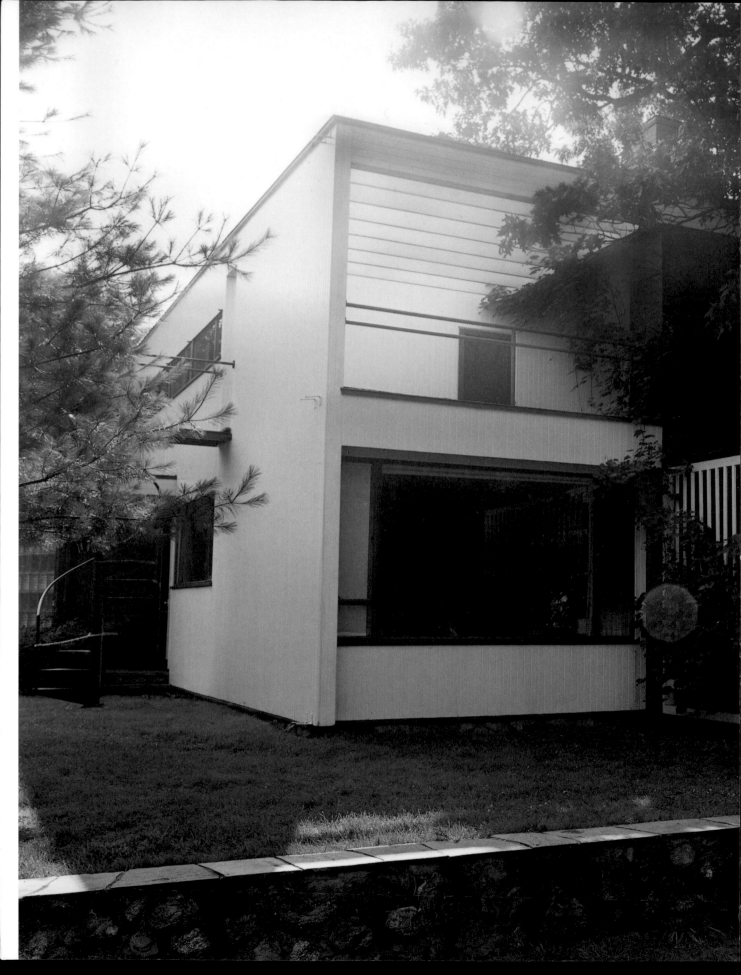

WALTER GROPIUS

LINCOLN, MASSACHUSETTS

W alter Gropius (1883–1969) is one of the über-icons of Modernism. His credentials are unassailable: founder of the Bauhaus and its director from 1919 to 1927, head of the architecture program at the Harvard University Graduate School of Design, and a teacher and mentor to countless names in the who's who of modern architecture and design—Marcel Breuer, Eliot Noyes, and Philip Johnson, to name a few. His influence is so far-reaching and his importance so indisputable that he can come across as one-dimensional and austere, but imagine Walter Gropius as a regular guy who lives down the street. When I walked into his home in Lincoln, Massachusetts, the great man quickly became the everyman, albeit one with an exceptional house.

Built in 1938, the home that he designed for his family remains lovingly intact thanks to his wife, Ise, who left it and its contents to be preserved as a house museum. With the help of their daughter Ati, the house is as it would have been on a typical day in the 1960s. Gropius designed a modest open-plan house and filled it with furniture that was designed and manufactured in the Bauhaus workshop. Metal tubular designs by Marcel Breuer are the dominant style of furniture, with Eero Saarinen's Womb chair (1948) and Breuer's plywood Isokon Long Chair (1936) thrown in. As I entered the office, I immediately noticed the desk; not only is it wood, but it is also clearly an earlier piece in both style and design, and the room appears to be designed around it. Breuer designed this desk, too. It was originally made for the Bauhaus director's office in Weimar, Germany, and Gropius had it brought over. What I find so fascinating about this desk is that it is a desk made for two, one seat for Gropius and one for his wife—truly the testament of a good marriage! On the desk sits artwork by friends, Gropius's glasses, correspondence, and some beautiful brass sculptures by Carl Auböck. A couple of pairs of binoculars sit on the top shelf which were likely used to watch birds (E. H. Forbush's 1927 three-volume set of *Birds of Massachusetts & Other New England States* sits nearby). In the living room I could not resist inspecting the wall of books—what did Walter Gropius read? All the things I had expected to see are there: his own books (Katsura's *Tradition and Creation in Japanese Architecture*, 1960), quite a few books on Japanese architecture, various architecture monographs including Le Corbusier's *Modulor 2* (1955), and some surprises, such as a book on wildflowers and *The Naked Ape: A Zoologist's Study of the Human Animal* (1967). It is the library of a polymath.

I climbed the stairs to the second floor and found the master bedroom at the top. A large window runs down the middle of the room, which struck me as odd until I realized that Gropius used this window to create two separate light-filled spaces. He simultaneously provided privacy and defined two zones for different functions: one side for sleep, the other for dressing. In place of a traditional headboard, a vibrant red tapestry is attached to the wall, and Ise's red evening dress, which she designed and sewed, hangs as a counterpoint next to the bedroom door. Ati's room lies across the hall. L-shaped, it has a desk and two beds, one of which can be closed off by curtains, creating a cozy little nook. A door leads to an outdoor deck and a spiral staircase goes down to the front of the house and provided Ati with her own private entrance. Of course, the staircase was within sight of the Gropiuses' shared desk on the ground floor, and Ati's comings and goings were discreetly monitored. Gropius the everyman was a shrewd father—and a brilliant architect.

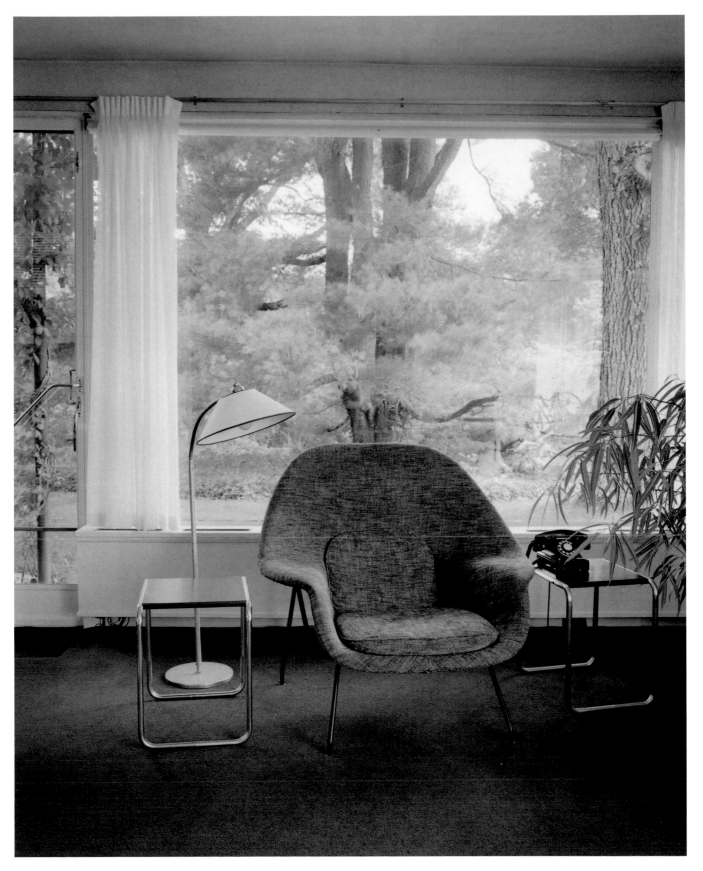

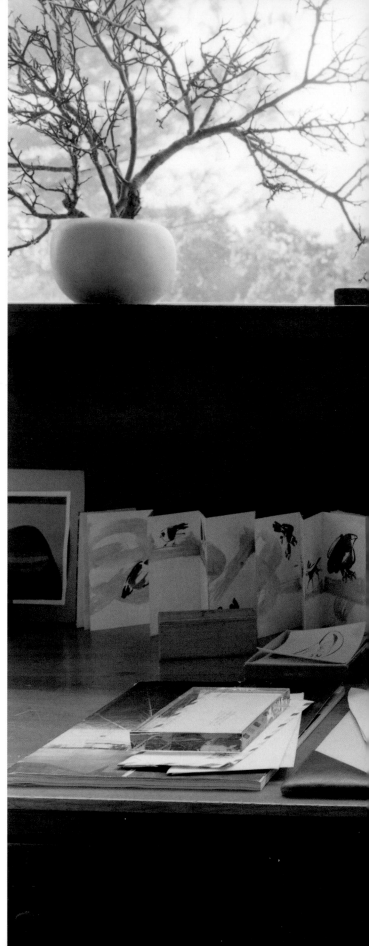

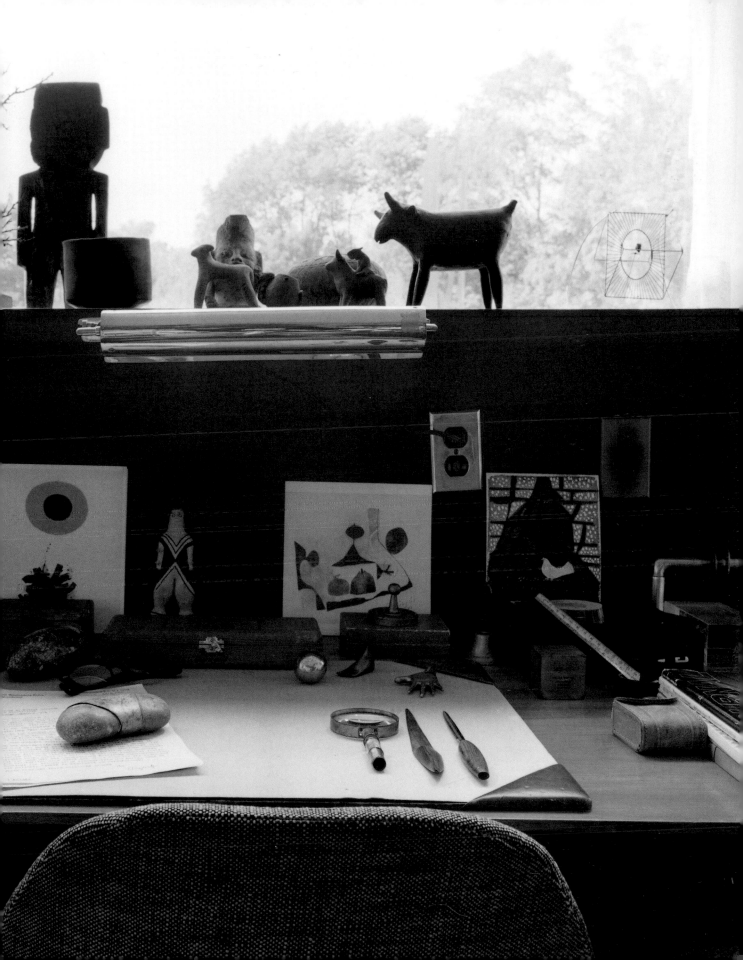

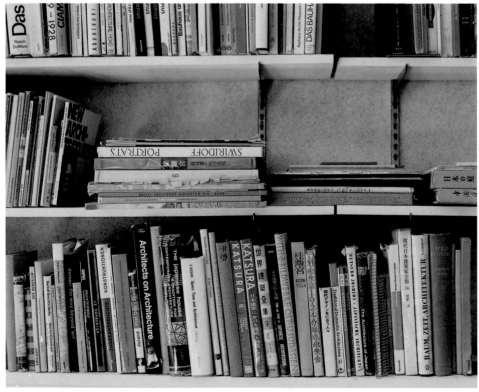

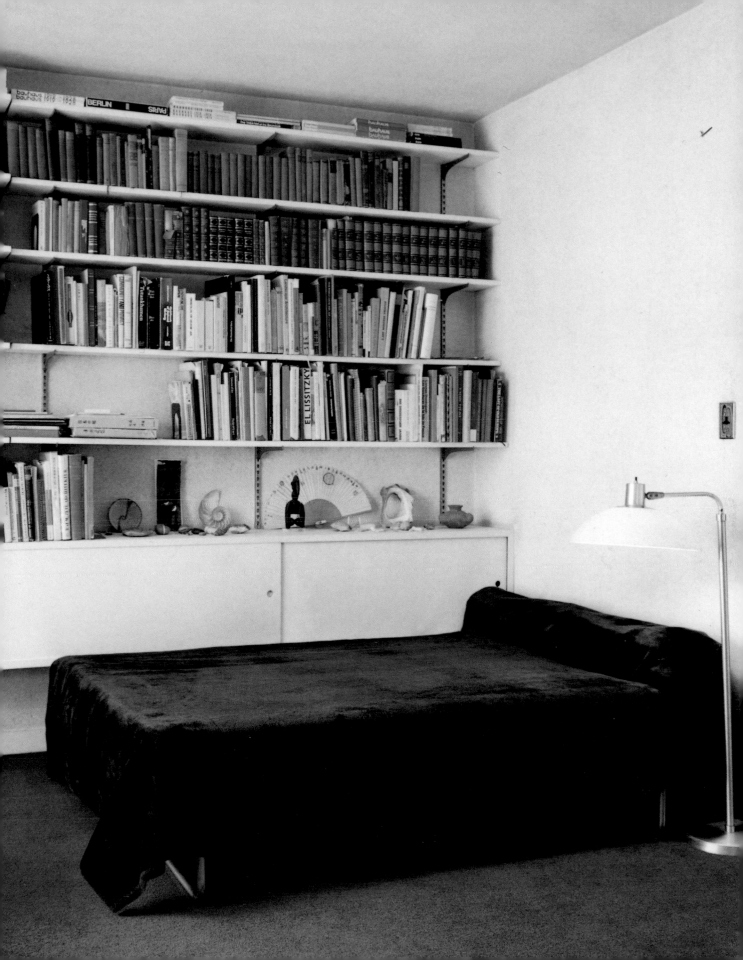

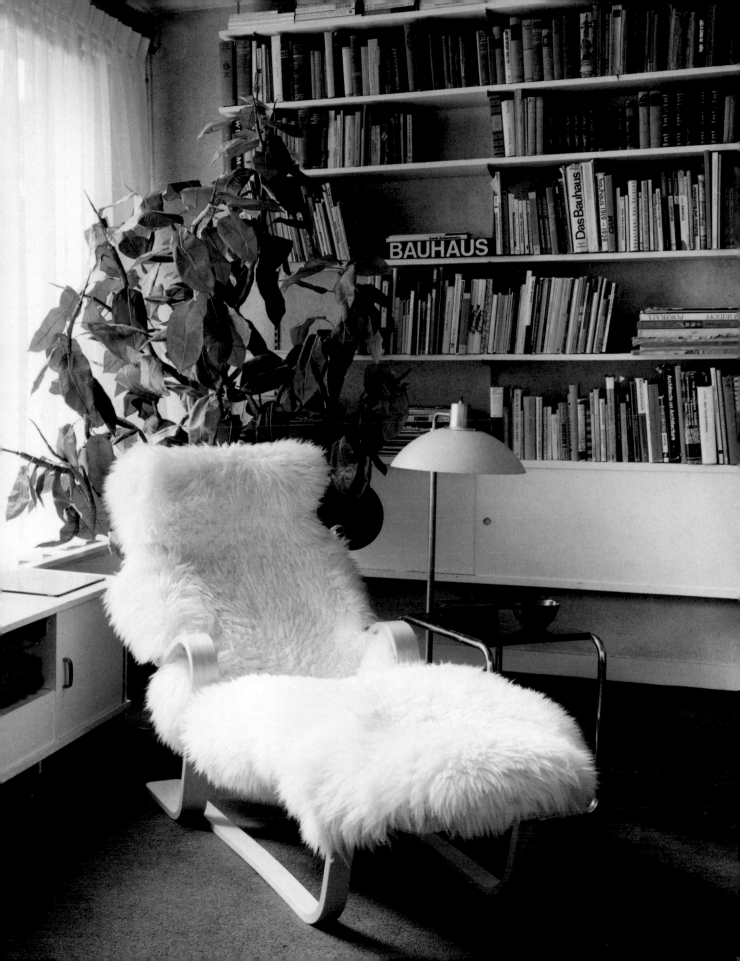

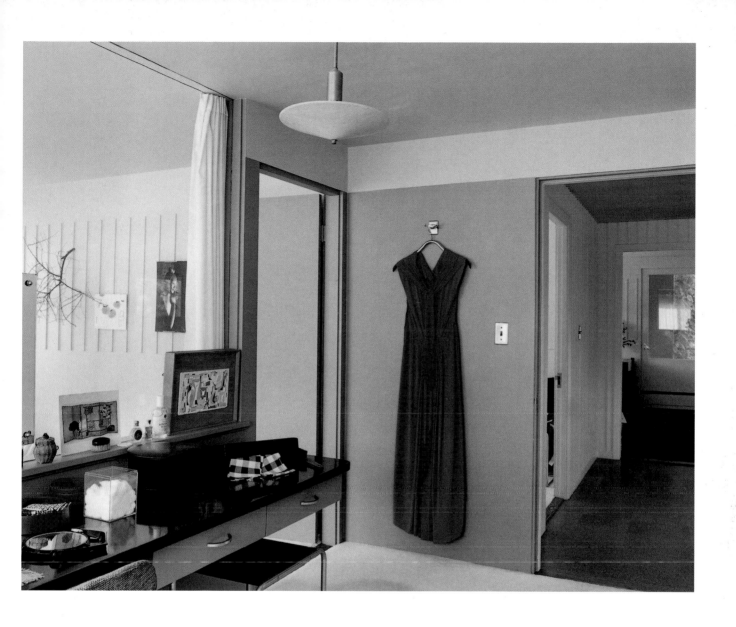

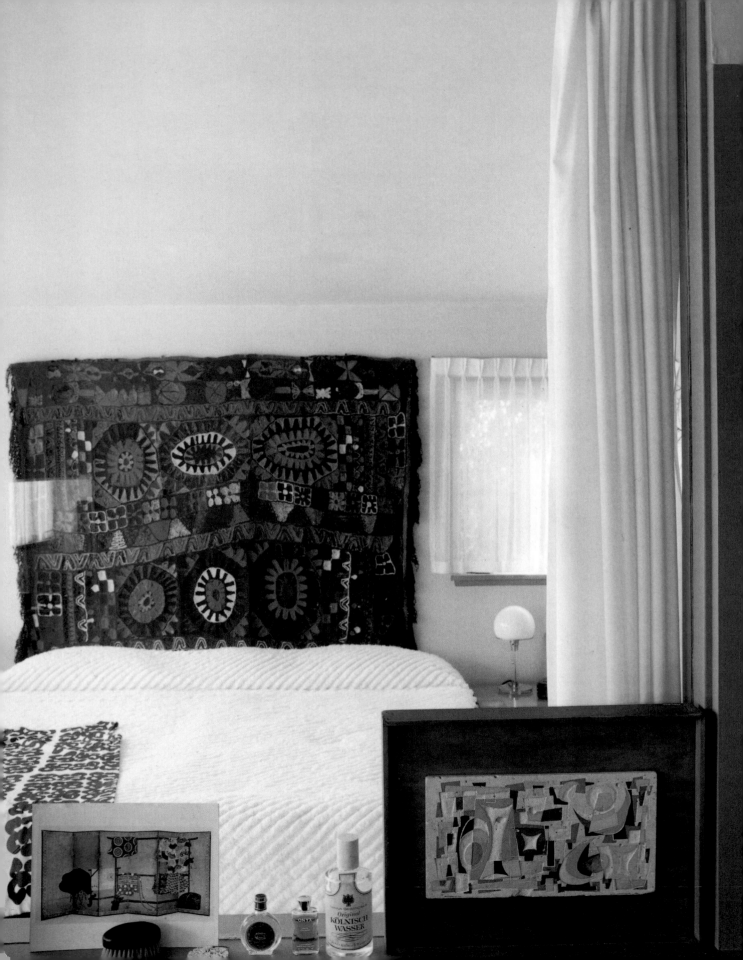

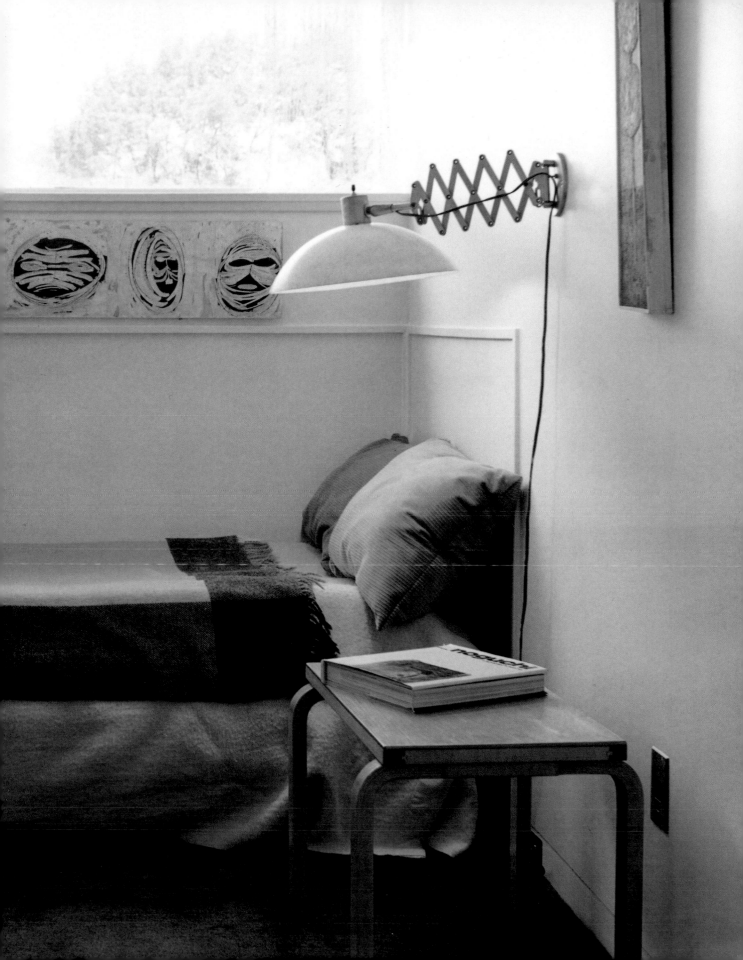

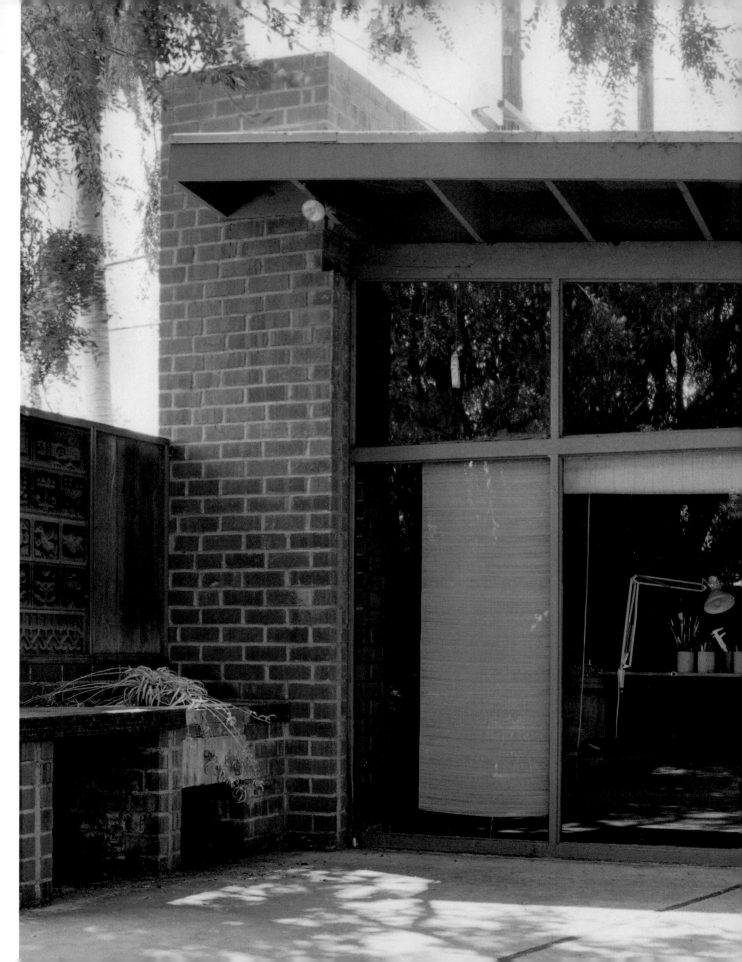

JEROME & EVELYN ACKERMAN

CULVER CITY, CALIFORNIA

W hat would it be like to go to the museum one day and have your life changed forever? This is what happened to Jerome (b. 1920) and Evelyn (b. 1924) Ackerman on a trip to the Detroit Institute of Arts in 1949. They went to see "An Exhibition For Modern Living" organized by Alexander Girard, and by the time they left, they were inspired to embark on a life in design. "That exhibit really changed our way of thinking," Jerome Ackerman—or Jerry, as he is known to friends and family—told me. "We saw the Eameses doing it, and we thought, why not us?" With their companies Jenev and later ERA Designs, the Ackermans made a life for themselves designing affordable modern products for the home. They specialized in decorative wall accessories in a variety of materials including mosaics, wood carvings, silk screens, tapestries, cabinet hardware, and ceramics. Over the course of the fifty-plus years they have lived in their home in Culver City, California, they have customized it with the fruits of their labors.

The first time I walked into the Ackermans' modest bungalow, I may have come across as a little rude. The Ackermans met me at the door and they had barely said hello when I caught a glimpse of their carved wood *Signs of the Zodiac* (1964) lining the bottom of one of the kitchen walls, and I shot straight into the kitchen. I had never seen the carved wood panels in person before and became perhaps overly exuberant inspecting Evelyn's whimsical illustrations—I was practically on my hands and knees! Fortunately, the Ackermans were pleased by my keen interest. Across from the wood panels are a small Saarinen-inspired kitchen table and more ERA-designed cabinet hardware. Entering the living room I passed one of Evelyn's tapestries, *Cat & Bird* (1962), in a wonderful bright pink that complemented the cherry red of the couch. The furniture in the living room is by a veritable who's who in modern furniture design—with a few curveballs thrown in. A Nelson Bench (1946), Hans Wegner's sewing table (1950), and Mies van der Rohe's Barcelona chair (1929) sit among lesser-known examples of modern furniture—all of which prove the Ackermans' impeccable eye for good design. The light hanging over the Barcelona chair, by the Dutch company Raak, used to hang in the Ackermans' showroom years ago and they liked it so much they brought one home. On a small one-of-a-kind mosaic table made for Jerry's mother perches a wonderfully expressive bust of a forlorn man carved in wood, a gift from a college beau of Evelyn's. The design studio, located off the living room, was added on in the 1960s, and its wall of windows makes it an ideal place to work. Evelyn did much of her designing at the wood drafting table next to the window. The studio is brimming over with files, drawings, ERA products, and antique dolls and toys, another of Evelyn's areas of expertise.

Walking down the hall I peeked in a small bedroom and saw one of the most perfectly designed twin beds I have ever seen. Jerry and Evelyn Ackerman were amused by my enthusiasm for it as I started peppering them with questions about it—Who made it? Was it their daughter's childhood bed? (Hagen & Strandgaard, and yes, it was their daughter's bed.) This is what the whole house was like—one discovery after another of little-known designers.

On my last day of shooting, the Ackermans took me to their favorite noodle house for dinner. Sitting across from this lively couple and hearing stories about their years in design and their career retrospective at the Mingei International Museum in San Diego, it struck me what the perfect term would be for the Ackermans' home and their work: Warm Modernism.

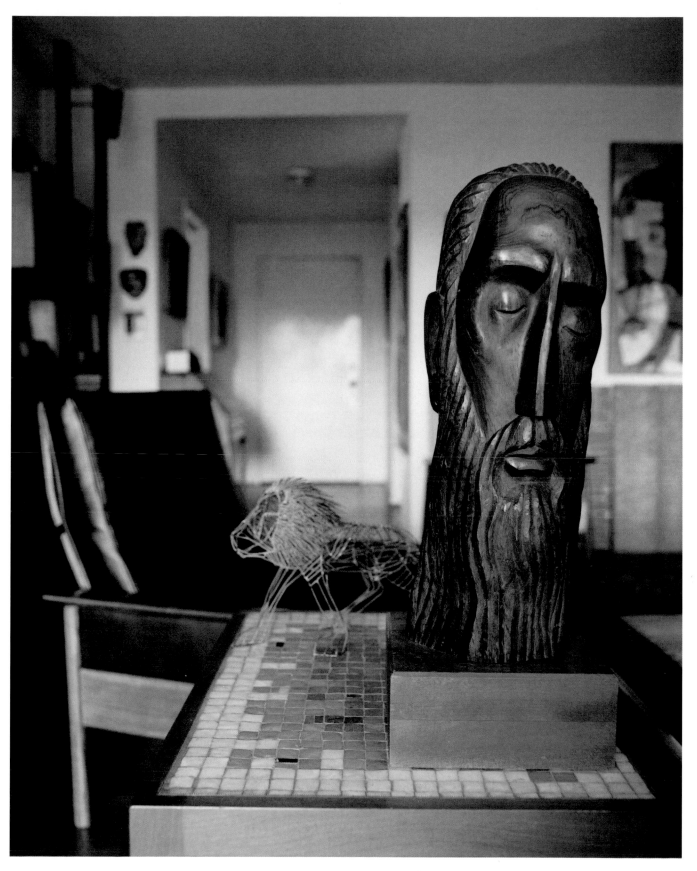

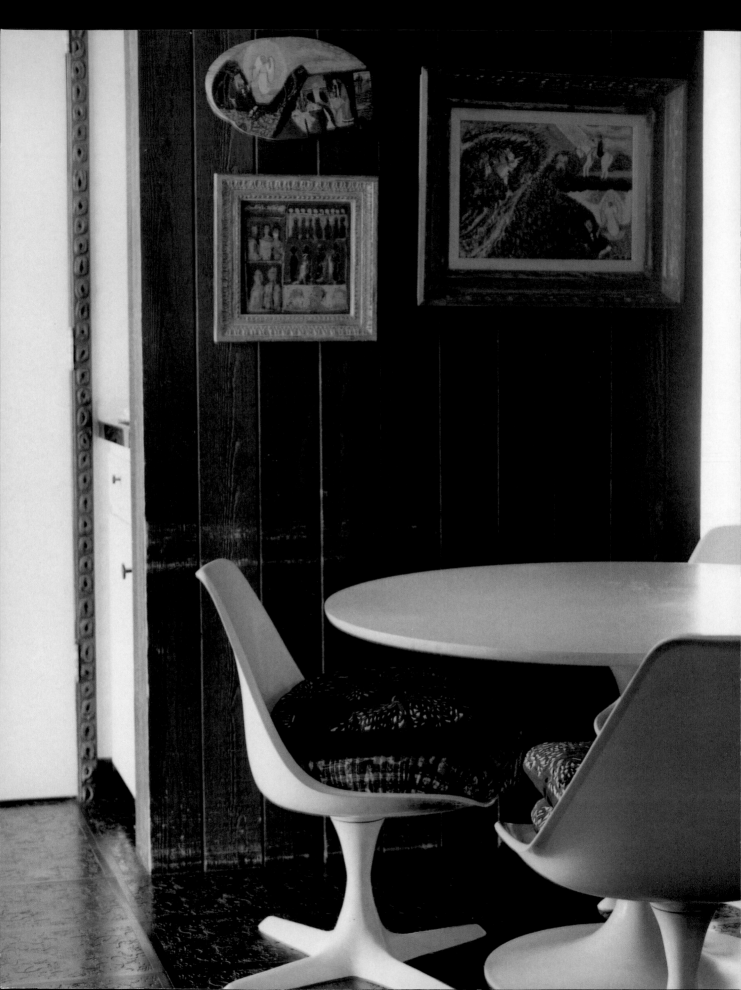

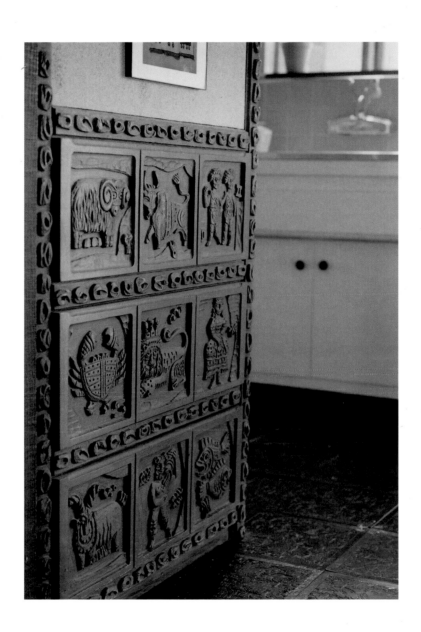

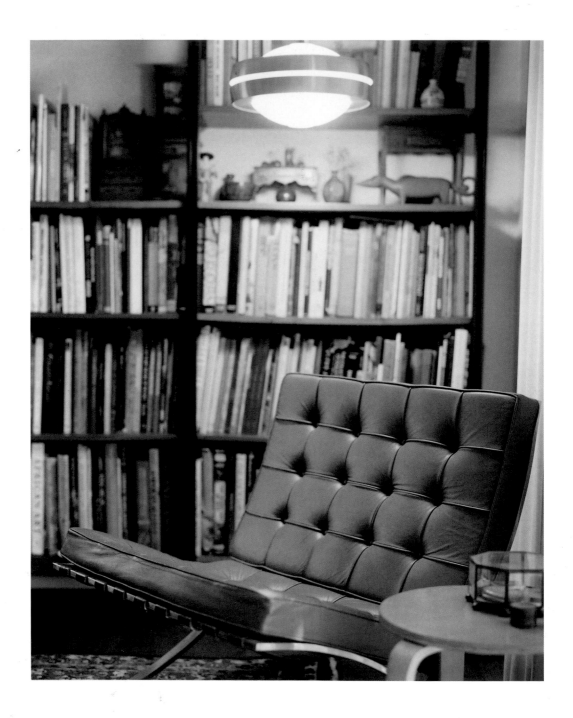

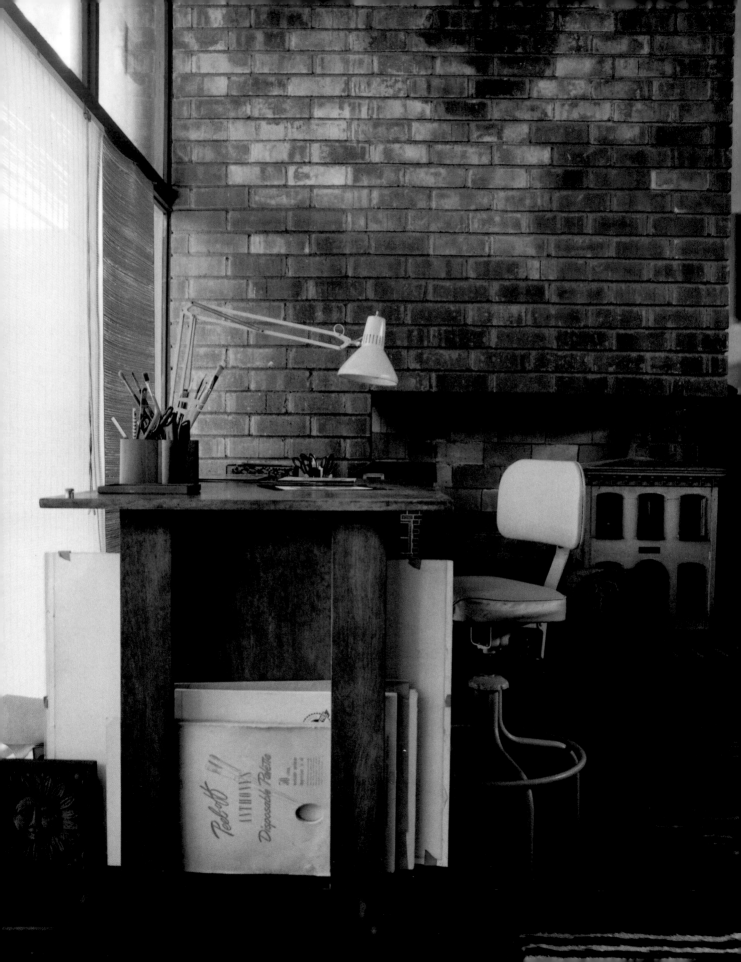

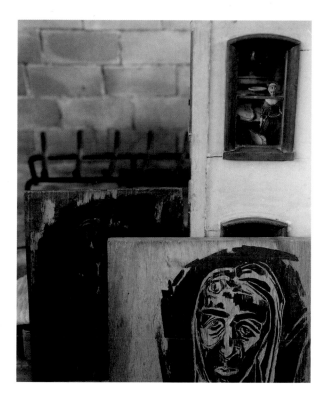

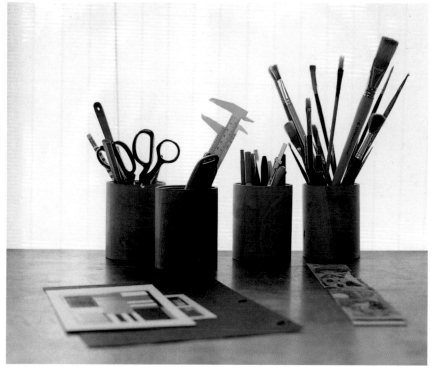

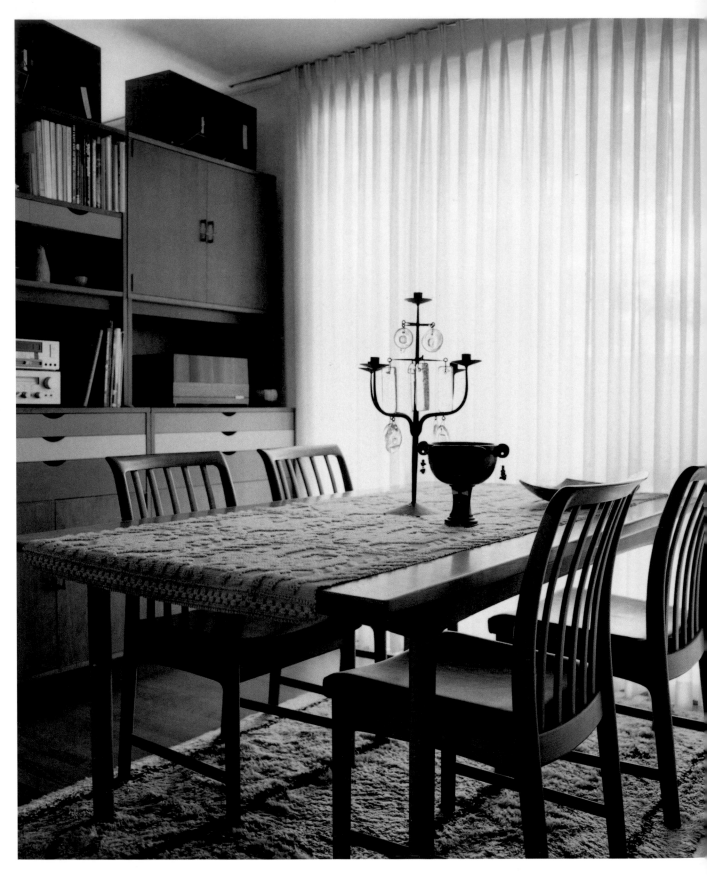

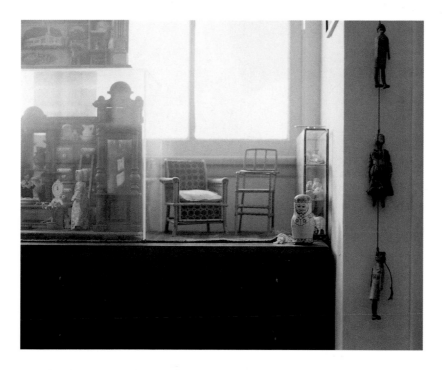

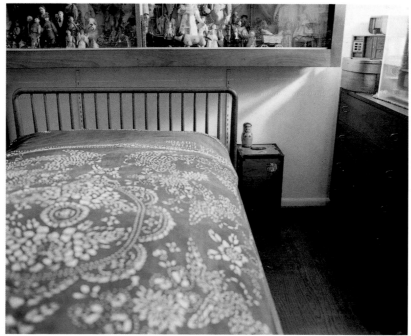

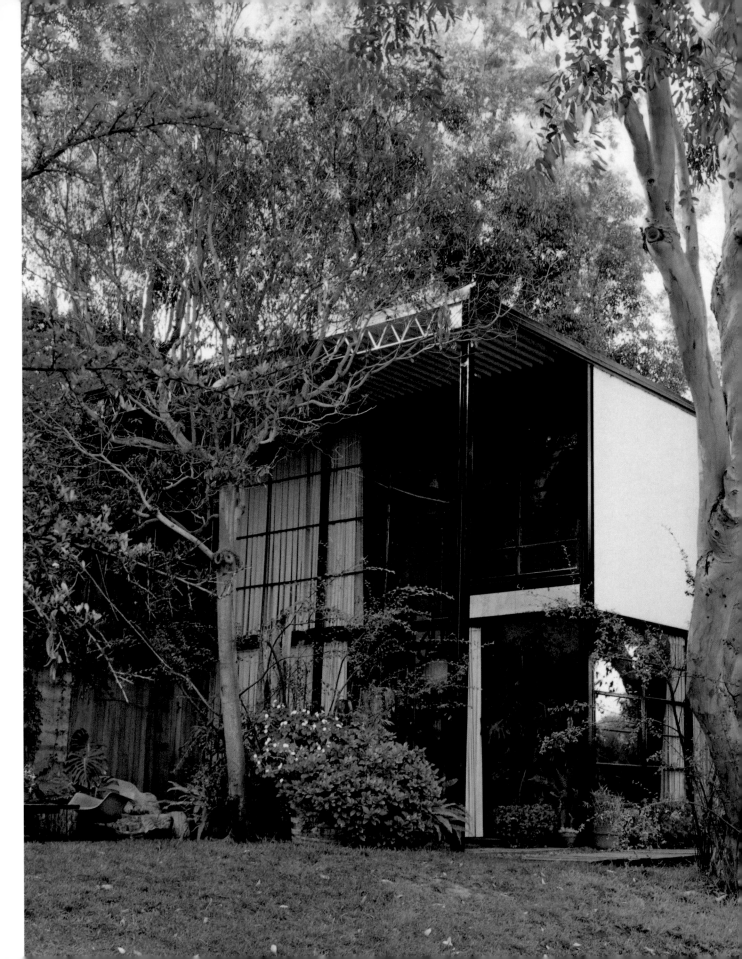

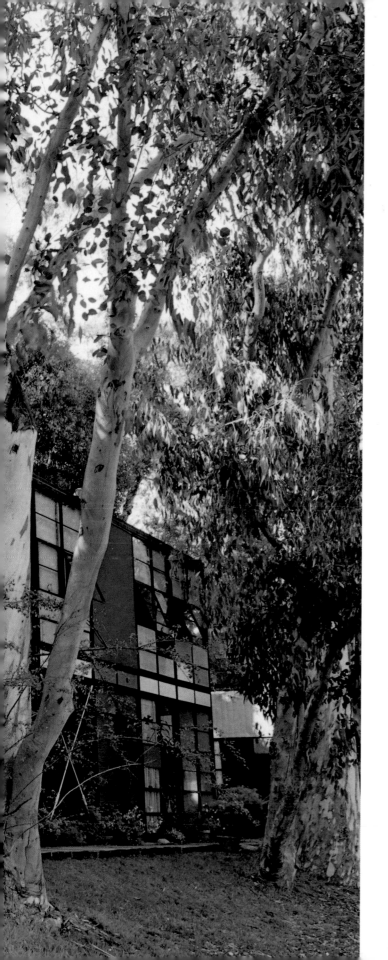

CHARLES & RAY EAMES

PACIFIC PALISADES, CALIFORNIA

The Eames House, also known as Case Study House No. 8, is a modern-day treasure chest overlooking the Pacific Ocean. It is not an exaggeration to call the house a modern icon—as were its designers and inhabitants, Charles (1907–1978) and Ray (1912–1988) Eames. When I first embarked on this project, I had no intention of photographing it. I thought everyone had seen the house, and there was no need to photograph it yet again, but how wrong I was! With a little internet and library research I realized the interiors have rarely been photographed. So I began my long journey to get inside the Eames House and photograph all of its rich details.

The house is filled with the Eameses' furniture designs, books, and collections of objects, all bathed in sunlight. The warmth of the midday sun in the main living room makes it very inviting. If I was there as a guest, I would not have been able to resist curling up on the couch with a book from their bookshelf. Their collection of books is so wide-ranging in subject matter that I became distracted browsing the shelves—*A History of Fireworks* (1949), artist monographs on Isamu Noguchi, Henry Moore, and Alberto Giacometti, books on dolls and folk toys, and *A Computer Perspective* (1973), among others. An African footstool in the shape of a hippo sits next to the second Eames Lounge Chair (1956) off the production line (the first went to director Billy Wilder). A democratic mix of tribal and native art and textiles testifies to the Eameses' omnivorous love of all design. I had heard stories about what a voracious collector Ray Eames was, and evidence of this abounds throughout the house. Three leather headrests for a geisha are paired with other figurines from Asia on the bookcase, and a low marble table is devoted entirely to black-and-white objects, both natural and man-made. Ray Eames layered textiles in the same hodgepodge style. When I looked at the different patterns and colors of the numerous rugs, blankets, and pillows, I could never have imagined that they would sit so harmoniously together—but they do! Animal prints, Americana quilting, and American Indian rugs look as if they were made for each other. Each area of the house appears to be conceived as an intricate still life. The kitchen speaks to Ray Eames's devotion to everyday objects with blue-and-white porcelain in every possible pattern, American Indian art, and a tower of tea and its accoutrements at stove-side. Inside a seemingly innocuous occasional table reside canisters full of the Eameses' films and cookbooks, almost as if they were stashed there haphazardly until a better storage place could be found.

The second floor of the house was the Eameses' private zone, and thus few photographs exist of this area. Heading up the spiral staircase a small abstract painting by Ray Eames hangs just beyond view of the front door. When the house was built in 1949, the entire frame was put up in a day and a half from prefabricated steel, and at the top of the stairs I was able to get a closer look at the metal beams and corrugated roof that made this house so remarkable. The second floor consists of a sleeping area that can be divided into two parts, a dressing area, and his-and-hers bathrooms—Ray's with a tub and Charles's with a shower. Their bedroom, though surprisingly small, opens up to the downstairs like a balcony.

It dawned on me as I packed to leave that the true treasure here is not just this house and its contents, but the insatiable appetite for discovery that they signify. Charles and Ray Eames seemed to figure out a way to maintain a childlike wonder throughout their lives and their home is a testament to this dedication to discovery.

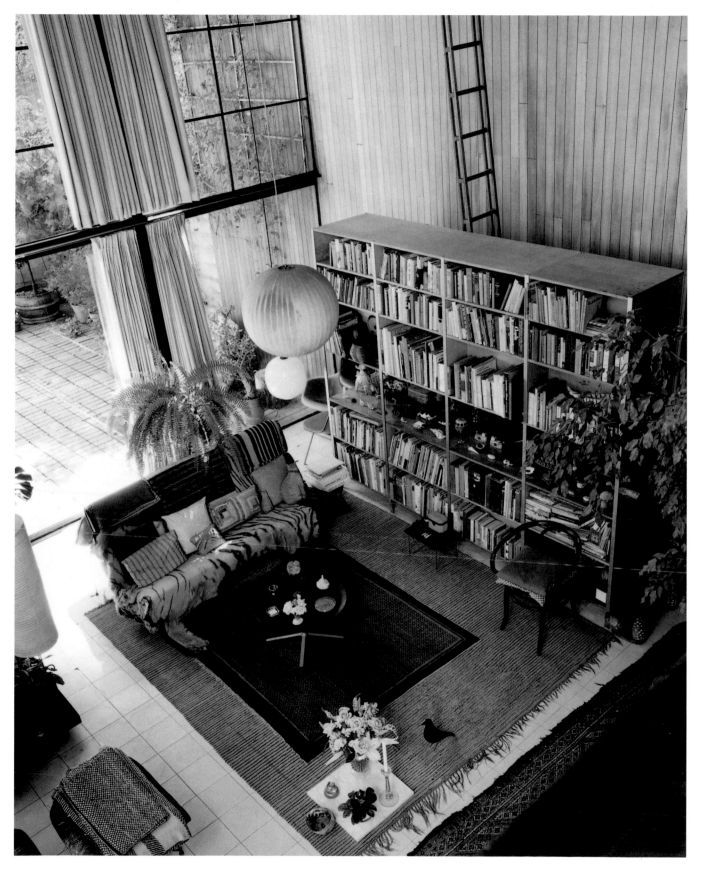

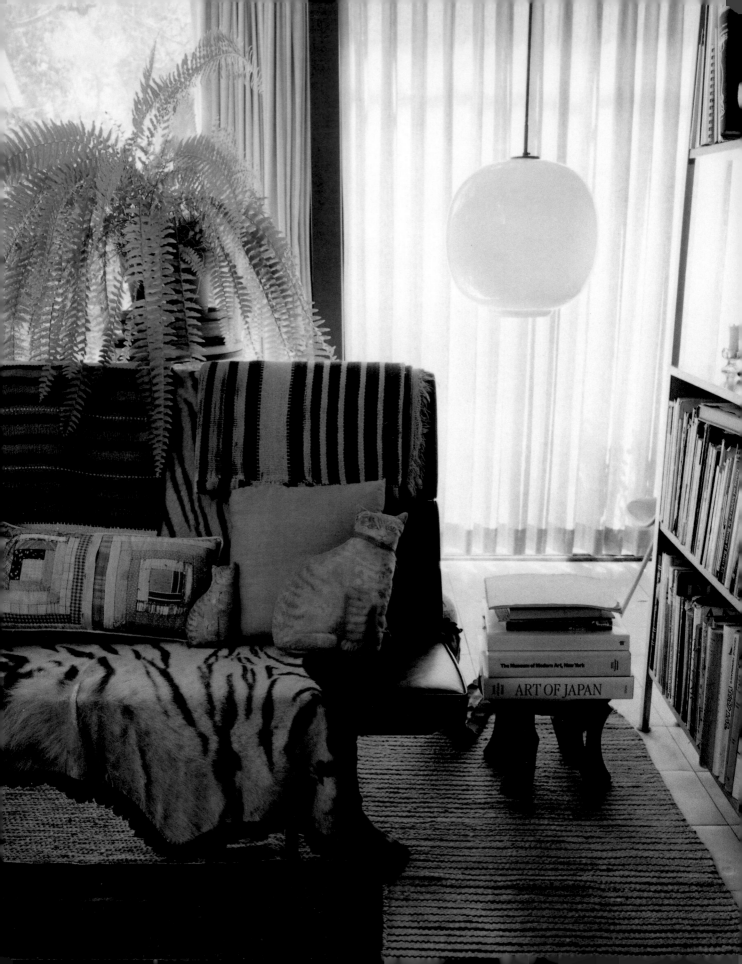

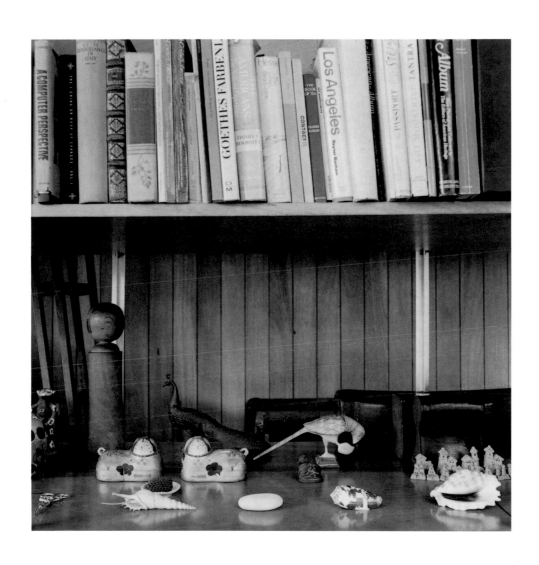

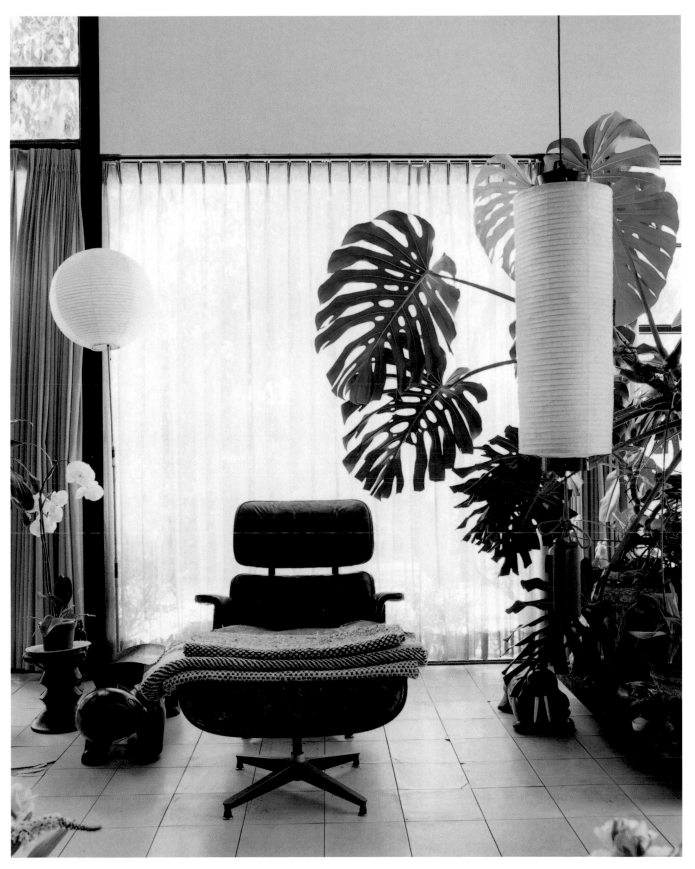

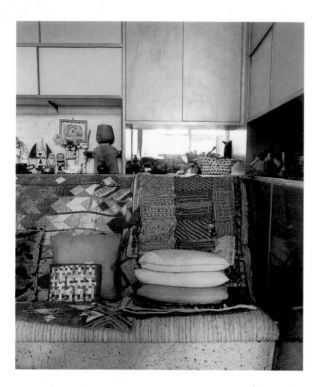

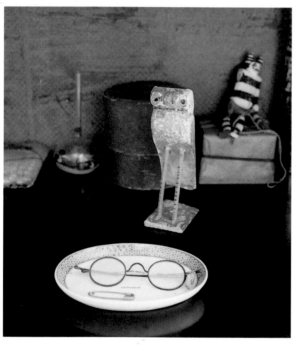

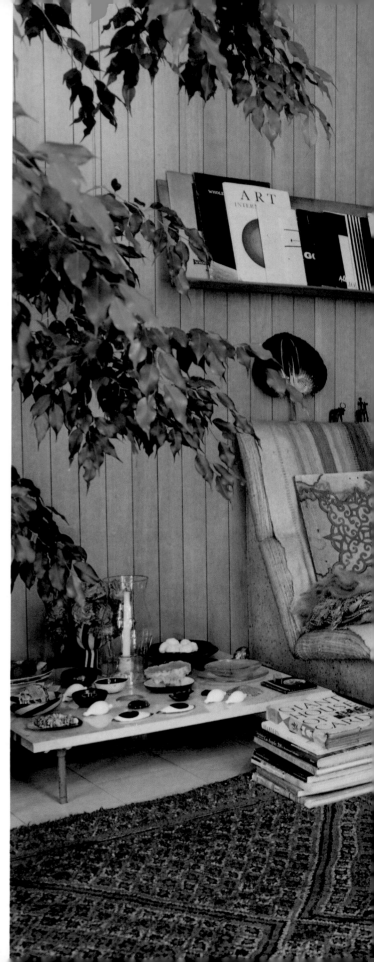

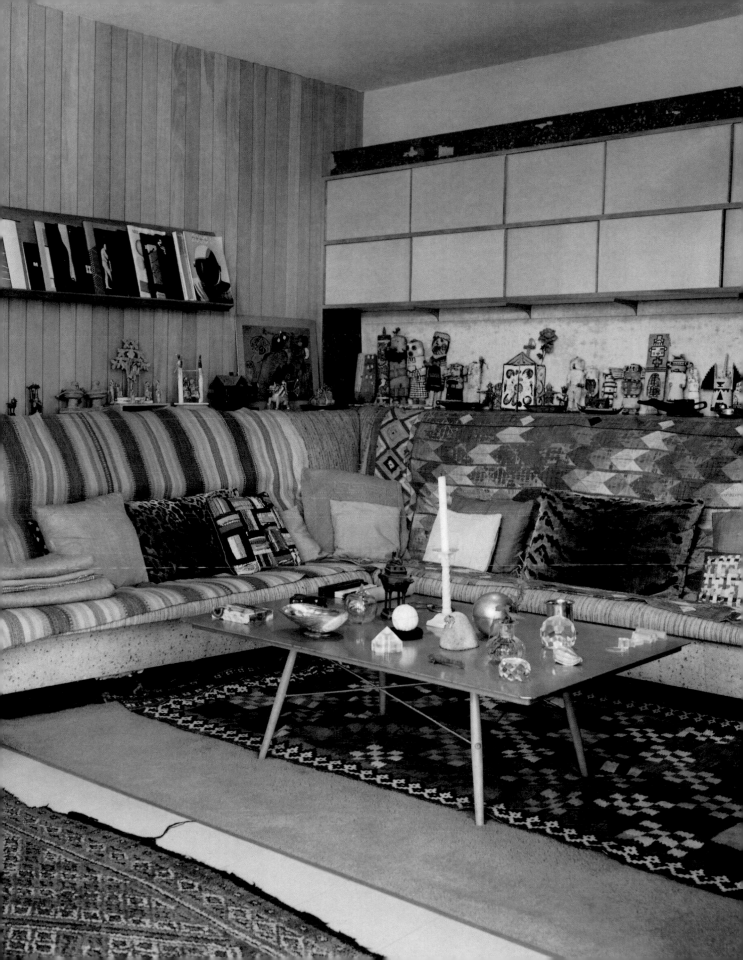

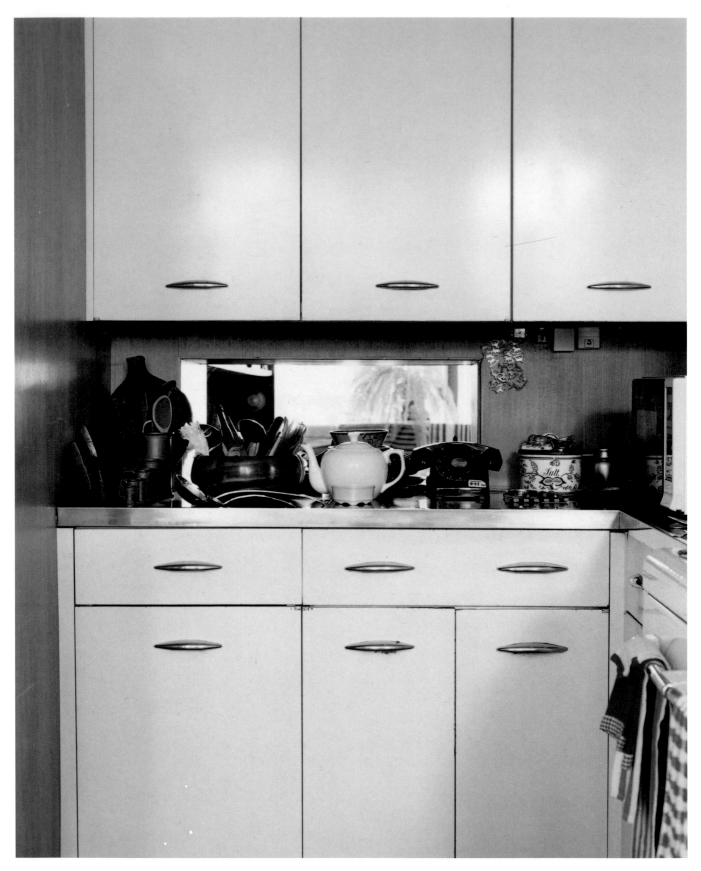

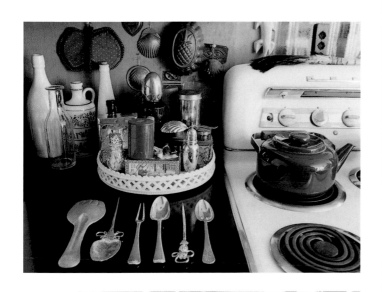

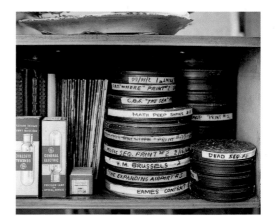

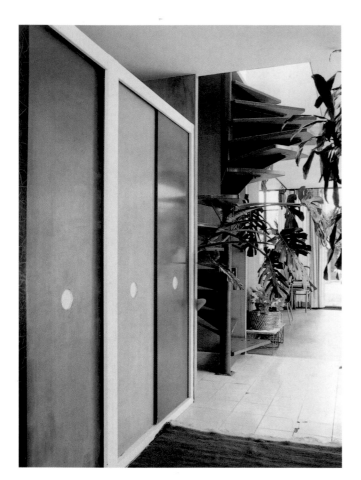

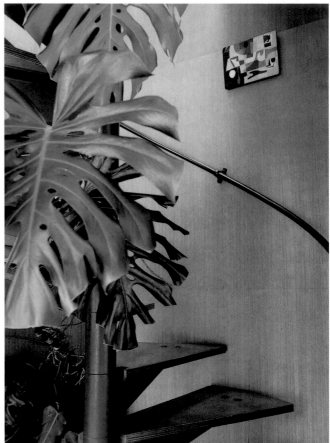

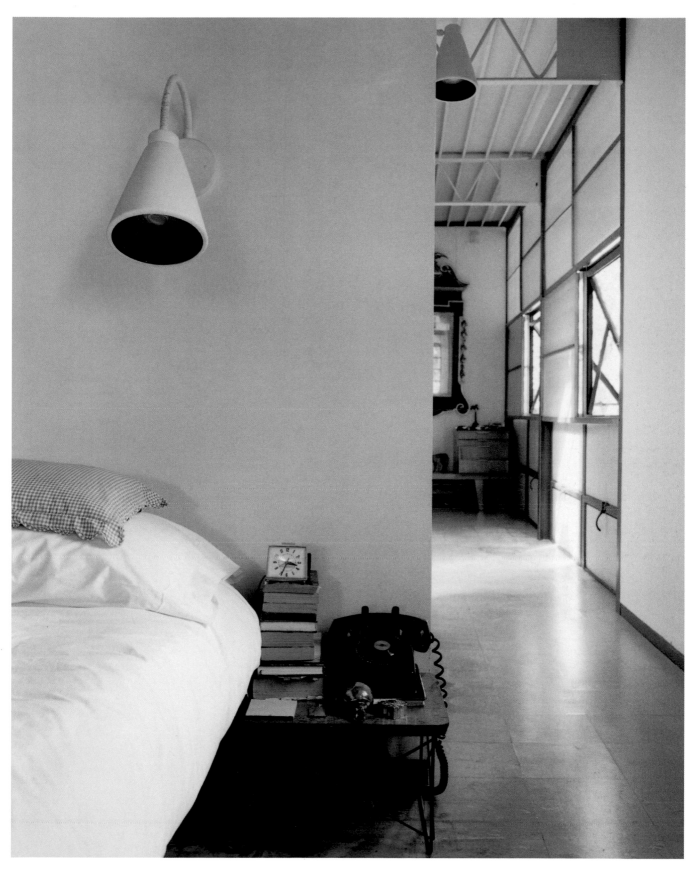

CHARLES & RAY EAMES 177

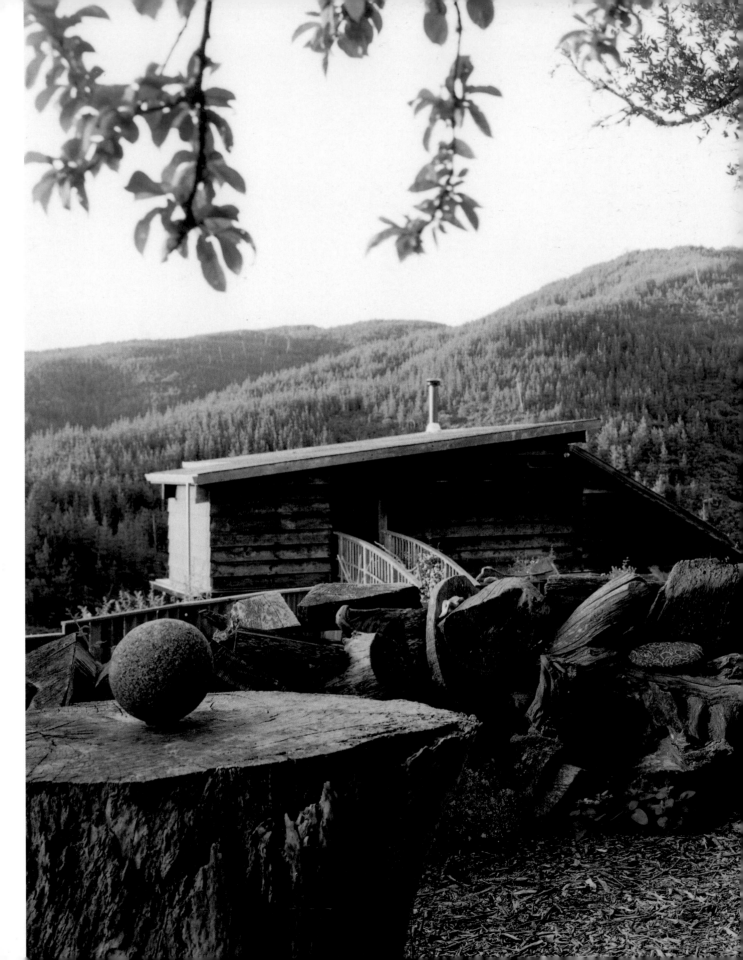

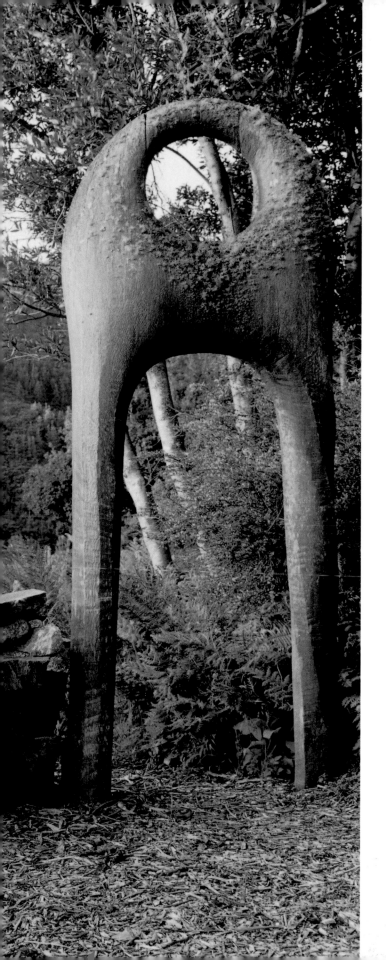

J. B.
BLUNK

INVERNESS, CALIFORNIA

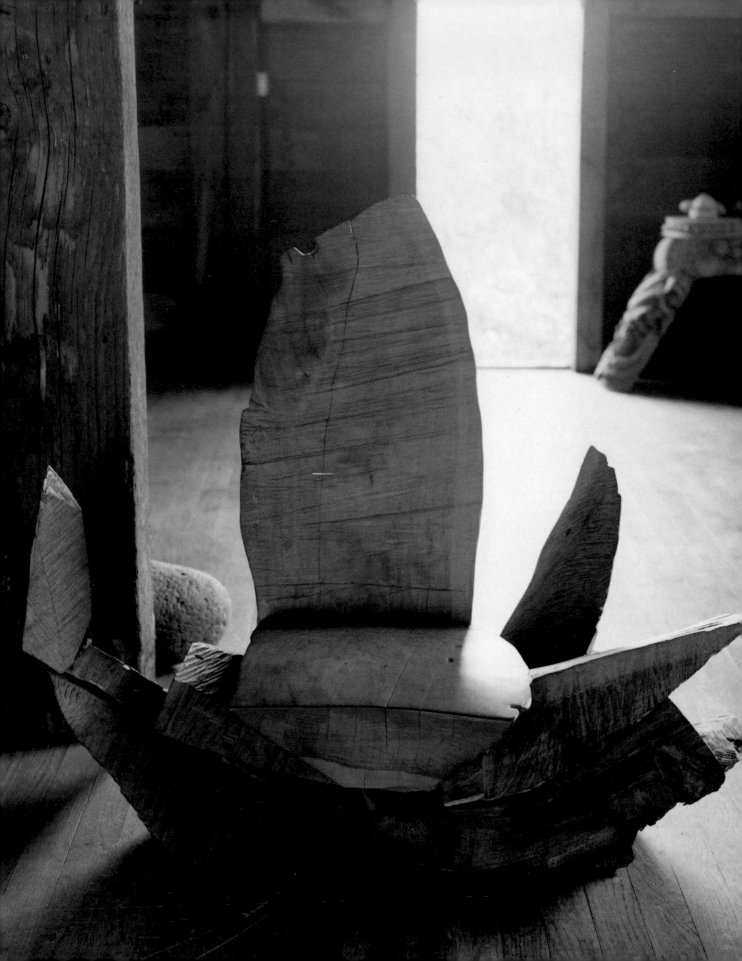

I am completely biased when it comes to J. B. Blunk (1926–2002) and his home. Come to think of it, that is true of every home in this book, but Blunk is a more acute case, because this is the only home in which I stayed. Currently run as an artists' residency, Blunk's daughter, Mariah Nielson, allowed me to stay one night because I was photographing the exterior of the house at sunrise the next day. Thus, I experienced it in a much more intimate way. The house itself is essentially a modernist cabin—the shape of the structure is simple and linear but the materials are raw and rustic. A basic one-room plan with a small loft and a bathroom off to the side, it is sparsely furnished, mostly with furniture made by Blunk himself. All the wood for this house was picked up from local beaches over four years because Blunk and his wife were strapped for cash, and the doors and windows were salvaged locally. It took them from 1959 to 1963 to complete building it, and the sum of these salvaged and found parts is one of the most serene and calming places in which I have spent time.

The first thing I noticed upon entering the house is Blunk's "scrap chair." Made out of offcuts from another sculpture, it appears almost like a child's chair because it is so diminutive and close to the ground. From the main room I caught a glimpse of the hand-carved redwood sink in the bathroom off to my right, and I immediately felt compelled to go and run my hand along the ridged edge. The bathroom is where I fully understood how completely the house was built from found materials. The ceiling and walls are a pastiche of different woods, mostly untreated with the exception of a part of the ceiling that has some whitewashed boards. The bright red of the stained-glass window above the sink plays off the textiles and even the plants in the room. When I looked at the stained-glass window more closely, it became apparent that it is probably half of the original window and has been abbreviated to be the desired size.

The main room is arranged simply—no doubt influenced by Blunk's years in Japan studying pottery— and in it sits only furniture, art, and natural objects found in the surrounding land. The art is not all by Blunk, though. A delicate music scale sculpture in the bathroom is by former assistant Rick Yoshimoto, and to the left of the kitchen sink hangs a mask given to Blunk by his longtime friend and mentor Isamu Noguchi. Up the ladder in the second-floor bedroom, added in 1985, is a massive assemblage desk by Blunk, which dominates half of the room. The other half is a wall of windows overlooking miles of trees and the Tomales Bay.

This is the room that I woke up in on the morning before my sunrise shoot. At one point on my second day of photographing, I became mesmerized by a red-tailed hawk that appeared to levitate outside these windows. Right at eye level, it was floating on the wind currents on what seemed like an endless ride. An antique bed is positioned right next to the windows so the first thing I saw in the morning was the incredible view. When I woke up here, it was still dark and in my rush to get the perfect shot of the exterior of the house, I almost missed the sun just starting to rise above the bank of fog sitting on the bay miles below. As I turned around before trudging out the door, I took a quick photo with my iPhone. I still have that shot as my screen saver. It is by far the best place I have ever woken up.

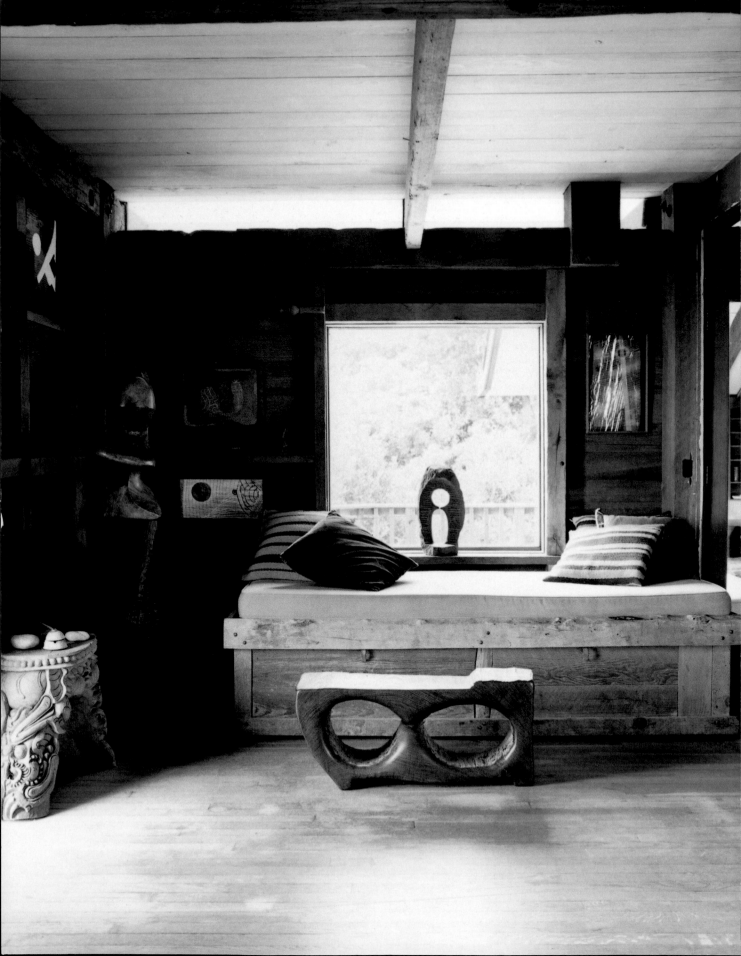

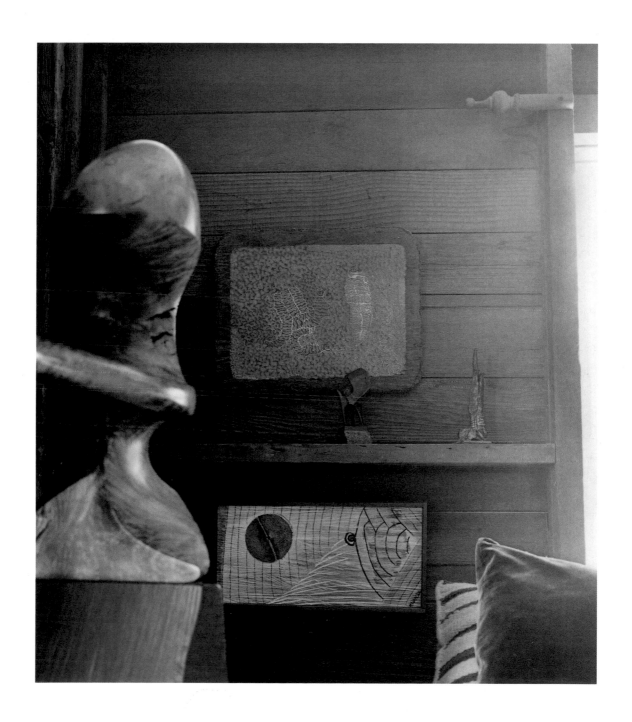

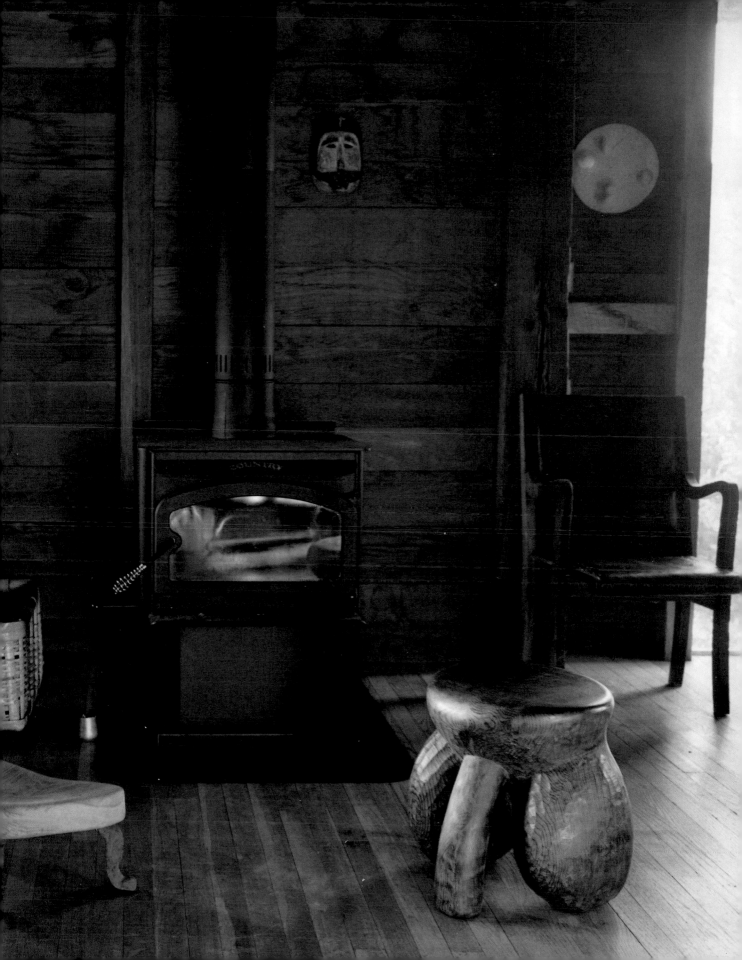

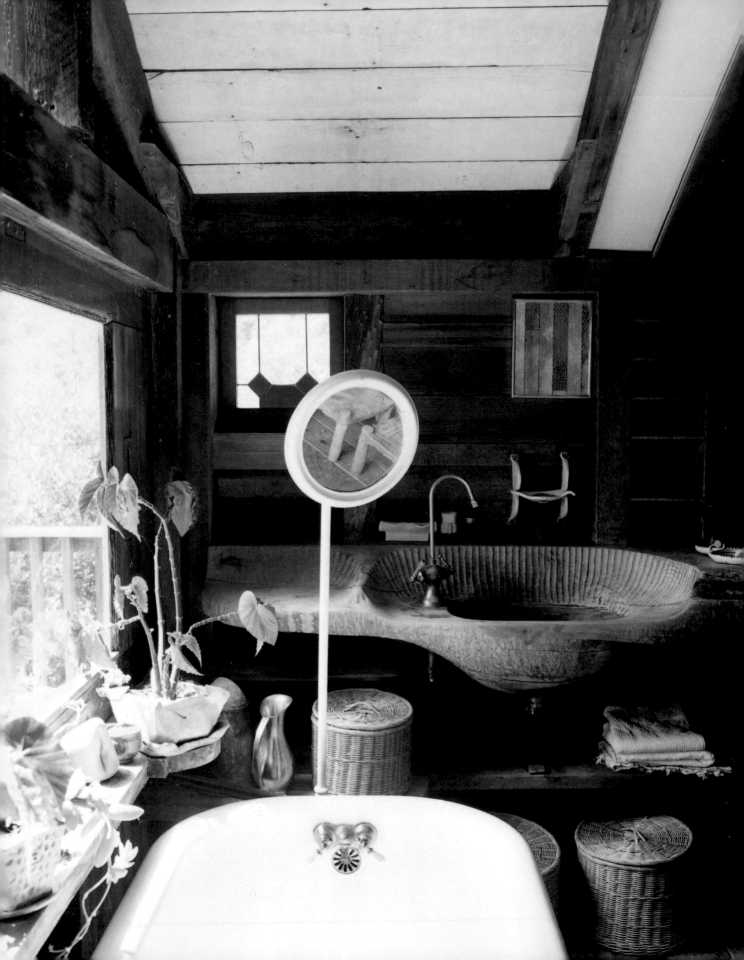

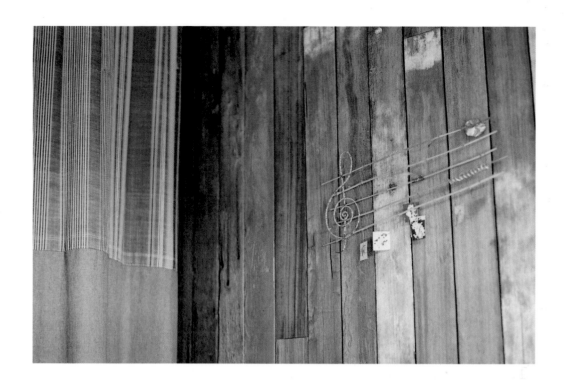

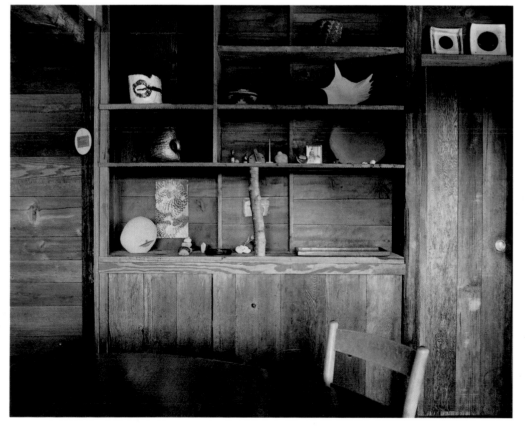

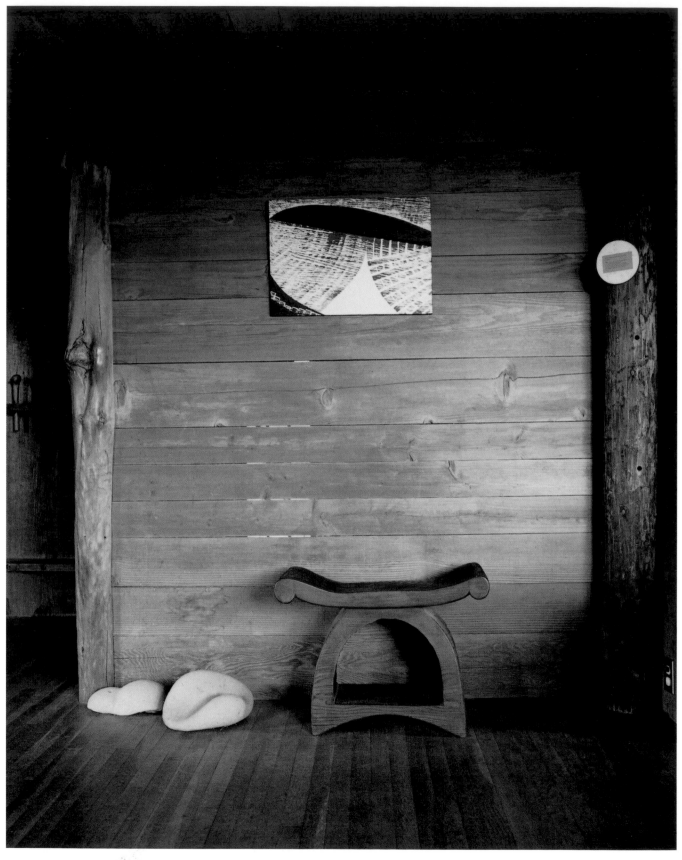

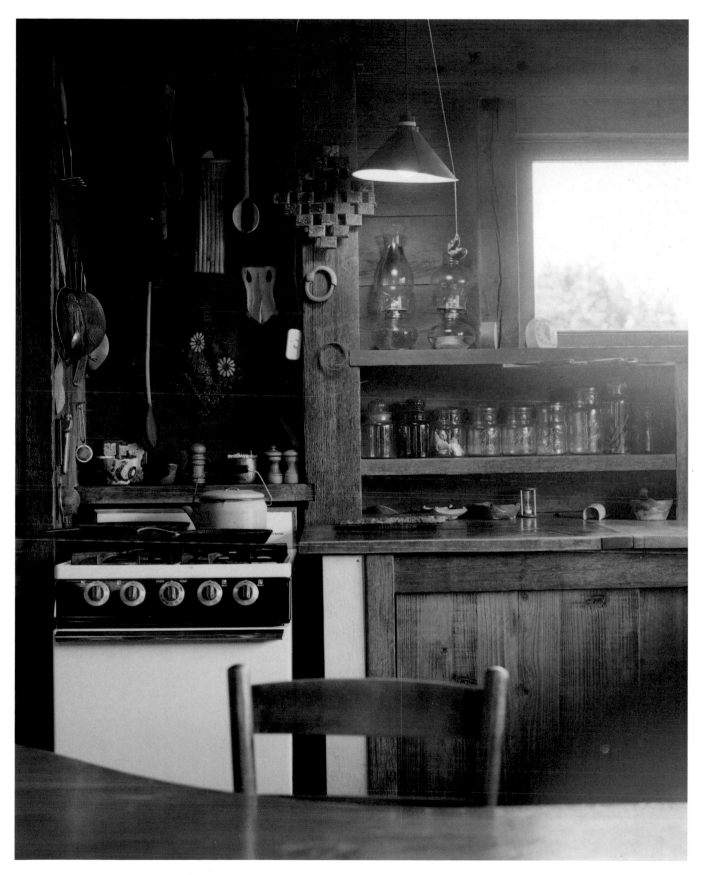

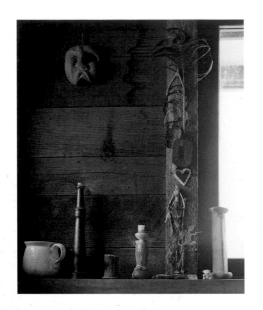

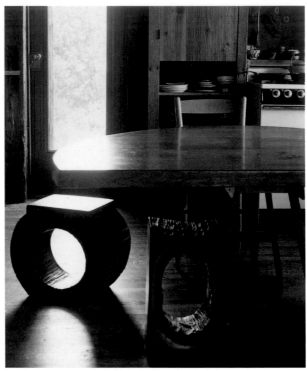

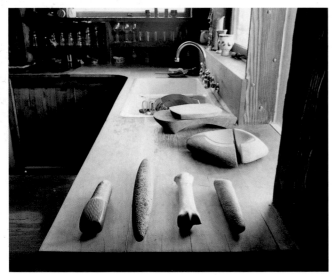

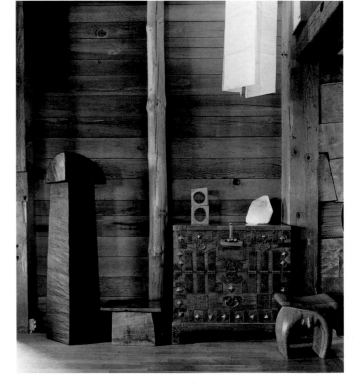

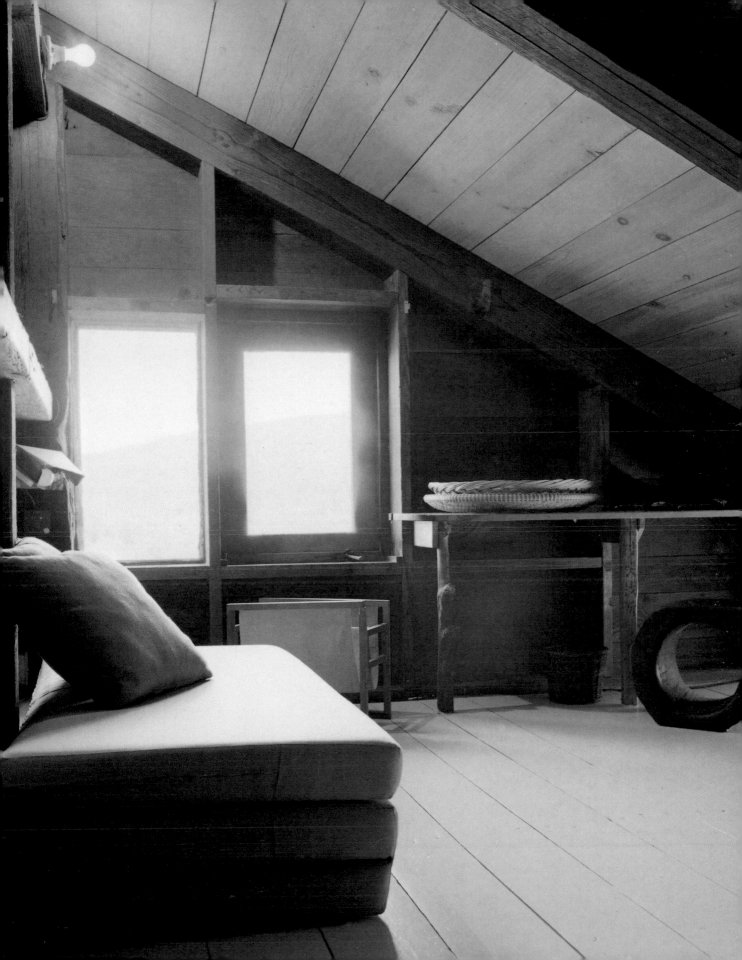

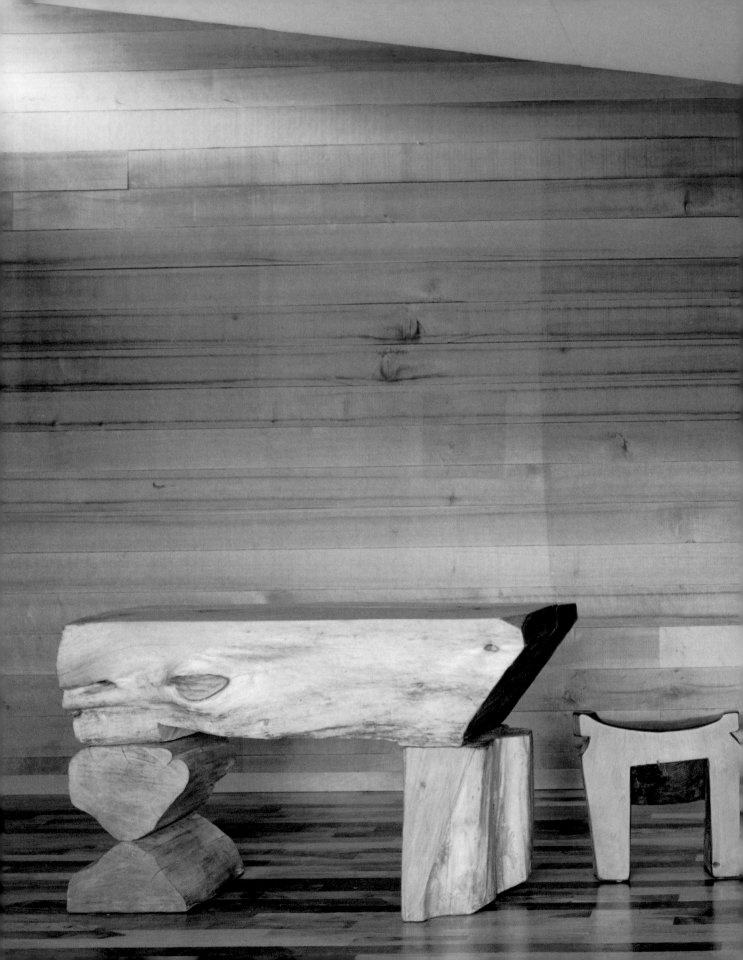

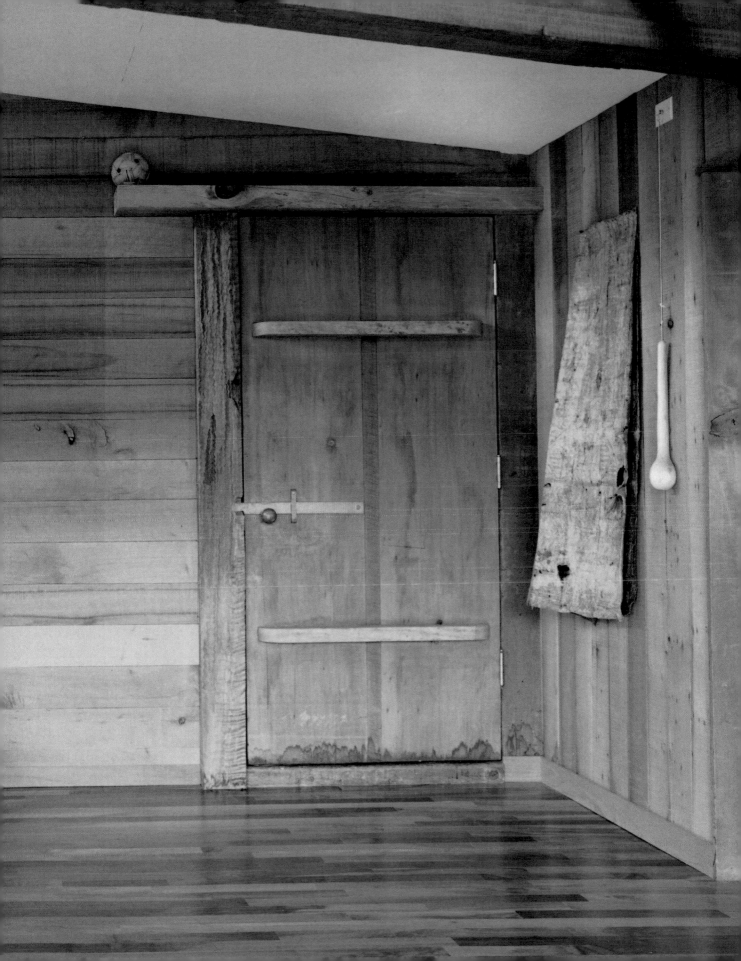

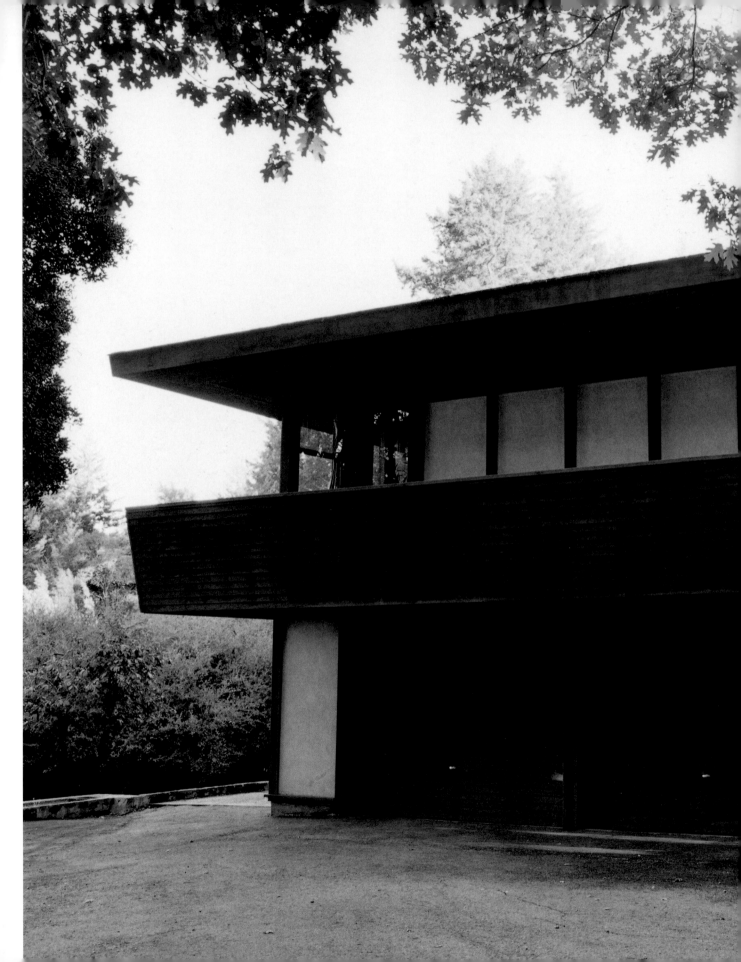

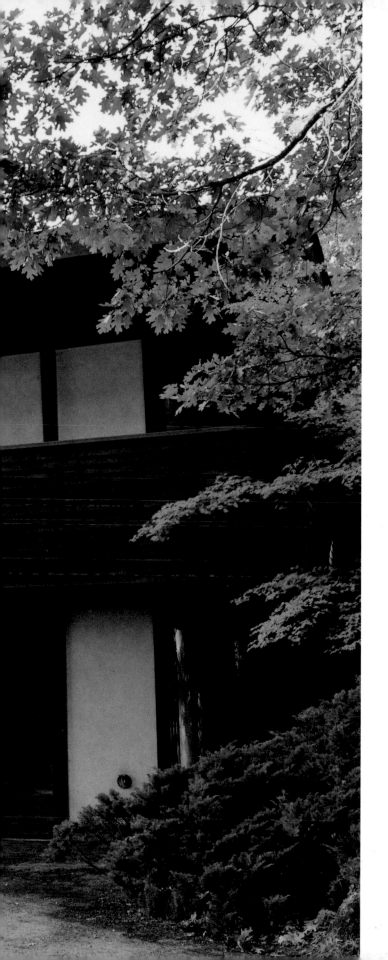

JOHN KAPEL

WOODSIDE, CALIFORNIA

The first time I went to John Kapel's home, I became obsessed with how he camouflaged his toaster. He disguised it so it could not be seen while sitting in the small cabinet that hangs on the wall of his dining room (pg. 202). What a brilliant solution, I thought! There are certain necessary items in our everyday lives that are eyesores, and usually, if you are like me, there are two ways to deal with it: keep it put away except when in use or leave it out and live with it. Kapel's skills as a woodworker and metalsmith made it possible for him to deal with these daily visual blemishes in a third way, by constructing something to disguise it in plain sight and make it beautiful at the same time. His home is chock-full of these little details. Kapel and partner Jerry Weiss designed and built the house in 1959, and Kapel has been fine-tuning the interior to suit his needs ever since.

His is not a name widely known beyond furniture design aficionados, but from the 1950s to today, John Kapel (b. 1922) has been designing prototypes for furniture companies—most notably, Glenn of California and Brown & Saltman—as well as making artwork and one-of-a-kind furniture by commission in his basement workshop. His home is a testament to his master craftsmanship and attention to detail. Looking around, it is hard to identify a piece of furniture in the house that he did not make—the built-in units, the dining table, the high-back chair, even many of the small lamps, and a majority of the artwork are his. The most notable exceptions would be the Hans Wegner dining chairs (Wegner was a friend from his time in Denmark learning metalsmithing), and the terra-cotta sculptures by his wife, Priscilla. Two of the most distinctive pieces of furniture, the small hanging cabinet in the dining room that holds the toaster and the large built-in wall unit in the living room, incorporate antique Japanese bookplates into the design. Kapel mentioned to me that the small hanging cabinet will be in the Los Angeles County Museum of Art's collection and that he has to make something to go in its place. That is how finely tuned his home is—that cabinet was made for that wall, and the wall should not be without a piece like it. To Kapel the wall would not make sense without it. As he explained to me, "Living is in the details, that is what I always say!"

Truer words could not be said of his work or this house. The closer I looked, the more I realized how precisely designed and arranged his home is. On first glance, the wood backsplash in the kitchen appears to be merely beautiful wood detailing, but when I saw it out of the corner of my eye, it turned into a sun, its rays stretching the length of the counter. Even the can of Comet cleanser that sits on the sink has been altered to meet Kapel's specifications. "That was slippery for me!" Kapel responded when I asked. He wrapped the can in sandpaper, making it less slippery and also creating a Morandi-like still life on the kitchen counter. As with the toaster cover in the dining room, with a little attention and thought—and a lot of talent—everything can be beautiful. In Kapel's home, it is.

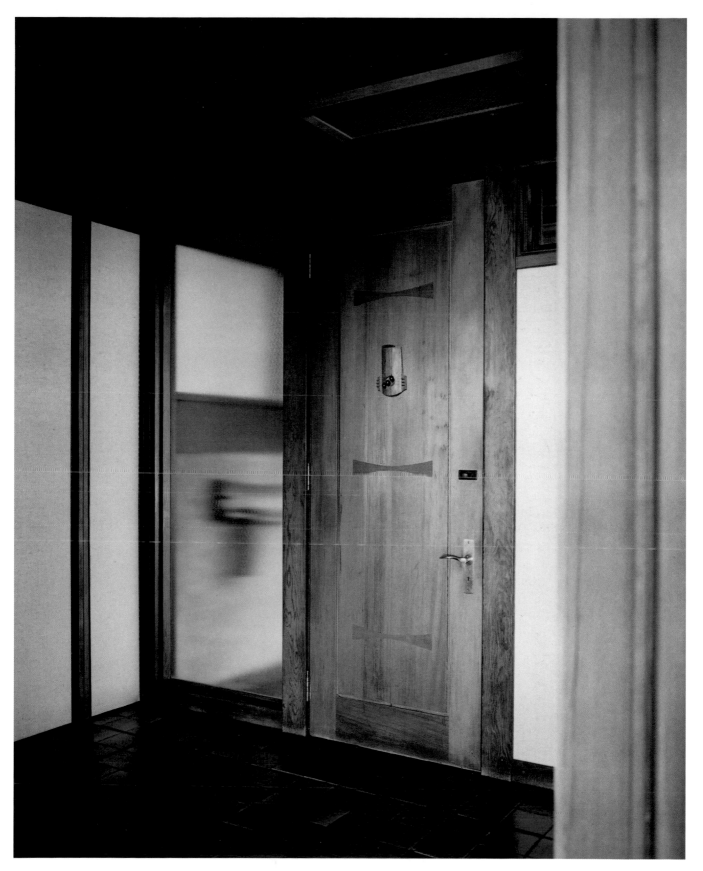

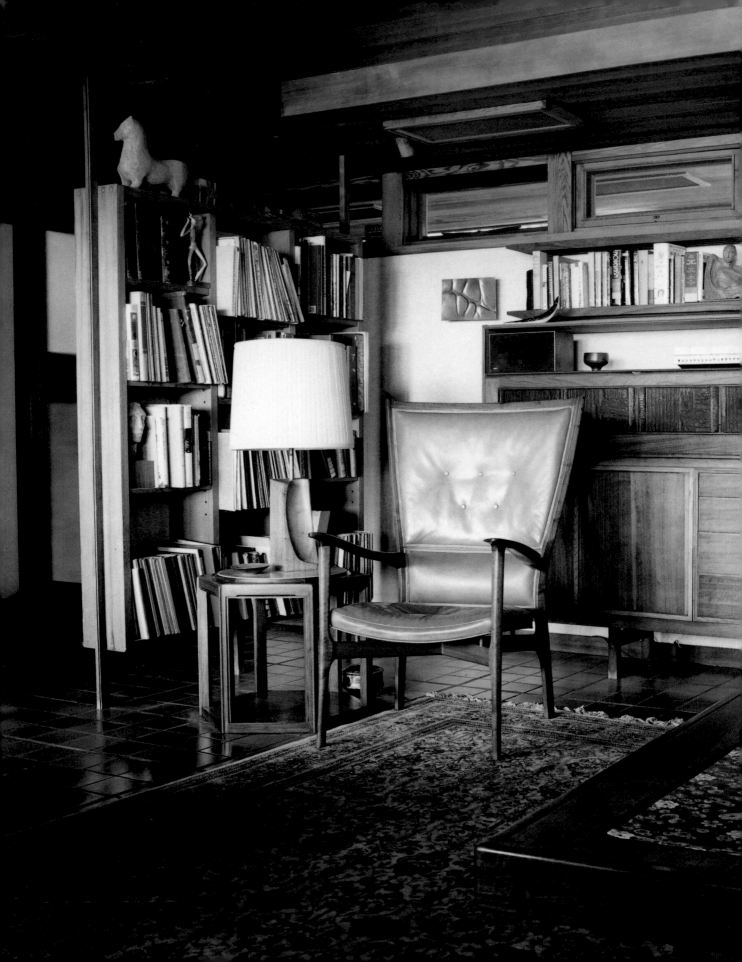

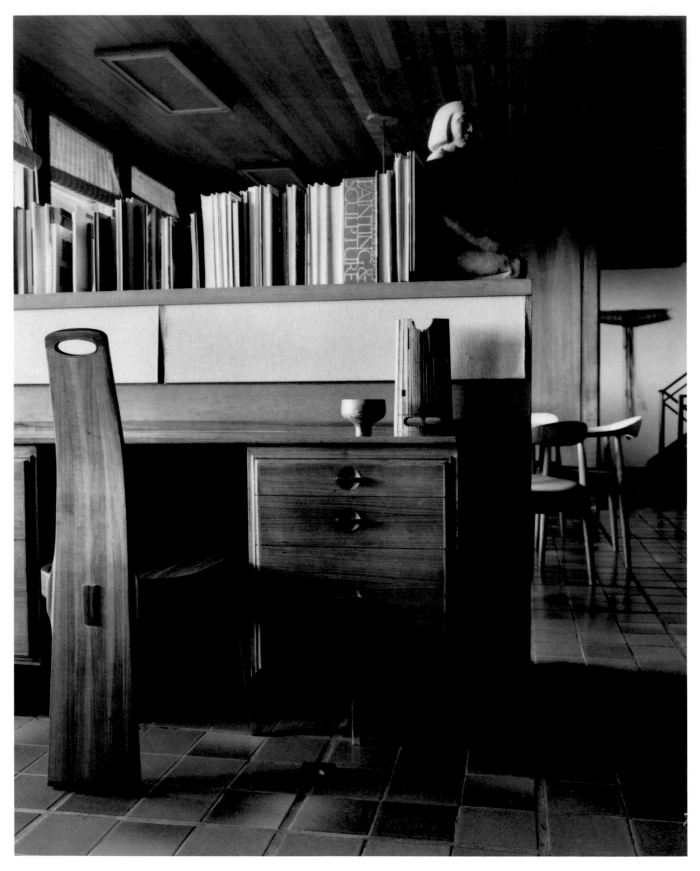

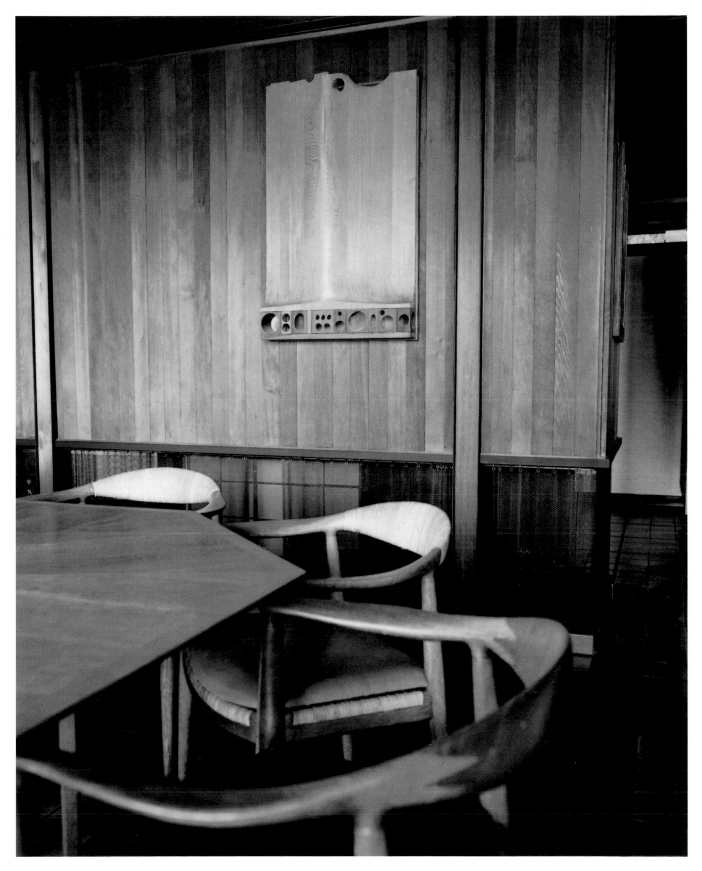

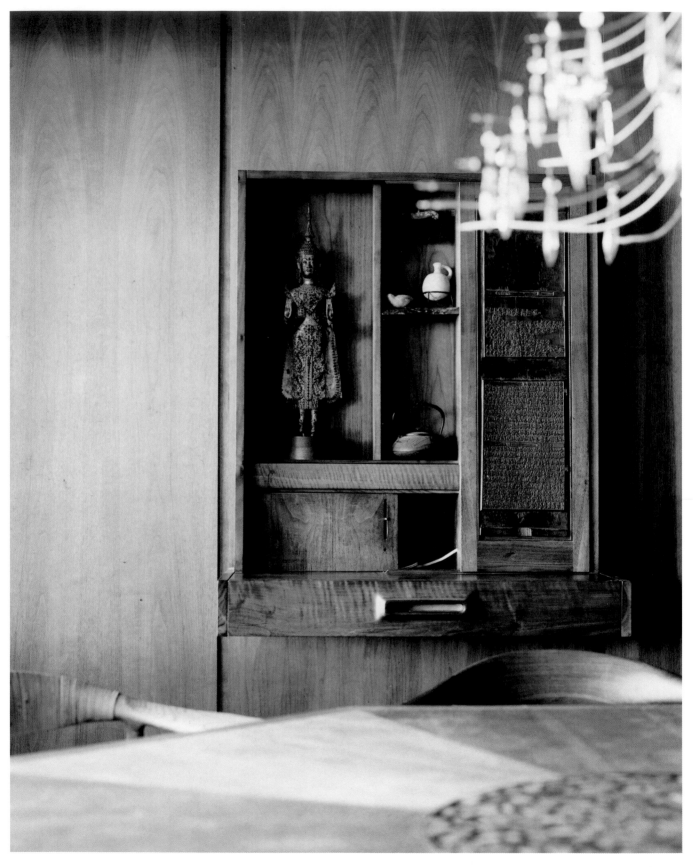

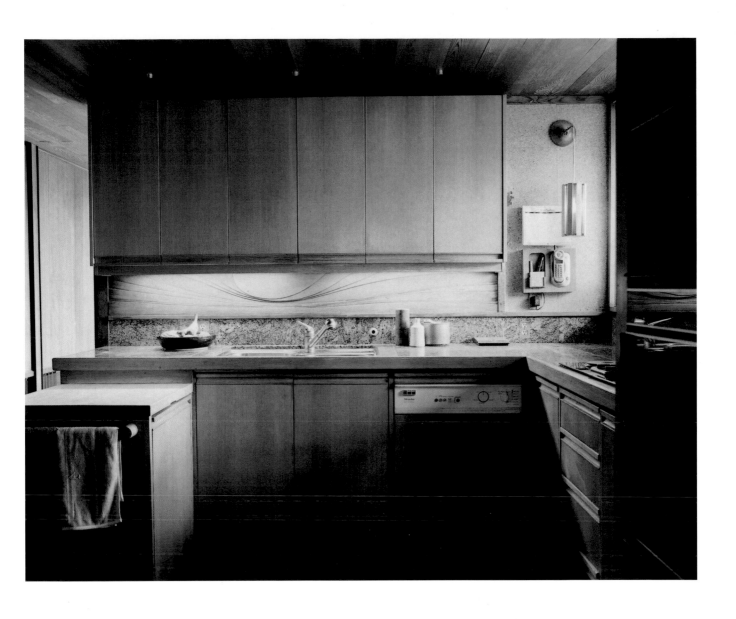

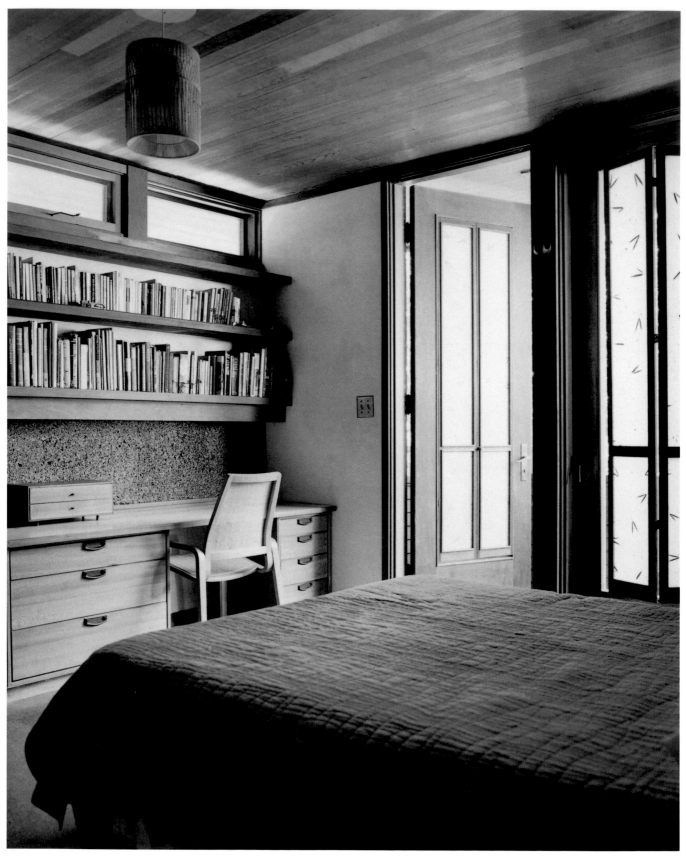

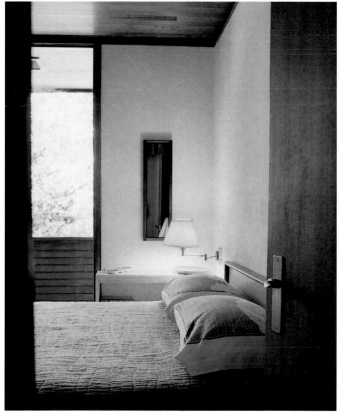

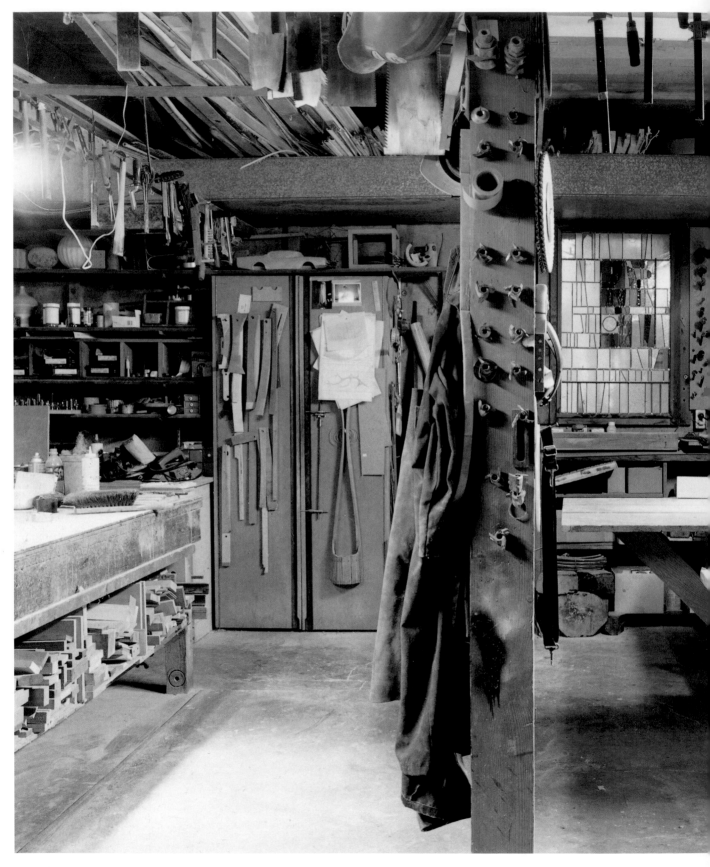

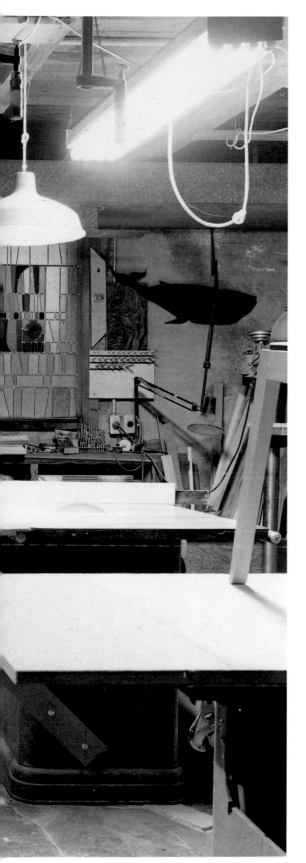

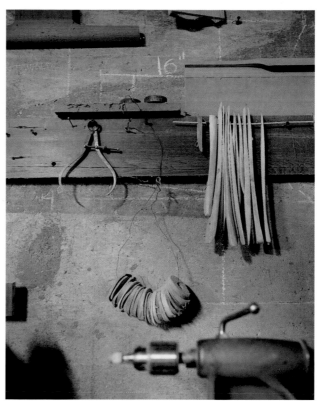

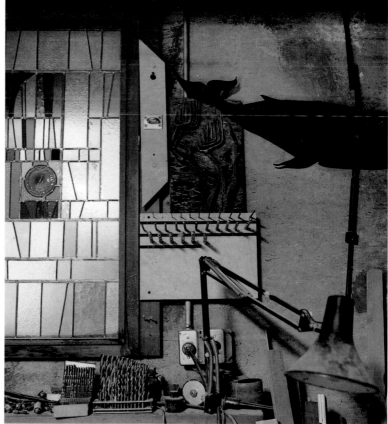

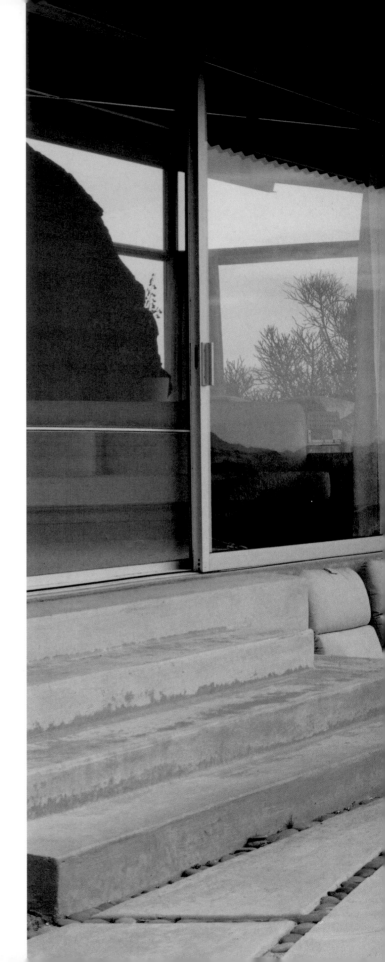

ALBERT FREY

PALM SPRINGS, CALIFORNIA

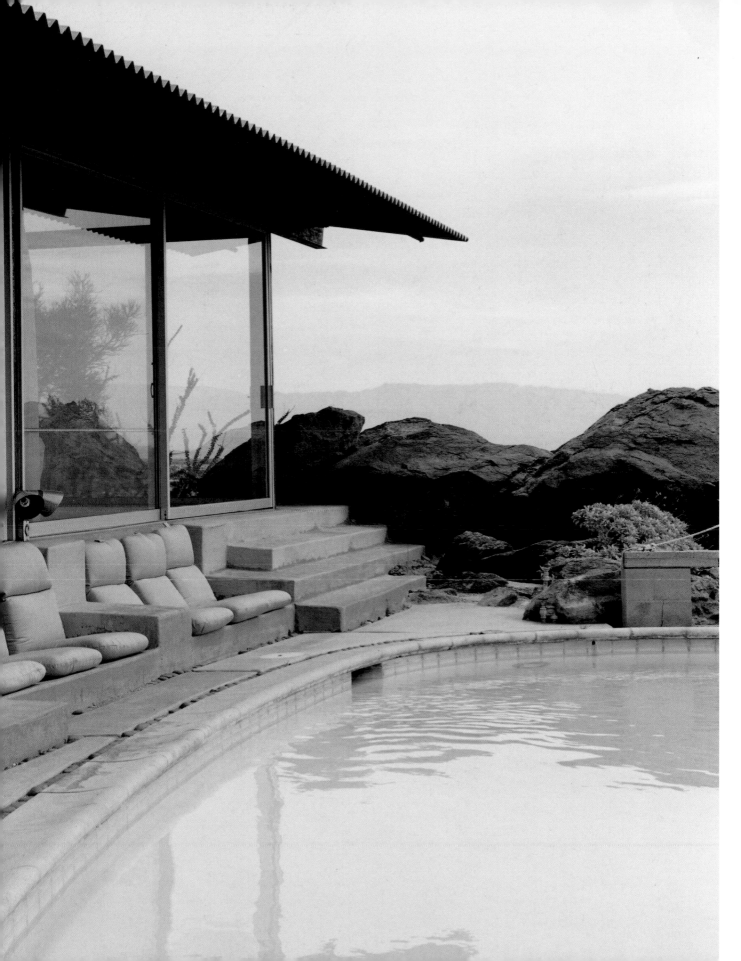

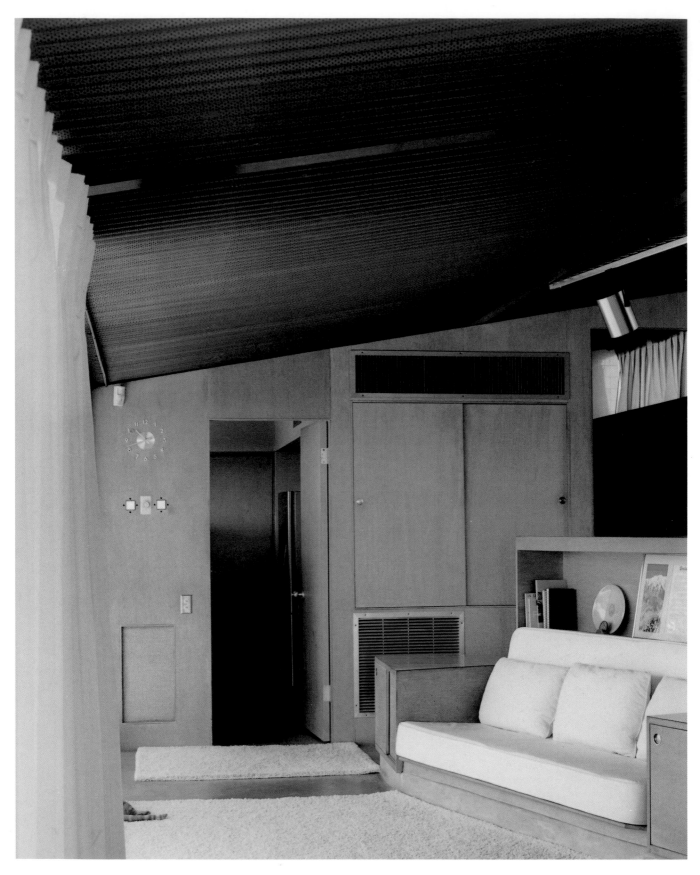

This is the home that started the project: Albert Frey's home in Palm Springs. I love the desert and every time I would visit Palm Springs, I would notice Frey's house on the hillside. It resembled a glass hang glider clinging to the side of the San Jacinto Mountains. I could not imagine what the interior was like so I researched it in books but nothing I saw satisfied my curiosity. Frey (1903–1998) was Swiss, and thus his love of the mountains could have been fait accompli, but his interest in modern building practices could not be satisfied in his home country. He traveled to various cities in Europe to work and study architecture, including some time with Le Corbusier in Paris, before eventually coming to the United States. By 1939 he was living full time in Palm Springs, California, where he would spend the rest of his life.

Over some sixty years, Frey helped shape Palm Springs into the modern architecture mecca it is known as today, and in the process, he developed a style of building that is known as desert modern. Walls of glass, flat sweeping roofs, and corrugated metal are some of Frey's hallmarks. These can all be found in the Frey House II, as it is now called. My fanciful notion of the house resembling a glass hang glider was completely thrown out the window the second I climbed the steps from the drive and could see it from a proper perspective. The house has three glass walls that allow the living room to be a part of the desert landscape as the structure steps up the rocky terrain of the hillside. Frey played on this by matching his yellow drapes to the flowers of the spring-blooming encelia bush outside his windows, but the views in the living room did not capture my attention as much as the large rock jutting into the center of it. Upon buying the land, Frey quickly realized there was no getting around this boulder so he incorporated it into the architecture. The rock became a divider for the sleeping and living areas of the main room, and Frey ingeniously installed a light switch in it—thank goodness for colored mortar.

Similar to Frey House I (1940), the first home he built for himself on the valley floor, this hillside home adhered to a three-room plan, similar to what would affectionately be called a studio by today's standards. The original footprint of the house is 800 square feet with an all-purpose living room, a kitchen, and a bathroom. At the time I was living in a cramped studio apartment, and walking through Frey's home was a revelation—all this in such a compact footprint! He planned the layout of his house so meticulously that it offers brilliant solutions to living in small spaces and addresses many of our modern-day needs. All furniture is built in including the bed, a clock on the wall, and the outdoor patio furniture. The kitchen is galley-style, with some cabinets so shallow that Frey installed a ridged fiberglass surface to store his plates standing up. The bathroom, with its floor-to-ceiling pink tile, holds Frey's closet behind an accordion door that extends the length of the room. Delicately perched on the steep hillside, his house occupies a tight footprint, but packed with space-saving ideas and generous views of the surrounding landscape, it feels expansive. Although his home was only a bit larger than my studio at the time it struck me as infinitely more spacious. An inherent simplicity is required when living in such a small space, and Frey mastered it.

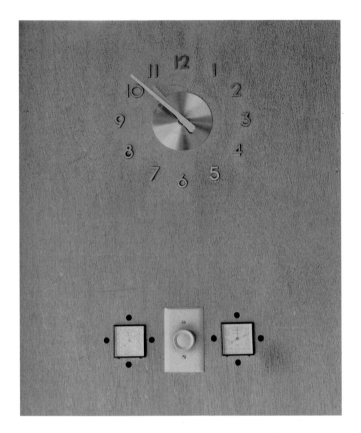

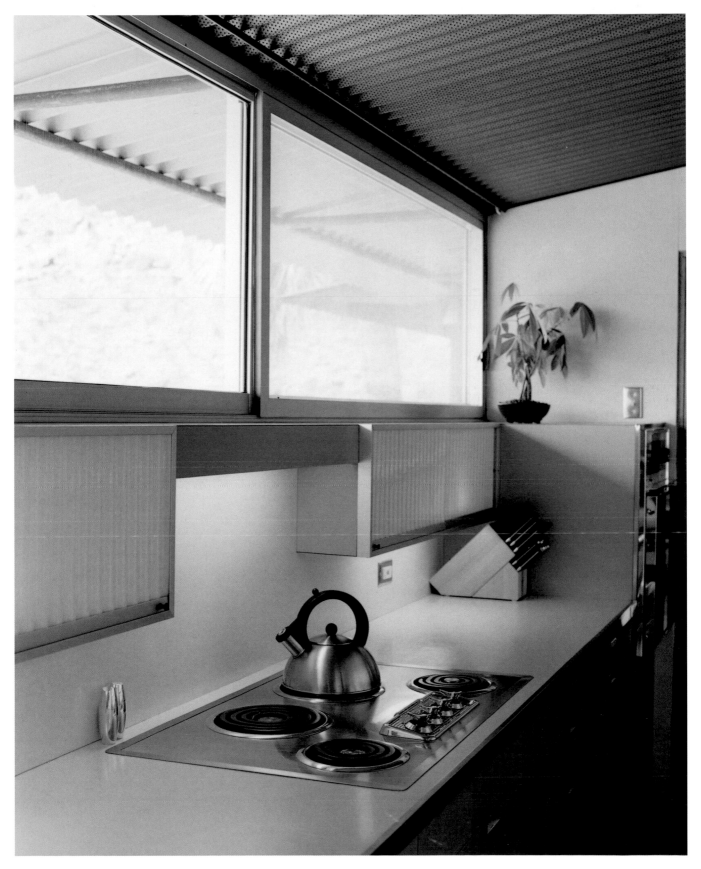

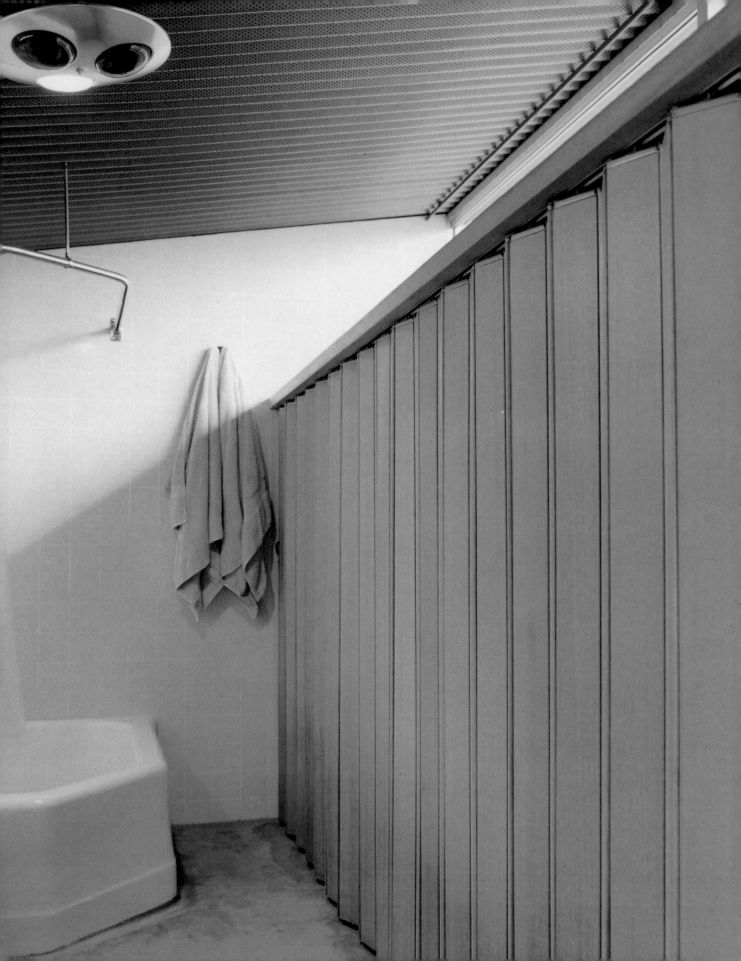

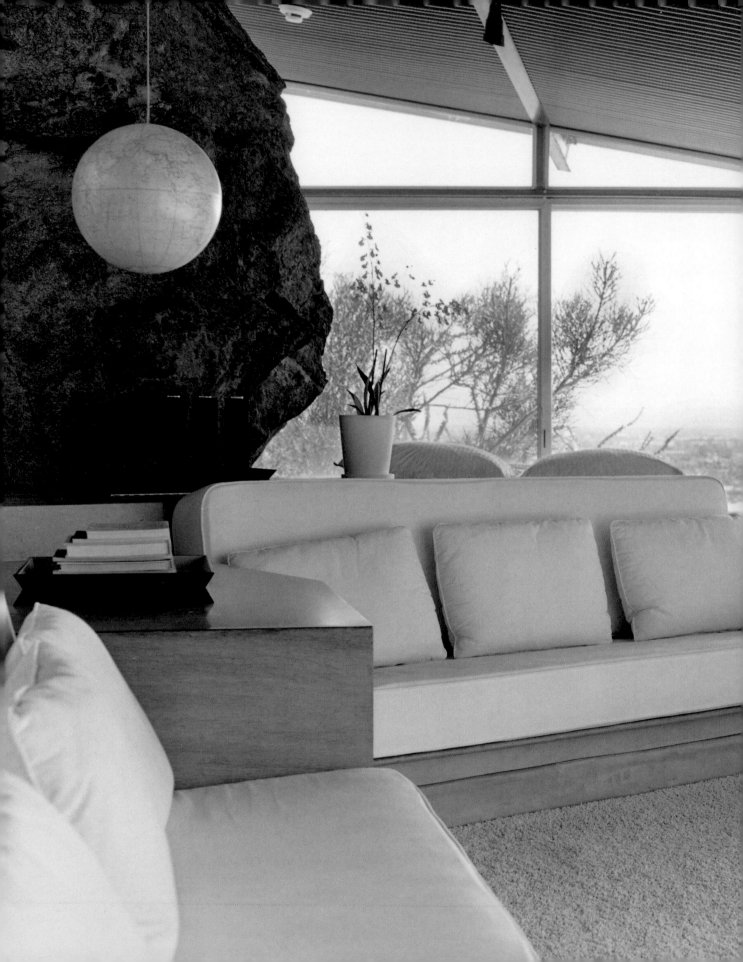

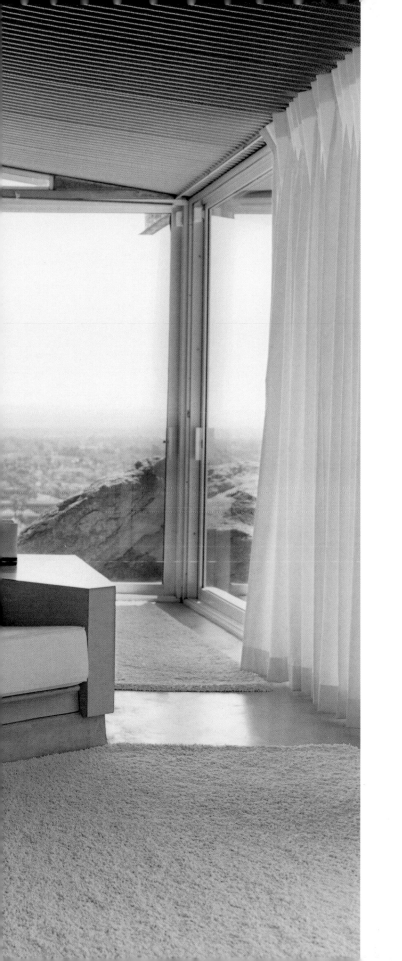

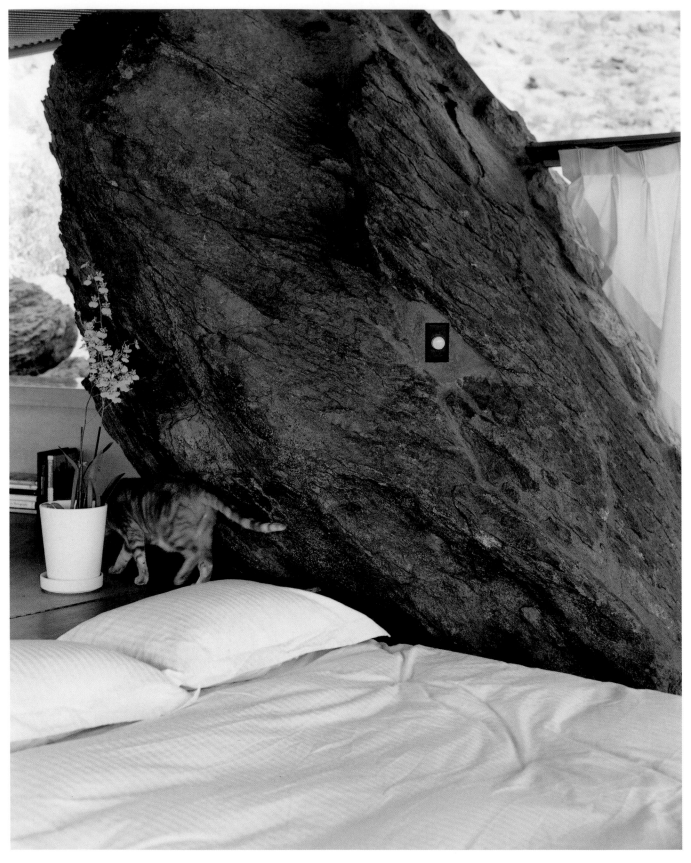

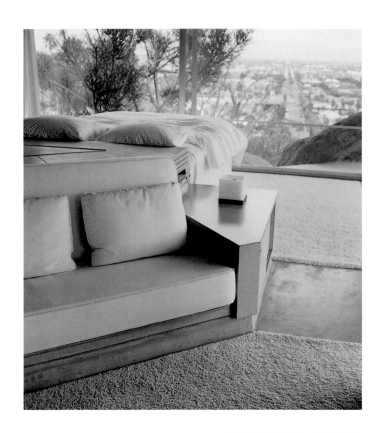

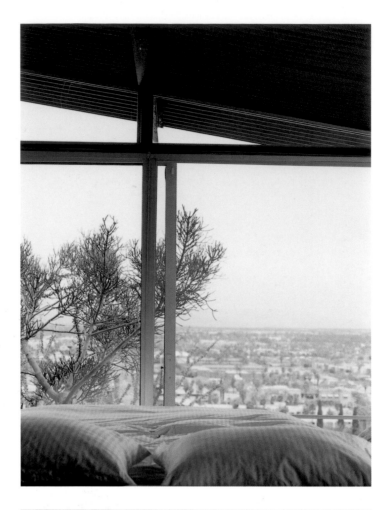

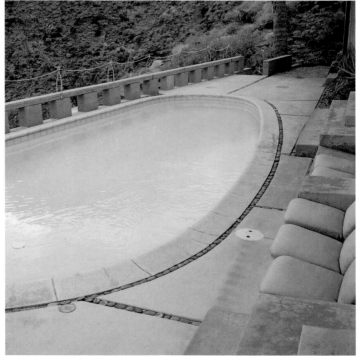

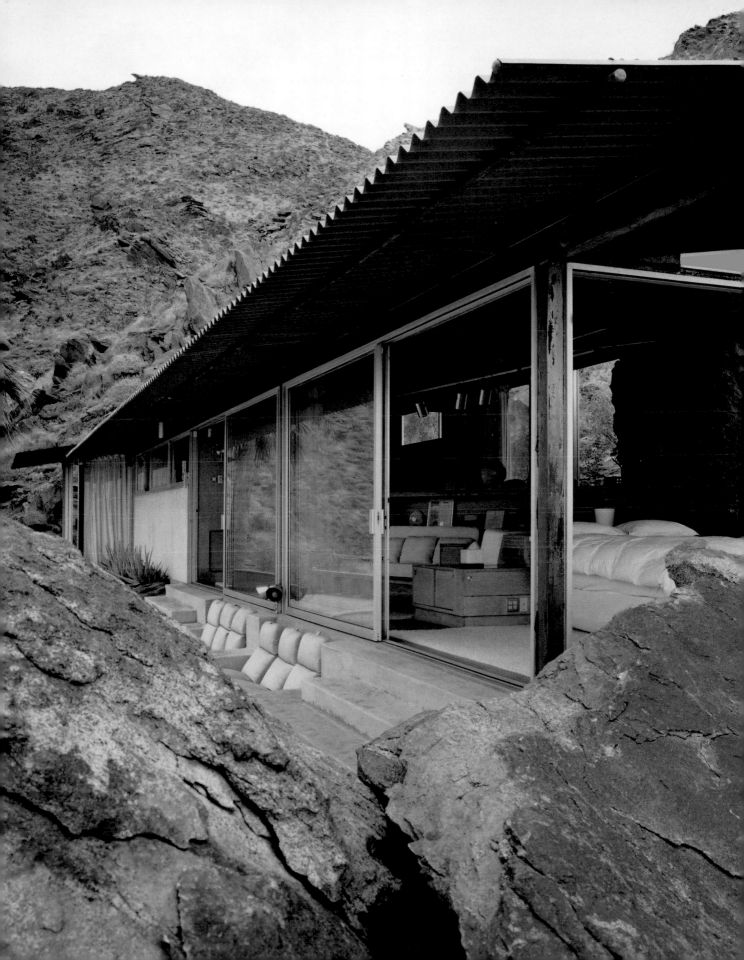

ACKNOWLEDGMENTS

I am deeply grateful to all the homeowners and institutions who allowed me to visit and spend two entire days photographing these houses. They have provided me with some of the best experiences of my life.

Special thanks to:

Jerome and Evelyn Ackerman, Laura Ackerman-Shaw; Val Bertoia, Melissa Strawser, and the Artists Rights Society; Mariah Nielson of the J. B. Blunk Residency; Eames Demetrios, Lucia Atwood, and Genevieve Fong; Ruth Esherick Bascom, Bob Bascom, Rob Leonard, and Paul Eisenhauer; Bob Bogard, Sidney Williams, and Kathy Clewell of the Palm Springs Art Museum and Mary Perry; Susanna Crampton, Wendy Hubbard, and David Moore of Historic New England; Irving and Belle Harper; Vladimir Kagan and Erica Wilson; John Kapel; Kevin Nakashima and Mira Nakashima; Jens and Henny Risom; Lori Moss of The Russel Wright Design Center; and Eva Zeisel and Adam Zeisel.

A special thanks to Dung Ngo, Charles Miers, and Meera Deean at Rizzoli; Adam Brodsley, and everyone at Volume Inc. for helping me shape this project into the book I wanted it to be. Thanks to Lightwaves Imaging, San Francisco, for working with me to make the images as beautiful as possible, especially Dirk Hatch and Brian Gernes and to Rayko Photo Center in San Francisco, where I toiled away in the darkroom to print many of these images.

There are many people who helped me with this project during these past four years, be it with suggestions for possible homes to include, a place to stay while traveling, or simply listening to me talk about these fantastic places and my experiences there. All your support and encouragement were greatly appreciated:

Jennifer Bostic, Chona Reyes, Renee Zellweger, Todd McPherson, Bill Stout and everyone at William Stout Books, Karen John, Gerard O'Brien, Steve Roden, Brooks Beisch, Mary Beth Phillips, Cathy Bailey, Julianna Goodman, Jeffrey Head, David Sykes, Lesley Unruh, Joe Kish, Janet Pullen, Jenny Shears, and Grace Choi.

And most importantly, a heartfelt thank you to my father, Cletus Williamson, and my mother, Vicki Sykes. Your support and unwavering faith in me have made this book and everything else possible. I won the lottery with you two.

VISITING THE HOUSES

The following homes can be visited and toured. Please contact
the respective homes for further details.

Eames House
http://www.eamesfoundation.org

The Wharton Esherick Home and Studio
http://www.levins.com/esh7.html

Gropius House
http://www.historicnewengland.org/visit/homes/gropius.htm

Nakashima Woodworker
Although George Nakashima's home cannot be toured,
Nakashima Woodworker does give tours of some of the
workshops on Saturdays.
http://www.nakashimawoodworker.com

Russel Wright House
http://www.russelwrightcenter.org

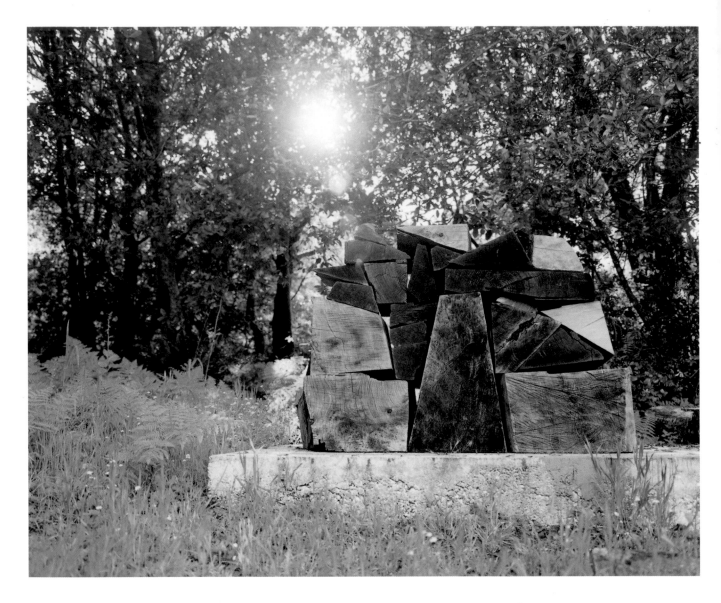

First published in the United States of America
in 2010 by RIZZOLI INTERNATIONAL
PUBLICATIONS, INC.
300 Park Avenue South
New York, NY 10010
www.rizzoliusa.com

ISBN-13: 978-0-8478-3418-1
Library of Congress Control Number: 2010926513

Photography of the Eames House © 2010 Eames
Foundation (www.eamesfoundation.org)

Artworks shown in the Harry Bertoia photos
© 2010 Estate of Harry Bertoia / Artists Rights
Society (ARS), New York

Photography of Frey House II by Leslie
Williamson taken with permission of the Palm
Springs Art Museum.

Frey House II, Palm Springs, California (1963-
1964; 1970-1971). Collection Palm Springs Art
Museum, bequest of Albert Frey

Editor: Dung Ngo
Design: Volume Inc., San Francisco

Distributed to the U.S. trade by Random House,
New York

Printed and bound in China

2011 2012 2013 2014 / 10 9 8 7 6 5 4